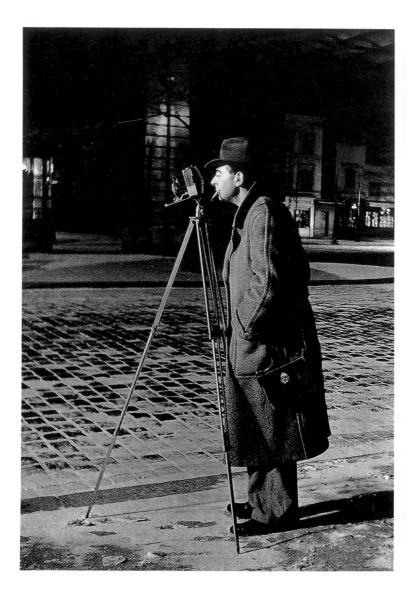

PHOTOGRAPHY

Willfried Baatz

With a foreword by L. Fritz Gruber

BARRON'S

Cover photos from top to bottom and left to right:
Etienne-Jules Marey, *Chronophotograph of a Man Dismounting from a Bicycle*, ca. 1890–95,
Cinématèque Française, Paris / Charles Nègre, *Portrait of his Photographer Friend Henri Le
Secq on a Tower of the Cathedral of Notre Dame*, Paris, 1851, Canadian National Gallery,
Ottawa / Plate camera "The Mammoth," built ca. 1900 in the USA, National Museum of
American History, Smithsonian Institution, Washington / Man Ray, *Glass Tears*, ca. 1930,
© Man Ray Trust, Paris, VG Bild-Kunst, Bonn, 1997 / Rudolf Koppitz, *Study of Movement*, ca.
1929, © Rudolf Koppitz, Courtesy of Galerie Kicken, Cologne / Karl Blossfeldt, *Adiantum
pedatum, Maidenhair Fern*, 1915–25, © VG Bild-Kunst, Bonn, 1997 / László Moholy-Nagy,
Photogram, 1922, © VG Bild-Kunst, Bonn, 1997 / Alexander Rodchenko, *Steps*, 1930,
© Alexander Lawrentiev, Moscow / Man Ray, *Rayography*, 1926, © Man Ray Trust, Paris, VG
Bild-Kunst, Bonn, 1997 / Ernst Haas, *Rose*, 1970, © Ernst Haas, Magnum, Agentur Focus /
George Hoyningen-Huene, *Swimwear by Izod*, 1930 / Jacques-Henri Lartigue, *Auto Racing;
Grand Prix of the A.C.F.*, 1912, © Association of the Friends of Jacques-Henri Lartigue, Paris
Back cover photos from top to bottom:
Twin-lens reflex camera Rolleiflex, 1929 / Harold Edgerton, *King of Hearts and Bullet*, un-
dated, © The Harold E. Edgerton Trust, Courtesy of Palm Press Inc. / Chargesheimer, *Portrait of
August Sander*, © Chargesheimer, Museum Ludwig, Cologne, Photograph Collection
Frontispiece:
Brassaï, *Self-portrait*, ca. 1932, © The Estate of Brassaï, Paris

American text version by: Editorial Office Sulzer-Reichel, Overath, Germany
Translated by: Sally Schreiber, Friedrichshafen, Germany
Edited by: Bessie Blum, Cambridge, Mass.

First edition for the United States and Canada
published by Barron's Educational Series, Inc., 1997.

First published in the Federal Republic of Germany in 1997 by
DuMont Buchverlag GmbH und Co. Kommanditgesellschaft, Köln.

Text copyright © 1997 DuMont Buchverlag GmbH und Co. Kommanditgesellschaft,
Köln, Federal Republic of Germany.

All inquiries should be addressed to:
Barron's Educational Series, Inc.
250 Wireless Boulevard
Hauppauge, New York 11788

Library of Congress Catalog Card No. 97–71965

ISBN 0-7641-0243-5

Printed in Italy by Editoriale Libraria

Contents

Preface 7

Foreword: Photography, The Authentic Image 8

The Prehistory of Photography 10

Early attempts at picture making/
Scientific prerequisites

Early Processes 16

Niépce and Daguerre/The English competition/
The triumph of a new medium

New Methods—Other Paths 28

The wet-plate process (wet collodion)

I *Stereophotography: The Third Dimension* 34

Photographs as status symbols: Portrait photography/
Nadar—Photographer, Bohemian, Aeronaut/The
opposite extreme—André Adolphe-Eugène Disdéri/
The photographic image of the naked body/Ideal
and reality/Early photojournalism—Documentation
of events/Halftone reproduction/The discovery of
new worlds: Travel and landscape
photography

The Forerunners of Modern Photography 58

Expanding the means—Photochemistry and
phototechnology/Capturing movement/Kodak—
Photography for all/Pioneers of color photography/
Pictorialism around 1900/Stieglitz, Steichen, and
the Photo-Secession/The truth behind the objects/
Eugène Atget—A photographer of old Paris

The New Vision 84

Straight photography/New objectivity/
The renaissance of the portrait/Glamour

and fashion/The avant-garde—The search for
new forms/Photogram and photomontage/
Surrealism and Man Ray/
The Russian avant-garde

🏛 *Photography and the Bauhaus* 106

The beginnings of modern photojournalism

The Discovery of Everyday Life 112

Portraying life/American life/
The photography of high fashion/
Technical advances/Social
documentary/War pictures

FSA *Farm Security Administration* 126

The Postwar Period 128

Human interest/Realism and subjectivism/
Masters of the street/The portrait as icon—
Photographic memorials/Masters of
beautiful illusion/The influence of abstraction/
Subjective photography/Art as photography/
Pop art and hyperrealism/Art and document

📷 *Magnum* 152

Hard Realities 154

Photojournalism/Social engagement/The
photographer as *auteur*/International
developments/Impressive casualness/Erotic
photography—The language of lust/The
arranged image—Photography as construction
and staging/Becoming pictures—Photography
in contemporary art/Recent trends

Glossary 172
Chronology 174
Galleries and Museums 178
Magazines 180
Selected Bibliography 180
Monographs 181
Subject Index 184
Index of Names 187
Picture Credits 19▪

Preface

Photography has been offering a seemingly authentic image of reality for a good hundred and fifty years—not very long compared with the history of traditional painting and drawing. And yet in this relatively short time, photography has powerfully influenced the way we see. The work of photographers has sharpened, perhaps even forever altered, our perception.

Photographs have long held a secure place in our visual memory. Always recognized for its illustrative possibilities, photography's artistic possibilities were not so readily accepted, or understood. Today, however, photography easily ranks throughout the world among the most respected of arts. Comprehensive photographic collections in museums as prestigious as the Museum of Modern Art in New York, the Museum Ludwig in Cologne, and the Victoria and Albert Museum in London document photography's ascension into the realm of the muses.

Of course, as the number of photographs and photographers proliferated, and as the medium grew freer, so, too, the number of books devoted to the various aspects of photography has grown. A gap remains, however, between specialized scholarly research, thick exhibition catalogues, and elegant coffee-table books. This Crash Course hopes to bridge that gap.

The present book does not attempt a systematic, scholarly or encyclopedic summary but rather offers a concise history of photography enhanced with exemplary photographs to illustrate both historical stylistic developments and the important movements that added to the development of the medium.

Whenever technical developments and influences have had an important influence on photography—or, at its origin, brought it into existence—these historical facts are integrated into the photographic history.

Limited, single examples of the work of important photographers, of technical developments, or other important themes are provided as references to particular movements and trends, and are meant to shed light on the connections and developments within the various epochs of photographic history.

For further reference, the extensive appendix includes a glossary of important photographic terms, a listing of major national and international photographic museums and collections, and a bibliography of selected photographic literature and journals.

Willfried Baatz

Foreword: Photography, the Authentic Image

This little handbook of photography offers more than its title claims. Written by a scholar of art history, well researched, well written, and easy to read, this single volume contains the important names, facts, and dates, and covers in a sense the contents of several encyclopedic volumes. Highly informative, the book closes a gap that needed to be filled.

The aim and accomplishment of the book are reminiscent of another short history of photography published by the German publisher DuMont five years ago, *The Imaginary Photo Museum*. On the one hand, the earlier book was the catalogue of a unique exhibition mounted in Cologne in 1980; this show included 457 works borrowed from 34 museums around the world, reaching westward to San Francisco and eastward to Tokyo. On the other hand, the book constituted the conclusion of a program begun in 1950 as the "Photo-Movie Exhibit of Cologne," which later became known as the biennial "photokina," which consisted of about 300 individual exhibitions of international cultural picture shows with 16 three-language catalogues.

Evelyn Richter, *Leipzig,* 1976

Thanks for the creation of this world fair of pictures were due to certain forward-looking individuals who recognized that in the new post-world-war age, photography would become an increasingly important medium of documentation, information, communication, and art. And yet, among the public, its importance went largely unrecognized. For this reason, a program of presentations and commentaries was launched to address questions about what photography really is, who developed it, who perfected it, and how it can be used—in short, how photography served people.

The title essay of the 1950 catalogue was "Photography—Reality and Illusion." Another article was called "The Beginning Was Difficult." The latter, which described the invention of the medium in the 19th century, was written by the collector and photo-historian Erich Stenger, who had just published a book based on his study, *The Triumph of the Photograph*. In May 1950, *Photo-Magazin* greeted the exhibit with its lead article, "The Omnipresence of Photography." Thus, the program began in a spirit of

Foreword: Photography, the Authentic Image

euphoria that was to span three decades of "photokina" exhibits and catalogues.

The Imaginary Photo Museum attempted to supply a provisional digest and summary of the creative uses of photography by means of two different, but mutually supportive, approaches. The "Chronology" presented a longitudinal listing of photographic works dating from 1839 to 1970, while the "Analogy" offered a horizontal analysis of photography, drawing attention to unusual combinations and confrontations of photography, irrespective of date of creation, under seven themes: objects, nudes, landscapes, portraits, the city, events, and vision. Two highly respected historians of photography enriched the author's short history with their own contributions: the American, Beaumont Newhall, and the European, Helmut Gernsheim. The book, which was published in German, Spanish, English, and American editions, is no longer in print.

But the interest in photography has continued to grow—not only in the deepened and expanded application of photography but also in its reflection as a social phenomenon. Witnesses to this are the many published studies striving to evaluate photography philosophically, sociologically, and politically.

But here, on the springboard into the 21st century, photography faces certain radical change. Its long-trusted credibility is challenged by developments in electronic media. For it is now possible to unrecognizably alter and even falsify any existing photograph; what is more, photography can now conjure worlds that do not exist and make them visible and "real." In fact, digital pictures are no longer photographs in the tried and trusted sense, but are the products of a completely different and independent medium.

Traditional photography—the "authentic" picture—will continue to serve an irreplaceable function. This is why it is helpful to be able to make a judgment on what has long seemed incontestable as the "triumphal march" of photography, and to recognize what is owed to whom. This need is what makes this book so valuable.

L. Fritz Gruber, Cologne, Germany
December 1996

Collector and publicist L. Fritz Gruber, born in 1908, is honorary president of the German Society for Photography, director of the cultural "photokina" Picture Exhibitions 1950-80, and, together with his wife Renate, cofounder of the Gruber Photographic Collection of the Museum Ludwig in Cologne.

The Prehistory of Photography

Early Attempts at Picture Making

1727 Death of Sir Isaac Newton.

1750 The Enlightenment increasingly influences western thought.

1751–72 *Encyclodédie* composed by Denis Diderot and Jean le Rond d'Alembert.

1765 James Watt invents the steam engine.

1768 James Cook begins his voyages of discovery.

1776 Declaration of Independence.

1789 French Revolution.

1789–97 George Washington first president of the United States.

1791 Wolfgang Amadeus Mozart, *The Magic Flute*.

1797 Alois Senefelder invents lithography.

1804 Napoleon crowns himself emperor.

1813 Jane Austen, *Pride and Prejudice*.

1814–15 Congress of Vienna reorganizes Europe after the defeat of Napoleon.

1823 Ludwig van Beethoven, *Ninth Symphony*.

1835 Alexis de Tocqueville, *Democracy in America*.

1837–40 Samuel Morse invents the telegraph and telegraphic alphabet (Morse code).

1837–1901 Reign of Queen Victoria.

The desire to capture the image of the fleeting and transitory moment is probably as old as the human race. Human beings desire to hold—and pass on—a representative picture of themselves. For millennia, only art could satisfy these desires. But art rarely held a mirror up to nature; instead, it often functioned as a socially conditioned medium for idealized—or, in any event, subjective—interpretations of life.

By the early 19th century, both the time and technology were ripe for a new and objective medium for capturing the image of reality. The urgency of the idea is seen in the fact that several inventors were working unbeknownst to each other on the same problem at the same time. Through centuries of development in optics, mechanics, and chemistry, the groundwork for photography had already been laid. Last but not least, the emergence of photography was a response to social developments that almost urgently demanded such a representational medium. Technically, there are three requirements for producing permanent photographic images: an optical system for capturing the image, a chemical substance whose appearance changes under the influence of light, and a medium to fix or hold this change. By the start of the 19th century, two of these conditions had been met.

Early attempts at picture making

The pinhole camera, or camera obscura (Italian, "dark room"), was one of the first developments in the history of photography. The phenomenon of a stream of light passing through a small opening into a dark chamber and projecting an exact, though inverted, image of the outside scene onto the opposite wall of the chamber was already familiar to Aristotle (384–322 BC), the Egyptian scholar Abu Ali Alhazen (965–ca. 1040 AD), and the medieval Dominican monk and scholar

Albertus Magnus (1193/ 1206?–1280 AD). But it was Leonardo da Vinci who first put the principle to practical use between 1490 and 1492. However, because he cryptically annotated his diagrams in a kind of mirror script that was not decoded

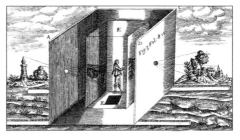

until 1797, his invention remained without issue for centuries. Later, in the 16th and 17th centuries, his technology was studied and developed by scientists such as Giovanni Battista della Porta and Johannes Kepler. Della Porta described the operation of the camera obscura in 1553, and fifteen years later his work was followed by a treatise by the Paduan professor Daniello Barbaro, who suggested substituting a lens for the plain pinhole to enhance the projected image.

At first primarily a drawing aid for artists, the early camera obscuras consisted of little more than a darkened room with a hole in an exterior wall. But in the 17th century, people began to build small box-shaped apparatuses with lenses

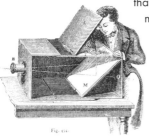

that cast a reverse mirror-image into the interior. These pictures were projected onto a glass plate on the upper side of the portable box, and the artist was able to trace the picture

from the plate. Johannes Zahn was probably the first to describe and illustrate such a box in 1685. The artistic effect of the camera's precision, angular play of light, and insight into perspective are very clear in the work of many artists of the Dutch and Flemish schools, notably that of Jan Vermeer.

until 1839

The camera obscura, seen here in a 1646 illustration of the "dark chamber" by A. Kirchner, was originally a portable, light-proof walk-in chamber in which the artist could copy pictures from nature.

The camera obscura normally contained a glass plate on which transparent paper was placed for drawing. The image captured by the lens (B) was projected by the inverted mirror (M) onto the drawing surface (N) where it was copied by the artist.

The Prehistory of Photography

Early Attempts at Picture Making

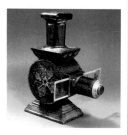

Joseph von Fraunhofer (1787–1826). At the time of the invention of photography, Frauenhofer's research into basic optic principles was generally known and, around 1840, became an important element in the production of the widely used objective lenses of Chevalier and Petzval.

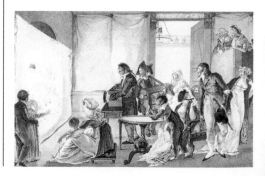

Laterna magica, or magic lantern, by the French firm Lapierre, ca. 1860–70. The magic lantern used a light source (usually a candle or an oil or paraffin lamp) to project transparent pictures and was thus a precursor of the modern slide projector.

By the beginning of the 19th century, the development of concave and convex lenses had advanced to the point where the Bavarian Joseph von Fraunhofer was able to improve the achromatic lens invented by John Dolland in 1758. Fraunhofer did pioneering work in the calculation of achromatic lenses and developed a method of determining the refractive index of different kinds of glass. Once the science of optics had done its job, the next step was the production of suitable kinds of glass and the mounting and combination of various lenses.

But before photography could finally make its triumphant appearance, a number of other optical devices were developed. Chief among these was the laterna magica, or magic lantern, dating from the 17th century. Taking advantage of simple laws of optics, the magic lantern projected light through a transparent image onto a surface. In a sense, the magic lantern is the forerunner of the modern slide projector; but like its predecessor the camera obscura, its initial function was to aid artists. Employed by painters who used its images as patterns for their painting until late in the 1870s, the laterna demonstrated the fundamental desire of the age for precision and realism in depictions of the world.

The appearance of an emancipated and growing middle class in the 19th century brought with

Illustration of an improvised magic lantern show by a traveling projectionist, ca. 1810.

Early Attempts at Picture Making

it an unparalleld demand for pictures; this was reflected in the extraordinary popularity of silhouette cutouts that merely required the "artist" to trace a shadow and cut it out. The physionotrace developed by Gilles-Louis Chrétien in 1786 also needed no high level of draftsmanship. The advantage of the process was that it produced miniatures suitable for reproduction by copper engraving. Another aid for those deficient in artistic talent was the camera lucida invented by the Englishman William Hyde Wollaston in 1807. This camera consisted of a right-angle glass prism clamped at eye level above a horizontal drawing board. With one eye looking down through the prism, and the other focused on the drawing board, the artist could trace the image that appeared to be superimposed on the paper. William Henry Fox Talbot later used the camera lucida to experiment with "photogenic drawings" and other small camera images.

All of these optical aids served to some extent to produce pictures—especially portraits—quickly and cheaply in response to increasing demand. These various devices not only influenced the aesthetics of the period, but also raised fundamental questions about the nature of artistic subjectivity.

If magic lantern projections offered a kind of illusion of reality, the panorama and diorama attempted even more exact copies of reality and were among the most popular artistic entertainments of the early 19th century. Visitors to a panorama stood on a raised platform and looked down at a monumental picture stretching 360 degrees around them. The panorama was meant to give the viewers the feeling that they were taking part in an action playing itself out around them. Typical pictures might consist of a ~ty or country landscape that had been ~oduced with the help of a camera obscura.

A silhouette of Swiss theologian, writer, and philosopher Johann Caspar Lavater.

Production of a portrait using a camera lucida, which relieved the artist of the trouble of acquiring artistic (or at least, drawing) skills—a need that many artistically ambitious "artists" of the time were happy to dispose of with the help of photography.

The Prehistory of Photography

Sectional drawing of the London panorama, early 19th century. The orientation plan shows the various viewing levels for the visitors of this gigantic panorama which was taken on a tour of many European cities. Scenes included the decorated bark of the Lord Mayor, marching soldiers, and other images of English life.

"The idea occurred to me—how charming it would be if it were possible to cause ... natural images to imprint themselves durably, and remain fixed upon the paper."
William Henry Fox Talbot, 1844

While the panorama provided a relatively static experience, the diorama developed by

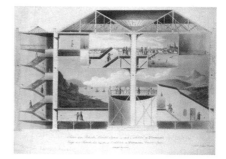

Louis Jacques Mande Daguerre and his partner Charles Marie Bouton enhanced the sense of reality. Daguerre, later celebrated as the inventor of photography, opened the first diorama in Paris in 1822. Through complicated illumination techniques, images of sunsets and sunrises, cloud formations, and billows of mist were reproduced on a painted screen. Simulated Swiss landscapes with "real" dairy farms and the tones of an alpenhorn and other sound effects were meant both to astound visitors and satisfy their craving for a "representation" of reality.

Scientific prerequisites

It has long been common knowledge that bright sunlight can affect the appearance of objects. In 1614, A. Sala, personal physician to the Duke of Mecklenburg, noted, "When one exposes salt of silver to the sun, it becomes as black as ink." Later, Johann Heinrich Schulze, German anatomy professor and natural philosopher, proved the light sensitivity of the silver salts scientifically. Experiments with light sensitive substances were also conducted by other scientists of this time, including the Italian physicist Giacomo Battista Beccaria, the Genevan theologian, Jean Senebier, and the Swedish chemist Carl Wilhelm Scheele, who di

covered that silver chloride was light-sensitive and that ammonia rendered blackened silver chloride insoluable—in short, ammonia was a fixative.

In 1814, a second light-sensitive argentic salt, silver iodide, was discovered by Sir Humphrey Davy. Shortly thereafter, Antoine Jérôme Balard discovered the third pillar of photography, silver bromide. Meanwhile, in 1799, the English chemist Thomas Wedgewood was investigating the use of light-sensitive substances to fix the images produced by the camera obscura for decorating plates and pottery in his father's earthenware factory. The images were too weak, but he had invented the photogram, a method of producing contact copies from leaves, and other objects without a camera. Wedgewood lacked a medium to preserve his images—an odd oversight, since he and his friend Davy were aware of Scheele's discovery. Wedgewood's findings were published in 1802, but it was not until 30 years later that Fox Talbot found a fixative process. Half a century later, the photogram was taken up by both Hippolyte Bayard and William Henry Fox Tulbot, and still later, around 1920, it became the basis of Schadography and Rayography, processes developed by D. Christian Schad and Man Ray.

until 1839

Carl Ferdinand Stelzner, *Self-Portrait*, miniature painting on ivory, 1833. Like many other painters of his day, Stelzner was originally a miniaturist. However, with the advance of photography into the traditional territory of art, many of these painters felt their livelihoods endangered. Some turned to photography or sought work coloring daguerreotypes.

Camera obscura: Daylight enters an otherwise light-proof chamber through a hole. On the inside wall opposite the hole, an exact image of the scene outside appears, reversed from left to right and top to bottom.

Laterna magica: A source of light, such as a candle or paraffin lamp, throws light, strengthened and reflected by a concave mirror, through an opening of a box onto strips of painted glass. These pictures are then projected onto the wall by means of lenses.

Camera lucida: Device for drawing objects from nature, consisting of a four-sided prism whose image conveys a natural impression to the eye. The viewer looks at the prism while copying the reduced prismatic image by hand.

Physionotrace: Drawing aid and engraving device for copying and transferring silhouettes onto metal plates, which can then be used for printing.

1839 – 1860

1843 Pioneers begin settlement of the American prairie.

1854 Doctrine of the Immaculate Conception announced by Pope Pius IX.

1845–49 Famine in Ireland results in mass emigration.

1848 Karl Marx and Friedrich Engels, *Communist Manifesto.*

1848 Bourgeois revolution in Germany.

1851 First World Exposition in London.

1854 Henry David Thoreau, *Walden.*

1854–56 Crimean War

1857 Gustave Flaubert, *Madame Bovary.*

1858 Charles Darwin, *Origin of Species.*

1859–69 Construction of the Suez Canal.

1861 Abolition of serfdom in Russia. Abraham Lincoln inaugurated as president of the United States; secession of the southern states and start of the Civil War.

Niépce and Daguerre

The details of the first practical photographic process were presented in 1839 before the Academies of the Sciences and the Fine Arts in Paris. Marking a decisive breakthrough in the history of modern visual recording technique, the report described what came to be called daguerreotypes—results of the work of inventor Louis Jacques Mandé Daguerre. But, to be historically more precise, several inventors, working independently, had simultaneously developed similar methods. Before 1839, many experiments involving the light sensitivity of silver salts in the practical production of pictures were being conducted simultaneously in England, France, and Germany. In France, the Niépce brothers—Joseph Nicéphore and Claude—had already started delving into the problem around 1812. Joseph

"Good daguerreotypes produce—because of their long exposure time—shapes so sensitive and delicate that later photography seems unable to match them."
 Alfred Lichtwark

Nicéphore, in particular, was looking for a new way to capture and hold images from nature as a way to compensate for what he thought of as his insufficient artistic skill. Excited by Aloys Senefelder's development of lithography, Niépce attempted to sensitize lithographic stones to light and to fix images produced by his self-made camera obscura. When the stones proved unsuitable, he turned to other media, such as metal and glass plates, which he coated with a light-sensitive layer of bitumen. Niépce hoped to etch the fixed image and then to print multiple copies on paper. His experiments were unsuccessful; the images did not hold up under the etching process. But this procedure, known as heliography (or "sun writing"), was later widely used as a photomechanical process in which the bitumen

layer served as an etching ground for copper and zinc plates which were then colored and printed. In 1822, Niépce succeeded in copying a copper etching directly onto an bitumen-glass plate after an exposure time of nearly a day, but he was unable to fix the image. Unfortunately, a few years later, the first exemplar of this important invention fell to the floor and shattered.

Niépce sought a remedy for this failure, and in 1826 or 1827 he produced the first picture that deserves to be called a photograph. From the Parisian optician Charles Louis Chevalier he acquired a professionally built camera obscura, as well as zinc plates, which he felt were a more suitable base for the coating of bitumen. Niépce set the camera up in the window of his country house, exposed the sensitized plate for approximately eight hours, and obtained a complete photograph—hazy due to the changing shadows caused by the time lapse—of the courtyard of his family estate "Le Gras" in Chalon-sur-Saône. He developed the picture with lavender oil, which released the unhardened areas of bitumen from the plate. Through Chevalier, Niépce and Daguerre both learned in 1825/26 that they were working on a similar

Joseph Nicéphore Niépce (1765–1833) is one of four inventors who can justifiably be credited with the invention of the photographic process. The oldest surviving photograph in the world is ascribed to him.

1839 – 1860

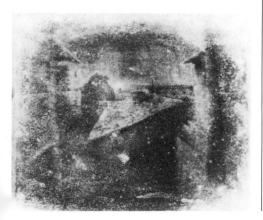

The world's first photograph: View from J. N. Niépce's workroom window in Maison du Gras, ca. 1826. This 6.6 x 8.4 in. photograph was taken with an bitumen-covered zinc plate and an exposure time of more than 8 hours. For many years, the photo was thought to have disappeared, but it was discovered in England in 1952.

1839 – 1860

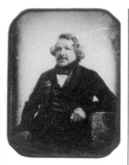

Louis Jacques Mandé Daguerre (1787–1851) is officially credited with the invention of the first practical photographic process in the world, daguerreotyping.

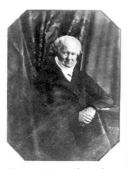

Hermann Biow, *Alexander von Humboldt* (1769–1859), daguerreotype, 1847.

problem. When Niépce's effort to present his process to the Royal Society in London was rejected because the inventor refused to disclose the process he used, he sought a partner to work with him on improving his heliographic process. Niépce and Daguerre met personally for the first time in 1827. Two years later they established a partnership. Niépce died in 1833 in relative obscurity, despite his invention of the iris diaphram, his entire estate exhausted in pursuit of his experiments. Daguerre, by contrast, who probably would not have been able to perfect his process without the work of Niépce, became famous.

Louis Jacques Mandé Daguerre, theater-set painter, diorama-owner, and successful businessman, had been trying since 1824 to use the camera obscura to create pictures with the help of light-sensitive substances, but until his partnership with Niépce, he remained unsuccessful. It was only this collaboration that prompted Daguerre to continue his quest for suitable light-sensitive substances. Unaware of Sir Humphrey Davy's research in England, it was probably by chance that Daguerre, too, discovered the light sensitivity of silver iodide, which he reported to Niépce in 1831. Six years later, Daguerre made the critical breakthrough.

By using mercury vapor, Daguerre was able to develop the latent—that is, present but not yet visible—image on the silver-iodide plate. At first, he used simple table salt—sodium chloride—as a

The daguerreotype process: A clean, polished silver-coated copper plate is exposed to iodine vapor, producing an extremely thin, light-sensitive iodine layer. The plate is then placed in the camera obscura and exposed to light through the lens opening for several minutes. The still-invisible picture is then developed by vaporized mercury in a second closed box. Finally, the image is fixed (treated to prevent further alteration by light) in a lukewarm salt bath, washed, rinsed with water, and dried.

fixative, but upon the recommendation of Sir John F. W. Herschel, he switched to sodium thiosulfate.

Because Daguerre used silver-coated copper plates as a ground, every photograph was unique—and laterally reversed. It was not possible to reproduce a daguerreotype. Each of the shiny silver shots, with their fine delineations and impressive sharpness, had to be kept framed under glass. Daguerre's first preserved picture, a still-life containing plaster busts, was created by this process in 1837. Nothing now stood in the way of the practical application of heliography. With great eagerness and a strong and sophisticated business sense, Daguerre sought to disseminate his invention; in so doing, he was not above exploiting nationalistic fervor in his marketing schemes.

The development of the latent image and the reduction of the exposure time from hours to minutes was especially appealing to politically influential physicist and National Deputy François Arago. On January 7, 1839, Arago informed the Academy of the Sciences in Paris of the new invention and advised the Academy to purchase it. After positive appraisals by Alexander von Humboldt and others, the French government decided to buy the invention; they awarded a life-long pension to Daguerre and to Isidore Niépce, who had inherited his father's share in the partnership, though his role in the sequelae of Daguerre's invention was strictly circumscribed by Daguerre: although the original partnership agreement stipulated that the invention would carry both their names, Daguerre slickly deprived the deceased J. Nicéphore Niépce of his fame by convincing the latter's son to alter the

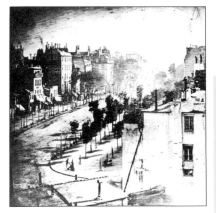

1839 – 1860

Louis Jacques Mandé Daguerre, *View of the Temple Boulevard*, Paris, daguerreotype, ca. 1839. The long exposure time of this very early photograph caused moving pedestrians and street traffic to disappear. The sharp outlines of the seeminlgy empty street scene belie the presence of life. Daguerre presented the photograph as a gift to the king of Bavaria.

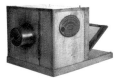

Daguerreotype camera, manufactured by Daguerre's brother-in-law, Alphonse Giroux. An insignia containing Giroux's name and Daguerre's signature identified this earliest serially produced camera.

1839 – 1860

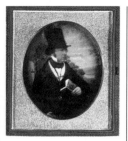

William Henry Fox Talbot (1800–1877), English scholar, discovered the principle that became the basis of modern photography: the negative-positive process. Michael Faraday, the leading physicist of his day, reported on Talbot's "photogenic drawings" before the Royal Society in London on January 25, 1839.

agreement. Thus, Daguerre was able to bequeath the process his name alone, and hence the term daguerreotype.The sensation could hardly have been greater when the details of the new process were announced and the French nation magnanimously donated the invention to the world on August 19, 1839. Six days earlier, however, Daguerre had patented his invention in England, thus securing for himself and his brother-in-law Alphonse Giroux exclusive manufacturing and distribution rights.

The English competition

News of the sensational invention reached Daguerre's leading English rival, William Henry Fox Talbot, shortly after the first press releases in January 1839. The news hit him hard; Talbot himself had been conducting experiments exposing sensitized paper to light since 1834, and, while his experiments had produced encouraging early results, he had set this line of research aside to pursue other work.

Talbot, a true renaissance man—scientist, mathematician, classical scholar, linguist, botanist, wealthy landowner, and Fellow of the Royal Society—was one of the most accomplished and well-to-do scholars of the 19th century, but his discovery of a new photographic process was almost accidental, motivated, as it was for so many who nudged the early history of photography along its inevitable path, by his artistic deficiencies. It was precisely his lack of talent that directed him onto the right track. While visiting Lake Como, Italy, in 1833, Talbot was consistently frustrated with his attempts to take impressions from nature by means of traditional drawing equipment. The following year it occurred to him to place

W. H. F. Talbot, *Photogenic Drawing*, ca. 1838/40. In his first photographic experiments, Talbot—who was also a botanist—used parts of plants which he laid on his self-made photographic paper. Today, such pictures, made without a camera, are known as photograms.

objects—in particular, plant leaves—on paper treated with silver nitrate and a salt solution and to lay them in the sun. Wherever the paper was not covered by the object, the paper gradually turned dark brown; the objects produced images of themselves as reverse shadows. Talbot fixed these "photogenic drawings" with a table salt solution. The earliest presereved negative produced by this method dates from August 1835.

Talbot's real interest, however, lay in capturing the images produced by a camera obscura. Since he possessed no device small enough, he had the village carpenter make tiny cameras, three inches in size, which he then fitted with lenses. His wife nicknamed the cute little camera boxes intended to capture light "mouse traps." Talbot placed these "mouse traps" in a circle outside his house and waited one to two hours until the various angles of his house began to appear on the dampened paper he had placed inside the cameras. Talbot's "mouse trap" negative images constitute the origin of all later negative-positive photography and are the foundation of the reproducibility of photographic images.

In August 1835, Talbot finally succeeded in the creation of the famous shot of the "Latticed Window" at his home at Lacock Abbey, near Bath. But it was not until after the announcement of Daguerre's invention that Talbot resumed photographic work on his own. Because he had never published his findings, and Daguerre had had the foresight to secure the English patent, Talbot's attempt to register a proprietary claim was futile. In 1840, Talbot discovered a substance capable of sensitizing photographic

Resembling a small wooden cube, Talbot's "mouse trap" served as his first camera in photographic experiments at his estate, Lacock Abbey.

1839 – 1860

"Please take note, that even when light does the work, the person remains the master."

Jules Janin, 1839

W. H. F. Talbot, *The Open Door*, salt-paper copy from a calotype negative, 1843. This photo clearly shows that Talbot was not only an inventor but was also sensitive to the aesthetics of composition.

1839 – 1860

Title page of the first book to be illustrated with glued-in original calotypes: *The Pencil of Nature* by W. H. F. Talbot. 150 copies were printed.

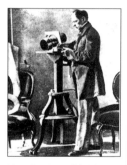

Hippolyte Bayard (1801–87), civil servant, jurist, and amateur inventor, discovered the direct positive process for silver chloride paper contemporaneously with Daguerre's invention. Bayard exhibited 30 of his pictures in Paris in July 1839. When he failed to gain acceptance for his process, he turned to calotypes and managed to achieve long-range success as a photographer.

paper and was able to shrink the exposure time from 60 minutes to a matter of seconds. Using beeswax, he produced a transparent paper negative which he then developed in a solution of gallic acid and silver nitrate. By laying the negative on a sheet of salt-treated paper, Talbot created a positive contact print called a calotype (later called talbotype). Talbot obtained a patent for the process in 1841, but his insistence on retaining strict control over the distribution and application of his process hindered its widespread use.

Talbot, who never received due recognition as a competitor of Daguerre, later toured often in Europe to promote his photographic method. His real contribution to photography stems from the years 1839–45, his later interest being confined to the purely experimental. Nonetheless, Talbot's work paved the way for photography's future as a mass medium. His discovery of the principles of phototypography and flash-lamp photography, along with his invention of a portable travel camera, indicate the breadth of his vision. His book *The Pencil of Nature*, appearing in 1844–46, was the first publication to incorporate photographs in a book, and thus to demonstrate the mass reproducibility of the calotype process.

Many aspects of Talbot's process would not find fruition until further in the future—creation of a

Daguerreotype Plate Sizes	
Whole plate	8.50" x 6.37"
Half plate	6.37" x 4.25"
One-third plate	6.37" x 2.83"
Quarter plate	4.25" x 3.19"
One-sixth plate	3.19" x 2.83"
One-eighth plate	3.19" x 2.13"
One-ninth plate	2.83" x 2.13"
Four-sixth plate	6.37" x 5.67"

The one-quarter and one-sixth plates were the most commonly used.

positive image from a negative, printing on paper, and limitless reproducibility of images. Aesthetically, however, the gleaming silver daguerreotypes continued to so impress the public that the possibilities offered by paper-printed photography were neglected for another ten years.

The triumph of a new medium

Reaction to the discovery of photography could hardly have been more enthusiastic. The immediate and widespread description of photography by the press and other publications in both America and Europe generated immense interest in the new medium. Daguerre publicized his method in more than 30 editions in 1839 alone, and by the end of the year, the process had already lured thousands of people under its spell—although the high price of the equipment proved a barrier for many would-be enthusiasts. If photography was going to become a truly popular pursuit, both its cost and the exposure time would have to be reduced. The further development and refinement of the recording process and so-called Petzval lens solved these problems. Perhaps the most important immediate refinement that

The specially calculated photographic lens developed by Viennese physicist Josef Petzval in 1840 was the most brilliant of its time. Another Viennese optician and master mechanic, Friedrich Voigtländer, built the first all-metal camera fitted with the Petzval lenses. They reduced the exposure time to one-sixteenth of what was required by daguerreotype devices, and produced round daguerreotypes with a diameter of 3.5 inches.

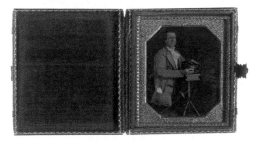

Usually daguerreotypes were ensconced in richly decorated passe-partouts inside folding cases lined with satin and silk and covered with decorated paper or ornately tooled leather.

increased the practicality of Daguerre's invention was the improved brilliance of photographic lenses. In 1840, Josef Max Petzval developed a lens sixteen times faster than earlier lenses. With this world-famous achromatic portrait lens, manu-

Glass studio with shed roof. The roof was made of glass on the north side and fitted with draperies to regulate the light. The letter "p" designates the movable gray backdrop (although painted backdrops were also increasingly used). The piano was for entertaining the customers during their long, strenuous sittings.

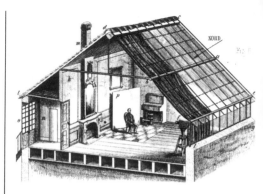

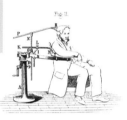

Daguerreotypes and calotypes required the subject to remain absolutely still before the camera for a number of minutes. To help steady the subject, photographers used devices like this to support the head and shoulders. Shown here is the Saronny universal head support.

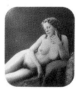

Philippe Derussy, *Nude*, 1851–52. Left half of a hand-colored stereo daguerreotype, tinted with gold. Nude portraits became a standard subject for photography only after 1847 and were often retouched and tinted according to contemporary fashion.

factured and distributed in 1841 by Peter Friedrich Voigtländer, exposure time could be reduced to 1.5 to 2 minutes. In the same year, the Naterer brothers introduced an improved light-sensitive plate coating that reduced exposure time in the best of cases to only a few seconds. Everywhere, people seemed willing to ignore the highly poisonous iodine and mercury vapors in the craze to produce daguerreotypes. John William Draper and Samuel F. B. Morse founded the first professional studio in New York in 1839; they were followed by Alexander S. Wolcott in 1840. Philadelphia, London, Paris, Berlin, Hamburg, and Vienna all saw similar developments.

In the early days of photography, the torture of sitting as a photographic model required considerable self-discipline. The best daguerreotypes, however, provided strikingly vivid images and a high aesthetic quality. Often, the pictures were signed by the photographer and, as small-scale works of art, presented as noble and esteemed gifts. Among the most active daguerreotypists were Jean Baptiste Sabatier-Blot in France, Richard Beard and Antoine Jean François Claudet in England, and Hermann Biow, Carl Ferdinand Stelzner, and H. Krone in Germany. In America, where the daguerreotype was highly popular, the roll call includes François Gouraud,

Charles Richard Meade, and Mathew Brady, who later became famous for his wet plate-process photographs of the Civil War. Most surviving daguerreotypes, however, were anonymous, and the names of the earliest photographers remain unknown.

Nothwithstanding its immediate popularity, photography was always the subject of debate and controversy, particularly among artists and critics. Euphoric enthusiam stood face to face with categorical rejection. Contemporary critics questioned the aesthetic and artistic value of the new medium. And, in fact, photography quickly intruded into the traditional territory of portraits, landscapes, nudes, and art reproductions. Many an artist felt threatened.

By 1850, the advantages of paper photography could hardly be ignored or denied. By this time, the pictures were more robust, cheaper to make, and were reproducible. Salt-paper photography, or calotypy, was the most common paper process. In spite of certain weaknesses, such as graininess and lack of brilliance or sharpness, remarkable results were being produced. The process developed by Talbot was particularly suited for artistic ambitions, which Talbot himself pursued. What many consider the first significant artistic results were attained by the Scottish painter David Octavius Hill and Edinburgh-based photographer Robert Adamson. In 1843, Hill

"In photography, one meets with something new and extraordinary; in the New Haven fishwife, eyes cast to the ground with such nonchalant seductive shame, something remains that does not escape the art of Hill's photographs, something that cannot be silenced, an unmannerly demand for the name of the woman who lived then and there, and who is also still real now, and who will never be able to disappear entirely into 'art.'"

Walter Benjamin, 1931

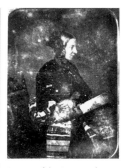

Portrait of the Leipzig photographer Bertha Wehnert-Beckmann, daguerreotype, ca. 1846. Married to the photographer E. Wehnert, she operated her own studio in Leipzig, Germany, as well as subsidiaries in New York (1849–51) and Vienna (1866). She is still considered one of the most consciously artistic photographers.

1839 – 1860

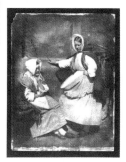

David Octavius Hill and Robert Adamson, *Fishwives of Newhaven*, 1845.

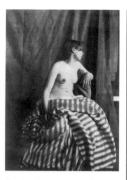

Eugène Durieu, *Frontal View of Nude Model*, ca. 1854. This nude study is part of a 1853–54 series shot by Durieu in his studio with his friend, French painter Eugène Delacroix.

Alois Löcherer, *The Metal-Caster, Ferdinand von Miller with the Head of Bavaria in the Courtyard of the Foundry in Munich*, 1848–50. The pictorial documentation of the Bavaria is one of the world's earliest photo reports.

Charles Marville, *The Former City Hall and the Pont d'Archole in Paris*, 1852.

was commissioned to create a monumental group portrait of all the participants of the founding association of the Free Church of Scotland—457 individuals. To make his task easier, someone suggested using calotypes and referred the painter to Adamson. By the time of his death in 1848, Adamson had created around 1,900 photographic portraits, group photographs, and landscapes. His photographs proved to be more, however, than mere mnemonic aids—they are in their own right masterworks of formal composition and belong to the incunabulum of photographic history.

In 1851, the Frenchmen Gustave Le Gray and Louis Désiré Blanquart-Evrard improved developing paper to the point where exposure time shrank from 40 seconds to 6. Blanquart-Evrard was able to make quicker and cheaper prints for the photography books and albums produced by his industrial printing house. The albums included a masterwork of early photography, the 122 photographs produced by the writer and amateur photographer Maxime DuCamp in 1849–52 on a tour through the Middle East with French novelist Gustave Flaubert. Blanquart-Evrard also published a series of important pictures by Henri Le Secq and Charles Marville, two professional painters commissioned by the French Ministry of the Interior to make architectural photographs of historical buildings. The albums included

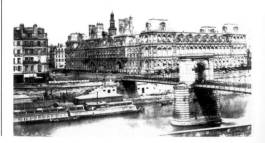

expedition photographs by American archaeologist John B. Greene and French archaeologist Auguste Salzmann. Beginning in 1844, in one of the world's earliest photo reports, Munich photographer Alois Löcherer documented the erection of the statue "Bavaria" in Munich.

However, the rigid licensing restrictions by which William Talbot controlled the use of his process continued to constitute a considerable obstacle to most photographers in England, and later in the United States as well. More was the pity for Talbot,

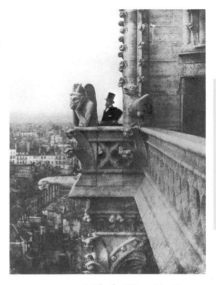

1839 – 1860

Charles Nègre, *Henri Le Secq at Notre Dame Cathedral, Paris,* 1851.

"In these miserable days, an industry has arisen that has done not a little to encourage belief in the hollow stupidity...that art is, and cannot be anything else than, a reproduction of nature
A vengeful god has listened to the voice of the people, and Daguerre has become his messiah."

Charles Baudelaire, 1859

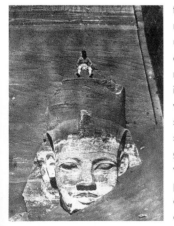

then, when news of a new, universally available method of coating glass plates with a light-sensitive colloidal substance was greeted with widespread public interest on both sides of the Atlantic.

Maxime DuCamp, *Statue of Ramses at Abu Simbel,* 1850. DuCamp took this photo while traveling through the Middle East and Egypt with the French novelist Gustave Flaubert in 1849. He took more pictures in 1851, while on an assignment from the French government to document buildings and monuments. The pictures (122 photos in all) were published in 1852 in the album *Egypte, Nubie, Palestine et Syrie*. To produce this book, the printing house of Blanquart-Evrard in Lille was able to complete 200 to 300 prints per negative per day.

1850 – 1880

1851 Founding of The New York Times.

1852–70 Charles Louis Napoléon Bonaparte declares himself Emperor Napoleon III; Second French Empire.

1863 Founding of the International Red Cross; abolition of slavery in the United States.

1864–67 Archduke Maximilian von Habsburg becomes emperor of Mexico, where he is executed three years later.

1867 The United States purchases Alaska and Russia purchases the Aleutian Islands; Karl Marx, *Das Kapital*; Alfred Nobel invents dynamite.

1870–71 Franco-Prussian War.

1870–84 Heinrich Schliemann discovers ancient Troy.

1874 First Impressionist group exhibition in Paris; Richard Wagner: *The Twilight of the Gods*.

1879 Thomas Alva Edison invents the electric light bulb.

The wet-plate process (wet collodion)

Three factors largely determined the development of photography and the speed and extent of its dissemination since the middle of the 19th century: the political and social ascent of the middle class, the new photographic aesthetic, and the ability to mass-produce photos each left its mark on the new medium.

The second half of the century was the age of technology and of the great world expositions. Henceforth, the industrial production of each of the economically highly developed nations was able to—and was forced to—measure itself against its competitors. World fairs became the mirror of industrial development—of both its failures and its successes. Photography, too, had a place in this history, although initially as nothing more than a technical apparatus for picture making.

The Great Exhibition held in London in 1851 had already demonstrated the general usefulness of photography and showcased new processes developed in Great Britain and in France. Of these new developments, the most important innovations of the time were the collodion process and stereoscopy.

Invented in 1846 by C. F. Schönbein, collodion is a solution of gun cotton (or nitrocellulose) in ethyl alcohol and ethyl ether. The use of wet collodion in photography in the so-called wet-plate process spelled entry into the second age of photography. Within a few years, the collodion method had replaced all earlier processes. In 1850/51, the Frenchman Gustave Le Gray and Englishmen R. J. Bingham and Frederick Scott Archer simultaneously and almost independently hit upon collodion as an emulsion carrier. Archer's process, however, won the field because Le Gray only partially published his findings. In the wet-plate process, a coating of an almost hardened, but not yet dry, iodide emulsion

was laid onto a glass plate that was then sensitized in a silver nitrate solution, immediately exposed, and developed. In spite of the troublesomeness of the process—the plate had to be prepared immediately before the photograph was made and developed immediately afterward—the wet-plate process quickly overtook all existing negative processes.

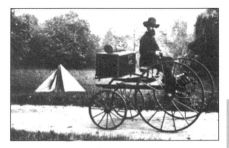

Traveling photographer with the equipment needed for the wet collodion process, 1874. In the background is a darkroom tent.

1850 – 1880

However, especially for outdoor pictures, darkroom equipment had to be carried along; the equipment, including a lightproof tent, stands, glass plates, and chemicals, often weighed more than 200 pounds, that is, about twice as much as daguerreotype equipment. Wealthy photographers turned their coaches into darkroom vans, while the less affluent pulled hand wagons or even carried the heavy equipment on their backs. Folding cameras with expandable bellows were already common. The bellows camera had first been introduced on the market in 1860 and had quickly supplanted mounted, multicomponent cameras.

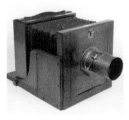

The chief advantage of the collodion method over the earlier negative processes lay in the considerably greater sensitiviy of the emulsion. For the first time, it was possible to produce negatives almost instantaneously, with exposure times of less than one second—a revolutionary advance that justified all the trouble. Still, further improvements in the process were necessary to produce photographs of high

Early collapsible-bellows camera for the wet collodion process. This English-made camera used a 5 x 7 in. plate. Other cameras were available in which the coated plates could be sensitized and immediately developed inside the camera, but they were rarely used by professional photographers.

tonal quality. Although it was already possible to make photographs as large as 8 x 12 in., 12 x 16 in., or even 16 x 20 in., the requisite tonal quality could only be attained when the collodion negative was accompanied by an albumen positive printing paper. At last, the possibilities of the new method could be exploited fully, and, as a result, the uses of photography proliferated.

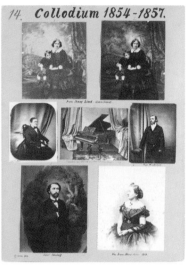

Hermann Krone, *Instruction-ary Tablet No. 14 for the Wet-Plate Process,* 1854–57. The Dresden photographer Krone was one of the early encyclopedists of photography. The high-quality works in which he presented his explication of the development of photography until the turn of the century make him one of the pioneers of photographic pedagogy.

From the very beginning, the irregular grain of paper as a vehicle for the emulsion had caused problems in the calotype process, with the paper's texture forming a constituent part of the resulting print. Glass had already been considered as an alternative vehicle for prints, and various substances, including the slime from snails, had been employed to coat the silver salts onto the glass. But only egg white seemed to offer a measure of success. Abel Niépce de Saint Victor, nephew of Joseph Nicéphore Niépce, invented the glass negative in 1847 by coating glass plates with the white of chicken eggs (albumen) mixed with potassium iodide. He then immersed the plates in a silver nitrate bath to make them sensitive to light. The resulting negatives rivaled the brilliance of daguerreotypes, but their relative lack of sensitivity to light required long exposure times. Slowness thus remained a major problem. It was Blanquart-Evrard who both improved the albumen plates and, in 1850, hit upon the idea of also coating the printing paper with albumen. Thus, Blanquart-Evrard created a medium for printing that was used into the 20th century. He was also the first to produce ready-to-use printing paper in mass quantities. Naturally, this industrial scale of production demanded huge

amounts of egg white. Probably the largest albumen factory in the world at the time was located in Dresden, Germany; it processed 68,000 eggs every day—each separated by hand. (The yokes

were sent to food production factories.) Because egg whites that had begun to ferment produced better-quality paper, both the factories and the neighborhoods in which they were situated were suffused with the odor of rotten eggs. Albumen-coated paper allowed the production of fine-toned brown or gold tinted photographs, which expanded photography's artistic possibilities.

One great disadvantage of the salt and albumen photographic papers, however, was their instability, which resulted in the pictures often bleaching out quickly. Moreover, the emulsion was oversensitive in the blue range of light and undersensitive in the red and green ranges. The gradual introduction of aniline dyes into the process corrected the imbalance until the first panchromatic plates and films appeared on the market in 1906.

During the collodion era, several direct positive processes appeared as a kind of bridge between

The enlargement device Solar, ca. 1890. Although most photographs throughout the 19th century were reproduced as contact prints, and therefore were the same size as the negatives, enlargements were occasionally made. The market of the late 1850s saw the introduction of daylight enlargers, which functioned like slide projectors. The amount of light was controlled by a side aperture, and the exposure could take hours or even days.

1850 – 1880

Albumen: The whites of fresh hens' eggs, beaten to a froth and allowed to stand until they turn liquid again. With the addition of chlorine, bromine, or iodine salts, the albumen was spread on a vehicle (glass or paper) and treated with silver nitrate to make it light-sensitive. The emulsion was then used for photographs or copies.

Wet collodion plate process: Directly after the invention of collodium (a solution of nitrocellulose in a mixture of ethyl alcohol and ethyl ether), this colorless, transparent substance was used as a photographic emulsion, especially by Frederick Scott Archer beginning in 1851. Not only were the manufacture of collodion and the coating of the plates complicated, but the plates sensitized by silver nitrate had to be kept moist until exposure, and then had to be developed immediately.

Unknown American photographer, *Man with a Sextant*, 1850s, ambrotype. Ambrotypes lacked the brilliance of daguerreotypes, but they were easier and cheaper to produce, and the customer could have the results in his or her hand almost immediately.

daguerreotypes and paper photographs. Until 1865, ambrotypes were placed in the same style of richly appointed satin frames as daguerreotypes. These gleaming, satiny, glass ambrotype negatives offered an inexpensive alternative to the daguerreotype.

Another alternative was the pannotype, the least stable of all photographs, in which the collodion emulsion was applied to black waxed linen. Ferrotypes offered improved stability by bringing the emulsion onto thin, black-laquered tin sheets. Also known as tintypes, ferrotypes were sold to the general public in inexpensive paper frames. In the United States, they were extraordinarily popular as cheap occasional photos, often hawked by traveling photographers who processed the photos on the spot.

The same period saw great advances in photographic optics. Petzval's 1840 portrait objective (the foremost lens of the day) caused

Carleton E. Watkins, *Yosemite Valley, California*, albumen print, 1866. The full tonal range possible with the albumen process was made available only in 1850 when both the negative and the print paper were first coated with the egg white emulsion.

considerable loss of sharpness at the edges of the picture. A new lens was needed to correct this fault. In Munich, Hugo Adolph Steinheil was working to develop his "Aplanat" lens at the same time that John Henry Dallmeyer introduced his famous "Rapid Rectilinear." In the coming decades, however, Steinheil's objective proved victorious because Dallmeyer lost his copyright suit against the manufacturers of his lens. Finally, in 1903, both lenses were superseded by the new anastigmatic lenses.

Panorama camera by Englishman Thomas Sutton, 1860. A water-filled spherical lens allowed this wide-angle camera to take photographs of 120 degrees. Previously, such pictures were possible only with moveable lenses. This very rare camera was built under license by A. Liesegang.

1850 – 1880

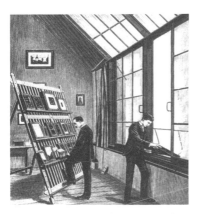

A photographer's print-making room. Single negatives were placed in a frame together with the copy paper and exposed to daylight. Exposure time varied between minutes and hours, depending of density of the negative, the intensity of the light, and the temperature.

Ambrotype—also melanotype (1852–90): Quickly exposed and developed iodine- or bromine-based collodion emulsion on glass. The pale, whitish negative was underlaid with black paper or satin to achieve the effect of a positive.

Ferrotype—also tintype (1855–1930/32): The first rapid photographic process. Quickly exposed and developed iodine- or bromine-based collodion emulsion coated onto dark lacquered metal sheets that lent the whitish negative a positive effect.

Pannotype (1853–63): Quickly exposed and developed iodine- or bromine-based collodion emulsion layer that was released from its base under water and applied to black waxed linen.

Stereophotography: The Third Dimension

With the advent of daguerreotypes, photography was able to gratify a longstanding human wish to reproduce the world accurately and permanently. More precisely, photography was now able to render an account of the shapes and shades of reality, but not of color, movement, or perspective. To capture this latter quality was the accomplishment of stereophotography.

In 1851, L. Jules Dubosq introduced to the market a stereoscope that gave photographs a sense of distance, or depth of field. However, the real inventor of the stereoscope was a friend of William Talbot, physicist Charles Wheatstone, who had already started investigating the implications of binocular vision in 1832. Not long after Talbot had developed the paper photography process, Wheatstone commissioned him to make stereo pictures.

Stereoscope, ca. 1870. Such viewing devices were normally shaped like a broad funnel: On the small end was a double eyepiece; at the opposite end was a frame for holding a pair of photographs side by side. When the two images were superimposed optically, the two rather small 3 in. square prints seemed to become a single large picture. The elaborately designed device pictured here is not typical; most viewers were cheap hand-held devices.

reality. In other words, the picture received with one eye is slightly different from that perceived by the other; it is the brain that unifies the image into a single whole, and the difference between the two images is what provides the sense of depth of field.

Wheatstone had already demonstrated this phenomenon before the Royal Society in 1838 using a home-made stereoscope.

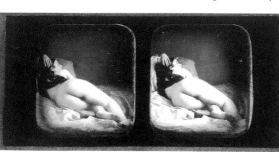

Anonymous stereo-daguerreotype, ca. 1855.

Stereophotography is based on the long-recognized visual phenomenon that a pair of human eyes perceives two slightly offset fields of

Probably the first stereo photographs were those made in 1839 and displayed in Brussels in 184 The first stereoscope for practica

Stereophotography: The Third Dimension

use, however, was the binocular stereoscope developed by Sir David Brewster in 1847. Twelve years later, Oliver Wendell Holmes designed a stereoscope based on Brewster's lens system, but easier to handle. It was not, however, until 1850 that paper stereoscope photos finally began to appear in large numbers, at about the same time as the popular pictorial "visiting cards."

Stereoscopes give the viewer the illusion of spatial perspective by using two photographs taken from within eye-distance of each other. Daguerreotypists, especially Antoine Claudet in London, turned to stereoscopes as soon as the method had become publicly known, but the true stereoscope boom was sparked by

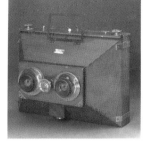

Stereo camera, Ottomar Anschütz, 1890.
Size: 3.5 x 7 in.

Queen Victoria herself, who graced the process with her particular attention at the 1851 Great Exhibition.

In England and the United States, a regular stereomania erupted. Stereocards with views of faraway lands and peoples were printed cheaply on paper, usually by multinational firms (Underwood & Underwood, Keystone, etc.) And thus, along with a thick album of visiting cards, an oak stereoscope with a pile of stereocards became a fixture on every middle-class parlor table at the turn of the century. Several decades later, stereophotography once more enjoyed something of a renaissance among amateur photographers.

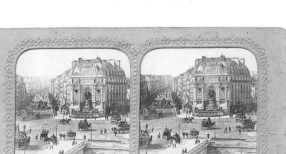

Stereo card. From the middle of the 1850s, such cards were produced in immense quantities.

35

Robert Howlett, *Isambard Kingdom Brunel*, designer of the Great Eastern, the largest steamship of its day, in front of the launch, November 1857. Conveying the radiant self-awareness of a man for whom all technical possibilities were attainable, this photograph contains one of the leitmotifs of the 19th century—and today fetches one of the world's highest prices at photographic auctions.

Photographs as status symbols: Portrait photography

The new photographic possibilities opened up by technical improvements explain only one aspect of the transformation of photographic aesthetics that began to take place around the middle of the 19th century. Up to this point, owning and viewing pictures were still experiences reserved only for the privileged classes. But, along with increasing industrialization came increasing self-awareness among the middle classes—and with this awareness, they acquired their own access to the privilege of photography. In the course of its commercialization, photography became established as both an artistic medium and an

> "Something extremely interesting takes place in the early days of photographic portraiture. While photography was standing with a still primitive technology on the threshhold of its development, it reached a level of artistic perfection that it has never attained again."
>
> Gisèle Freund

inexpensive commodity. Both of these aspects were clearly evident in portrait photography, and this brings us to two preeminent names in the field: Nadar and Disdéri.

Nadar—Photographer, Bohemian, Aeronaut

Probably the most significant of the early photographers to demonstrate the aesthetic independence of photography was Gaspard Félix Tournachon, who later adopted the pseudonym Nadar. He opened his photography studio in 1853 and it soon became a center of Parisian

Nadar, pseudonym of Gaspard-Félix Tournachon (1820–1910), led the quintessential bohemian life in Paris in the mid-19th century. By profession a caricaturist and journalist, he took up photography in the 1850s, opening his first portrait studio in 1853 with his brother Adrien. His artist's studio, opened six years later, became a gathering place for the intellectuals of Paris. In 1855, Nadar began systematic experiments with light and in 1858 made the first aerial photographs from a balloon. During the revolt of the Paris Commune in 1870/71, he commanded a balloon corps. Nadar stands as the foremost portrait photographer of his time and his country.

artistic life. A meeting place for both the artistic elite and bohemians, Nadar's studio played a central role in the emergence of impressionism; in 1874, it was the site of the first combined exhibition of avant-garde painters whose work had been rejected by the official galleries. Nadar is also chiefly responsible for the first golden age enjoyed by photography in Paris after 1850.

His fame, however, is not solely based on the excellence of his own photographs; Nadar had an unfailing flair for publicity. He was probably the first photographer to recognize the signi-

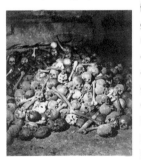

ficance of photography as an artistic medium and to make a commercial success of it. One of his groundbreaking contributions was his incorporation of new pictorial themes into photography after 1860; typical among these new themes were his photographs of the catacombs and the sewers of Paris. Nadar was also the first to take aerial photos from an anchored balloon, and later to construct one of the world's largest balloons—which ended up almost costing him his life and, together with his enormous studio, nearly drove him into bankruptcy. Together with his son, Paul, Nadar also conducted the world's first photo interview in 1886, when they met with the 100-year-old physicist M. E. Chevreul.

Almost on a footing with Nadar are the Bisson brothers, Louis and Auguste, as well as Gustave Le Gray and Etienne Carjat. Carjat's portraits stand among the best of their time. Born in 1882, Carjat, like Nadar, was a painter, a writer, and a caricaturist. Carjat circulated among the artistic

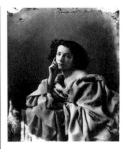

Nadar, *Sarah Bernhardt*, ca. 1864.

1850 – 1880

Nadar, *The Catacombs of Paris*, 1861/62. This picture met with considerable success at the 1862 London World Exhibition because it represented the first photograph taken underground with the help of electric light.

Etienne Carjat, *Charles Baudelaire*, ca. 1862. Portrait for Carjat's *Galerie contemporaine*.

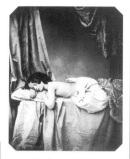

Franz Hanfstaengl, *Eugenie von Klenze,* ca. 1854.

Lewis Carroll, *Alice Liddell as Beggar,* ca. 1862. Alice Liddell was Carroll's model for the figure of Alice in his book *Alice in Wonderland.* Many of Carroll's pictures seem to anticipate Freud's still controversial theory of childhood sexuality.

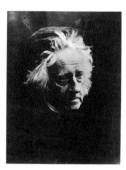

Julia Margaret Cameron, *Sir John F.W. Herschel* (1792–1871), 1867. Herschel had discovered a process for fixing an image at the same time as Daguerre and Talbot. Simultaneously with J. Mädler, he coined the term photography, and the designations positive and negative as applied in photography.

salons and also enjoyed many friendships in the bohemian life of Paris; from the 1860s onward, he photographed many of his artist friends against a neutral background and, like Nadar, was the master of a finely discriminating light that cast a unique aura on models like Charles Baudelaire, Honoré Daumier, and Paul Verlaine.

Another photographer with a background analogous to Nadar's was the Munich photographer Franz Hanfstaengl, who had served an apprenticeship in lithography before

turning to photography. He paid almost obsessive attention to the use of accessories in his portraits, and incorporated into his aesthetic process a then extremely controversial practice—retouching. Almost unbelievable at the time was his practice of making his changes on the negative, rather than on the positive.

While photography was experiencing a golden age in Paris, there were two English amateurs who were also producing excellent portraits. Charles L. Dodgson, an Oxford don and mathematician (better known to the world as Lewis Carroll, the author of *Alice in Wonderland*), perhaps not surprisingly created many outstanding portraits of children. Taking up this fashionable hobby at the age of 24, he photographed more than a hundred children between 1856 and 1880. Like most Victorian photographers, Dodgson sought to capture both the beauty of detail and the spirit of the child's expression in his photographs, which are at the same time both romantic and frank.

Carroll's enthusiasm was shared by Julia Margaret Cameron, also an amateur who began

to photograph at the age of 48. Cameron's photographic oeuvre may be divided into two separate categories: On the one hand, she produced restrained but penetrating images of exquisite quality; on the other hand, she engaged herself in making illustrative photos of models whom she posed as historical figures dressed in literary costumes in Pre-Raphaelite settings.

On the other side of the Atlantic, the best American portraits were produced by earlier daguerreotypists like Alexander Gardner and Mathew Brady. Among these portrait studies, perhaps the most famous are Brady's many portraits of Abraham Lincoln. Historical legend has it that Lincoln even attributed his election as president to the combined effect of Brady's photograph together with a speech he gave at the Cooper Union in New York. Today, it is the photo of Lincoln taken by Brady on September 2, 1864, that adorns the five-dollar bill.

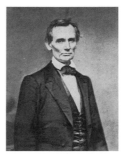

Mathew Brady, *Abraham Lincoln*, February 27, 1860. In addition to his documentary photographs of the Civil War, Brady also photographed and marketed a "politician's gallery" of the members of Congress.

1850 – 1880

The opposite extreme—
André Adolphe-Eugène Disdéri

While Nadar can certainly be said to have discovered and groomed the market for photography as a mass product, it was another photographer, André Adolphe-Eugène Disdéri, who first recognized the explosively expanding pool of public interest and potential customers—and generously supplied the kind of pictures the market demanded. Disdéri's contribution to photographic history is that he literally founded a portrait industry. His success was chiefly based on his ingenious idea of reducing photographs to the size of the then-traditional visiting cards—about 2.4 in. x 3.6 in. In 1854 he patented the idea. The enormous popularity of these calling cards not only led to people presenting photos of themselves as gifts, but also to collecting photographs of prominent persons. The relatively small

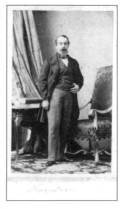

Napoleon III, "visiting card" photographed by Disdéri, ca. 1860. Even the English royal family had themselves photographed on "cartes de visite" in 1861; within three months, 70,000 prints were made—and supposedly another 200,000 followed.

Portrait of a dancer, "visiting card" shots before cutting. A single print from a negative taken with a visiting-card camera could be divided into eight pictures. Unskilled workers in giant photographic labs then cut the pictures apart and attached the paper prints to cardboard.

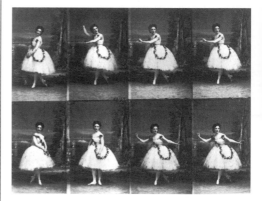

Ludwig II of Bavaria, studio of the Munich court photographer Josef Albert. When public interest in the "visiting cards" threatened to wane, enterprising photographers introduced a larger format, the approximately 4 x 6 in. cabinet photo, common until 1914.

size of the cards made ideal use of the negative, so that a number of prints could be made from the same negative. This multiple use lessened Desidéri's production costs and therefore the price of the photographs themselves.

The card mania spread like wildfire thoughout Europe and America, and even the royal houses of Europe adopted them. Disdéri's fame reached its pinnacle in 1859 when Napoleon III, as he was leading his troops to Italy to fight the Austrians, dropped by the studio to sit for a portrait. Events like this were a publicist's dream, and the visit assured Disdéri's ultimate commercial success. Napoleon elevated Disdéri to court photographer, thereby setting him solidly on the path to becoming a millionaire.

Visiting cards were hardly classical portraits; they were, rather, staged reflections of middle-class wishful thinking. They came to be known as "cartes de visite" for quite some time, exchanged in lieu of traditional visiting cards.

The photographic image of the naked body

Originally, nude photography was closely related in style to depiction of the naked body in the traditional fine arts—in painting, drawing, print

making, and sculpture. The formal and thematic connections between photography and painting are unmistakable in the early days of nude photography. But, although nudity hardly caused a raised eyebrow in mid-19th-century painting, the prospect of the camera actually capturing the image of living

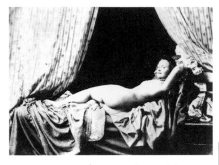

B. Braquehais, *Odalisque*, ca. 1855.

women—or occasionally men—in a completely unclothed state seemed to many viewers to raise the problematic specter of pornography.

Of course, photography had since its inception served voyeuristic impulses with erotic subject matter, but it had also at the same time attracted the interest of more legitimate artists. One of the first of these artists to focus intensely on applying the calotype to nude studies was the French painter Eugène Delacroix. At the beginning of the 1850s, Delacroix commissioned the photographer Eugène Durieu to photograph nude models according to the painter's specifications. Delacroix then collected and used the photographs as studies for his paintings.

After the middle of the century, many painters, particularly in Paris, realized that it was cheaper to paint from photos than to hire professional models. At this point, nude photography grew into a regular commercial sector for a specialized

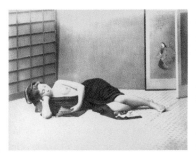

public—artists. Among the most important suppliers to the "academies" which pro-

Baron Stillfried, *Sleeping Japanese Woman*, ca. 1875. Among the most common themes pursued by European photographers in the name of reporting on foreign cultures are erotically suggestive set pieces from the world of the Japanese geisha.

1850 – 1880

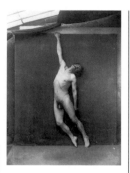

Anonymous photograph, ca. 1880. Starting around 1850, so-called academies provided and distributed nude studies for graphic artists.

1850 – 1880

duced such pictures were Belloc, Braquehais, and Vallon de Villeneuve. Photographs by the latter were used by Gustave Courbet, whose scenes from ordinary life reflected the influence of photography, and thus kept him at odds with the French academies.

Because the photographed nude clearly implied the presence of a live model, mid-19th-century photographers constantly needed to legitimize their pictures on the grounds of either art or science. Makers of voyeuristic photos, for example, might invoke ethnological research as a rationale for an exotic, alluring nude shot. There also arose a more blatantly erotic photography that could summon no valid justification for offending against "good morals." In such cases, ways and means could always be invented to embue putatively academic and scientific studies—for only such were considered to conform legally to good morals—with a racy tone. More and more, the subjects in these risqué photographs were prostitutes, rather than professional models. Perhaps it was inevitable that a thoroughgoing traffic emerged in the production of obscene "cochonnerie" (from the French, for "swinishness"). Try as they might to suppress the manufacture and distribution of such morally unacceptable photos, the guardians of social propriety of every nation were never completely able to succeed.

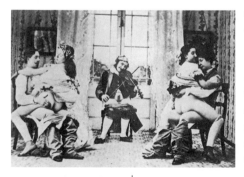

Anonymous photograph, ca. 1860.

However, the moral censorship that imposed bans on these images was the same authority that succeeded in bringing judgment against Gustave Flaubert's "scandalous" novel *Madame Bovary* and Charles Baudelaire's

poetry collection *Fleurs du mal* toward the end of the 1850s.

Ideal and reality

In a time that seemed to demand idealized and imposing pictures, a number of photographers saw an opportunity to offer a real challenge to conventional painting. They brought to photography the pictorial language of painting by imitating the latter medium.

The capabilities of photography, in particular its ability to capture fine detail, had expanded rapidly since the middle of the 19th century. In response, some photographers attempted to counteract their feelings of inferiority toward painting and painters by cultivating a kind of painterly quality in their work. In order to gain acceptance as an art form, they turned to trickery and technical manipulation, such as composite prints, the forerunner of photomontage, and soft focusing.

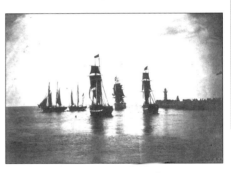

Gustave Le Gray, *Departure of the Fleet of Napoleon III as it Puts to Sea at Le Havre*, 1856/57.

1850 – 1880

At the same time, the very opposite capacity of photography, its ability to reproduce an image precisely, left its imprint on painting, especially among the Pre-Raphaelites. Certain photographers who came from an academic painting background, such as Le Gray, Oscar Gustave Rejlander, and Henry Peach Robinson, imported into photography principles of the formal arrangements of motifs. Attempts to create photographic allegories had been made in the days of the daguerreotype, but most were nothing more than illustrations of life. The use of soft focusing was tried out early, but did not generate much enthusiasm among the contemporary public until after 1850, when photographers

were able to use new photographic techniques to lend their pictures a certain dramatic verve. The clouded heavens of Gustave Le Gray's sea and naval pictures were an astounding accomplishment for their time. The state of contemporary photochemistry demanded

Oscar G. Rejlander, *The Two Ways of Life*, montage from 30 negatives, 1857. Rejlander photographed the individual groups of figures in such a way that their sizes would correspond to the distances between the groups as if seen in perspective in the finished, mounted picture. Other negatives, adorned with masks, were made to photograph the decorations.

extremely long exposure times to capture cloud formations satisfactorily. But could this long exposure be reconciled, for example, with the brief exposure required by the breakers rolling to the shore in the same picture?

Le Gray came up with a method that later became known as the combination print. Le Gray's career was given a strong boost when he was commissioned by the French authority for the preservation of landmarks to make gigantic photographs of medieval buildings. Other themes followed. Among his most famous works dating from the middle of the 1850s, when he was commissioned by the royal court to take photographs of the forest of Fontainebleau as well as marinescapes, are his pictures of the imperial military maneuvers of 1857.

Within the sphere of art photography, Oscar Rejlander and Henry Robinson used multiple negatives to compose a picture. Rejlander, a Swedish painter who had spent time in Rome as a copyist of the old masters and later in England as a portrait painter, broke ground for the new technique. While in England, he turned to photography and soon began to develop his own methods and techniques. Rejlander first arranged

several genre scenes which he photographed separately and then combined the prints into a single picture. His allegorical work, *The Two Ways of Life*, is composed of 30 individual negatives—an extreme example of the combination technique. He made the 28 in. x 16 in. photograph specially for the 1857 Art Treasures Exhibition in Manchester, England, where it was put on public display. Although there were some objections to its several nude figures, it was nonetheless well received, and was in fact purchased by Queen Victoria herself, who declared it to be "decidedly the finest photograph of its class ever produced."

1850 – 1880

Rejlander and Henry Peach Robinson were both active within the Pre-Raphaelite circle. Originally a painter and etcher, Robinson turned to photography in 1852. Also interested in combination photography, Robinson introduced multiple lighting as a formal medium. He achieved fame with his combination albumen print, *Fading Away*, which was composed from five negatives. Robinson's pictorial aesthetic, which he described in textbooks, was consciously based on the compositional techniques of the Italian Renaissance painter Raphael. Robinson was probably the most serious of those photographers who wanted photography to follow in the tradition of

painting. Even the royal family was interested in his photographs, and with its support, his success was assured.

Henry Peach Robinson, *Fading Away*, montage of five negatives, 1858. The public was shocked not only by the drama of the subject, but also by the supposed depiction of an actual death in a photograph—it was assumed that the scene was shot from life, rather than posed.

The dichotomy between the reproduction of unfalsified reality and the creation of beauty is also characteristic of the work of Julia Margaret Cameron. In a letter to a family friend, the scientist Sir John Frederick William Herschel, she described her artistic ambition as the desire to

"Any 'dodge, trick, and conjuration' of any kind is open to the photographer's use so that it belongs to his art, and is not false to nature. ... It is his imperative duty to avoid the mean, the bare and the ugly, and to aim to elevate his subject, to avoid awkward forms, and to correct unpicturesque."

Henry Peach Robinson, 1869

Julia Margaret Cameron (1815–79). Wife of a well-to-do British official, she took up photography upon her return from India in 1863, concentrating first on portraits, including those of Charles Darwin, Henry Wadsworth Longfellow and Robert Browning. Her photographs reveal her stylistic affinity with the Pre-Raphaelites. In 1870, Cameron began to illustrate the works of her friend Alfred Lord Tennyson with photos. In 1873, she and her husband moved to Sri Lanka (Ceylon).

render nature and beauty transcendental in the sense of her artistic models Perugino, Rembrandt, and Van Dyck. Accordingly, Cameron produced a number of illustrations of biblical themes in addition to her impressive portraits. In her *tableaux vivants* (living tableaus), both friends and employees appear as costumed actors, and she herself spoke of her genre pictures as thoroughly Pre-Raphaelite. Cameron considered the artistic high point of her imaginary photographic world to be her illustrations to Alfred Lord Tennyson's *Idylls of the King*, which she had made at the suggestion of the author.

Cameron's photography has probably contributed as much to our image of the Victorian age as the portraits by Lewis Carroll/Charles Dodgson have influenced our understanding of the beauty photography is capable of depicting. Dodgson, too, was a friend of Pre-Raphaelite artists such as Rossetti, Hunt, Millais, and Ruskin, but his photographs were only for his private use. Unlike Cameron, he did not use soft focus as an artistic tool, and his pictures tend to demonstrate a fascination for the child-woman ideal of beauty.

The photographs of the Viscountess Clementine Hawarden also bridge the gap between the real and the ideal. Like Cameron, Hawarden used family members to stage many of her photographs. In particular, the photographs dating from the 1860s portray her two daughters dressed in sumptuous Victorian costumes before mirrors or in diffused light.

Just as many photographers were influenced by painting, so many painters and illustrators

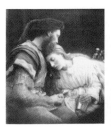

Julia Margaret Cameron, *Lancelot and Guinevere; William Warder and May Prinsep,* 1874. Illustration for Tennyson's *Idylls of the King.*

The Pre-Raphaelites: An association of artists founded by Dante Gabriel Rossetti in 1848 known as the Pre-Raphaelite Brotherhood aimed at a radical reform of English art. Central to their artistic principles were a return to nature, clear and comprehensible composition, and a strongly developed sense of detailed, realistic forms. The group preferred medieval themes in the style of Raphael and the Italian masters of the 15th century. The later art nouveau movement was strongly influenced the Pre-Raphaelites.

found photography useful. Eugène Delacroix, Jean Auguste Dominique Ingres, Jean-Baptiste Camille Corot, and Gustave Courbet all used photos as inspiration or models for their works; sometimes they specifically arranged scenes for series of photographs which they later used for sketches. Dante Gabriel Rossetti, Edgar Degas, Sir John Everett Millais, and Sir Lawrence Alma-Tadema used photographs for study purposes, while other artists painted complete pictures strictly from photographs. Several decades later, in the hands of artists such as Franz Lenbach, Pierre Bonnard, Edouard Vuillard, Edvard Munch, and Ernst Ludwig Kirchner, the camera would become a component of the artist's perception.

Lady Clementina Hawarden, *Young Girl in Front of a Mirror*, 1863/64.

1850 – 1880

Early photojournalism—Documentation of events

Growing public interest in current events created a keen interest in their pictorial representation. While many photographers attempted to pattern their photographic aesthetic after painting, others tried to capture reality directly and presented the public with pictures of never-before-seen landscapes, cities, and events. Producing documentary reports developed increasingly into an occupation for photographers.

Early forms of photojournalism emerged as soon as relatively usable pictures could be produced. For years, however, the extended

"My aspirations are to ennoble Photography and to secure for it the character and uses of High Art by combining the real & ideal & sacrificing nothing of Truth by all possible devotion to Poetry & Beauty."
Julia Margaret Cameron

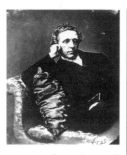

Lewis Carroll, pseudonym of Charles Lutwidge Dodgson (1832–98). Inspired by his uncle, Dodgson made his first photographic attempts in 1856; his style was strongly influenced by the Pre-Raphaelites. In addition to portraits of artists and genre scenes, Dodgson photographed children, particularly young girls, by whom he was erotically fascinated. Photographic evidence of his interest in the hobby continued until 1880, although many of his photographs were not discovered until 1949.

Unknown photographer, *Jane Morris Sitting as a Model for D. G. Rossetti*, 1865. The model's pose was arranged by Rossetti for a painting.

exposure times remained a major stumbling block, although Hermann Biow and Carl Ferdinand Stelzner used daguerreotypes to report on a fire in Hamburg, Germany, in 1842. But if photographers were going to be able to capture events that only lasted a few seconds, the photographic process would have to be refined. The collodion process and fast lenses with a short focus together with small photo formats enabled documentarists like Phillip H. Delamotte to report on the erection of the Crystal Palace in Sydenham, England, in 1851–54, and Robert Howlett to record the construction of the largest steamship of all time, the Great Eastern, in 1857. In this age of far-reaching technological, social, and political change, both military and political conflicts increasingly drew the interest of journalists and photographers. Photographers were already present during the war between Mexico and the USA in 1846–48.

James Robertson photographed the fall of Sebastopol and was the official photographer of the British Army suppressing the Bengal-Sepoy Mutiny in India in 1857. Together with Felice Beato, who later worked in China and Japan, he reported on the aftermath of the

Victorian photography: A photographic style arising during the reign of Queen Victoria (1837–1901). The style embodied many of the aesthetic attitudes of the Victorian era as well as the interest of the age in morality and edification. Victorian photography was supported by the enthusiasm of the royal family and by the prosperous industrial development of the age.

siege of Lucknow in 1858. Beato's photographs of the conquest of Tientsin in 1860 bear gruesome witness to early war photography.

The first systematic war reporting was carried out, however, by the Englishman Roger Fenton. Fenton's reputation was established by his early calotypes, produced on a journey to Russia in 1852, and his richly detailed oversized architectural photographs and still lifes. Queen Victoria appointed Fenton to photograph the royal family and its estates, and he later became the official photographer of the British Museum.

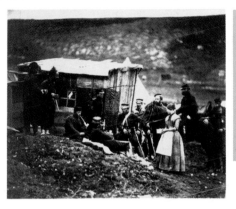

In 1855 the British war ministry hired Fenton to report on the Russian-Turkish war in the Crimea. He was assigned to photograph the English troops supporting the Turks in order to enliven the reports concerning the war. The photographs were, moreover, intended to sway the increasingly critical public opinion of British participation in the war—a job previously given to painters of battle scenes. Even this early photographic reportage revealed the problems of propaganda reporting. In part, the problems were technical—the equipment was cumbersome, and the heat and the exposure time of 3 to 20 seconds obliged Fenton to stage his photographs with extras and stand-ins.

Far more horrible and closer to the truth was Mathew Brady's record of the Civil War. Brady acted like a general, organizing his own contingent of photographers to take pictures of all scenes. His earlier *Gallery of Illustrious Americans* had already demonstrated his interest in history, and, thanks to his strong political

Roger Fenton, *Comradely Meeting of French and British Soldiers in the Encampment of the 4th Dragon Guards on the Crimean Peninsula*, 1855.

1850 – 1880

49

Roger Fenton (1819–69). The son of a family of bankers, Fenton trained as a painter in Paris under P. Delaroche and undertook a journey to Russia as a photographer in 1852. In 1854, he started taking his portraits of the British royal family and achieved fame for his Crimean War photographs, which were displayed in Pall Mall in 1855. He was a co-founder of the Photographic Society of London, but gave up photography in 1862 and let his archive be sold at auction.

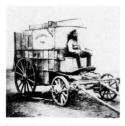

Roger Fenton, *Fenton's Assistant on a Horse Cart Transformed to a Darkroom*, 1855. Equipped with five cameras for the wet-plate process, 700 glass plates, chemicals, tools, and personal necessities, Fenton was the first true photojournalist.

connections, he obtained permission to enter the battle zones. The photographs taken by Brady's team convey an extraordinarily objective impression, but it is in fact possible that some scenes were manipulated—for example, the corpses of fallen soldiers may well have been rearranged for the sake of a better composition. Brady's team included some highly talented photographers, including Timothy H. O'Sullivan, Alexander Gardner, and George N. Barnard. By war's end, they had produced more than 7,000 negatives. For Brady, who originally planned to cash in commercially on his photographs, the tremendous costs of his photographic campaign led to financial ruin. Alexander Gardner established his own photographic corps in 1863, and Barnard later became the official photographer of General William Tecumseh Sherman.

All over the world, photography had become the preferred medium for documenting current events. Governments and political groups tried to adapt it to their own purposes. A photographic team was on hand to record the execution of the Austrian emperor Maximilian in Mexico in 1867. In Europe, photographers shot scenes from the German-Danish war of 1864 and a number of photographers from both sides recorded the Franco-Prussian war of 1870–71. Photographs of the Paris Commune became famous, among them group shots in front of the toppled Vendôme column—a picture that proved fateful to many of the rebels caught by the lens when the photographs were used by the victors to identify Commune members.

Halftone reproduction

Surprising as it may seem, 19th-century newspapers and magazines were not among the customers of documentary photographs. The

telegraph was able to disseminate news quickly, but to publish photographs was a much more involved process. Photographs were therefore usually first reworked as woodcuts or lithographs, a procedure which considerably detracted from their unique authenticity. The demand for immediate photo reportage had to wait for the invention and refinement of the halftone process. While the press and book publishers alike felt a strong need for pictures, the methods of production offered by sensitizing wood blocks or lithographic stones for photographic reproduction were simply incapable of adequately meeting the demand.

Timothy H. O'Sullivan, *A Harvest of Death, Gettysburg, Pennsylvania,* July 1863.

1850 – 1880

Composing and distributing pictorial reports to a wide audience imposed new demands on the printing process. How to reproduce photos became such an acute problem that the Société Française de Photographie (French Photographic Society) organized a contest in 1856 that was won by Alphonse Poitevin's charcoal reproduction process. Poitevin's method, which greatly increased the stablity of the pictures, was significantly improved by Sir Joseph William Swan in 1864 to the point where 1,500 prints could be made per day.

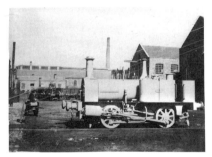

James Mudd, *Industrial Shunting Engine Built by Beyer-Peacock, Manchester, England,* 1858. Mudd's inventory of locomotives built by the English industrial-engineering firm are among the earliest industrial documentary photographs.

This was a real step forward, but hardly ~ough progress to meet the demands of a mass ~dience. Poitevin, however, developed the base ~nother process, today known as phototypy ~lotypy, but his method only became practi- ~fter decisive improvements by Joseph ~ 1868. Walter Bentley Woodbury

Joseph Albert (1825–86). Student of the photographer A. Löcherer, Albert opened his own studio in 1850 in Augsburg, Germany. In 1858, he was named Bavarian court photographer and opened a studio in Munich. He was not only the portraitist of the European nobility, in particular of Ludwig II of Bavaria, but also made decisive improvements in the phototype process and experimented with color photography as early as 1877.

"Photography is overtaking the world by everywhere searching out and finding magnificent subjects for the artist and the scholar to study. Soon, no corner of the earth will be untouched by photography All honor to the courageous, determined, and talented men who devote their strength to such undertakings!"

Ernest Lacan, 1861

proposed yet another process based on Poitevin's technique in 1865. But it was Karl Klitsch (Klič) who finally solved the problem of the gridlike resolution of a photograph—that is, the breaking down of a picture into individual points of various levels of gray for printing—with his development of heliogravure in 1879.

Joseph Albert's phototypies together with Klič's invention fulfilled the technical requirements for high-quality photographic printing. The real turning point that enabled large-scale printing of photographs, however, came with George Meisenbach's invention of autotypy in 1881. Finally, halftones could be reproduced for printing simultaneously with type. This process allowed the almost unlimited multiplication of photographs. It remains the basis of photograph reproduction today.

The discovery of new worlds: Travel and landscape photography

The 19th-century thirst for knowledge was well served by the possibilities offered by photography in exploring the unknown. New discoveries were revealing secrets of the world once beyond the grasp of the average person's experience. Expeditions now set out to bring back pictures from the entire planet—photographs of remarkable, because unknown, lands and extraordinary events. It was at this time that travel photography emerged as a new, important endeavor. Europe, the Middle East, Asia, the Far East, Africa, and the South Pacific provided inexhaustible themes for photographic research expeditions.

Photography's ability to bring home the entire world in authentic pictures would have a revolutionary effect on human experience. On the hand, it is hardly surprising that the camera's expeditionary testing grounds were exactl

places that had already long been the subject of western education and culture. People apparently felt a need to test their common knowledge against the authenticating evidence of photographs.

To undertake a photographic expedition in the latter part of the 19th century was no small feat. Because it would be impossible to replenish one's

Traveling photographer carrying the equipment for the wet collodion (wet-plate) process, including a darkroom tent.

1850 – 1880

supplies once underway, everything had to be brought from home. The development process was laborious and complicated, and the equipment heavy. Heat, dust, unimaginably bad roads, uncertain border-crossing procedures, and difficulties with customs were just a few of the problems that infused such ventures with a fair

Reproduction processes

Woodburytypes (also intaglio prints): A chromic acid gelatin relief printed on paper, produced by a metal printing block that is pressed onto the fluid gelatin.

Pigment printing: A relief made of a pigmented chromium-containing, image-producing gelatin that is transferred by bathing onto a pigmented paper and exposed under a negative.

Heliogravure (also photogravure): An intaglio or rotogravure process in which the dye is pressed onto the paper. The printing block is an etched photo-aquatint plate on which tonal values are created by means of a layer of fused bitumen dust that forms a kind of screen or raster.

Phototypy (also collotypy): A direct photochemical low-relief process in which a glass plate coated with an expandable chromium-containing gelatin layer functions as the printing block. The plate is exposed beneath a right-sided halftone negative film. The scanning of the image takes place through the grains of the negative film.

Autotypy: A photomechanical reproduction process for manufacturing high-pressure book-printing plates based on the halftone process. The scanning of the picture takes place through raster points that are copied onto light-sensitive metal plates. The printing plates are created from the system of raised points.

Alexander Gardner, *Arapaho Indian Big Mouth*, Colorado territory, 1874.

degree of risk, particularly in the regions that had been rarely or never visited by Europeans or Americans.

Soon, several different directions in travel photography had defined themselves. Some photographers collected travel impressions—often buildings and monuments—for their personal edification. Others produced photographs to sell to audiences interested in popular science. Still others were themselves driven by their interest in scientific study, for example in archaeology or ethnology. After 1860, yet another trend arose among professional photographers: They opened photographic studios in exotic locales such as Italy, Greece, Japan, China, or the Middle East, from which they sold architectural pictures or set photos of folk life directly to tourists.

Among the professional photographers who aimed at earning a livelihood with photography were Maxime DuCamp, Francis Bedford, and Francis Frith. The Englishman Frith visited Egypt three times between 1856 and 1860, as well as the Holy Land; in 1858 he completed a series of 16 x 20 in. plates under extreme desert condi-

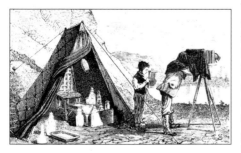

Darkroom tent containing the laboratory of a landscape photographer, ca. 1860. To the left, behind the photographer, the photographer's assistant holds a prepared collodion plate.

tions. From the start, he aimed at generating income from the commercial publication of his photographs. He brought his own dark room with him—a sight that met with great suspicion among the indigenous peoples until an illuminating explanation dawned: Perhaps the strange wagon carried the stranger's harem.

Wilhelm Burger, by contrast, operated with no personal commercial interest as part of an Austrian navy expedition. Burger was a member of the Imperial and Royal Mission to East Asia

and South America, where he photographed native arts and crafts; his images of the people of Japan convey the photographer's sensitive and respectful attitude toward his subjects.

India always seemed to hold a particularly strong fascination for English photographers. Samuel Bourne, among others, started a photographic compendium of the distant provinces of India in the 1860s. Probably the most important European photographer in India was C. Shephert, who had a studio in Simla. The romantic, heroically stirring photographs from his three expeditions into the Himalayas capture the powerful natural settings, which he also described in his impressive reports for the *British Journal of Photography* and other publications.

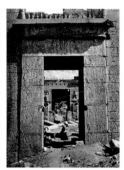

Francis Frith, *Pylon of the Temple of Ramses III in Medinet Habu, Upper Egypt,* ca. 1857.

Photographic travel reports like Bourne's from India or John Thomson's from Southeast Asia found great favor with the public because they offered visual presentations of places and regions normally beyond the ken

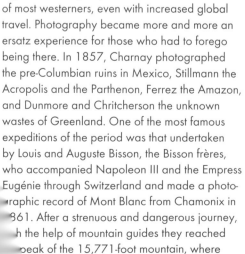

of most westerners, even with increased global travel. Photography became more and more an ersatz experience for those who had to forego being there. In 1857, Charnay photographed the pre-Columbian ruins in Mexico, Stillmann the Acropolis and the Parthenon, Ferrez the Amazon, and Dunmore and Chritcherson the unknown wastes of Greenland. One of the most famous expeditions of the period was that undertaken by Louis and Auguste Bisson, the Bisson frères, who accompanied Napoleon III and the Empress Eugénie through Switzerland and made a photographic record of Mont Blanc from Chamonix in 1861. After a strenuous and dangerous journey, with the help of mountain guides they reached peak of the 15,771-foot mountain, where

Francis Frith (1822–98). Son of a Quaker family, Frith operated a printing press in Liverpool, England. He was a cofounder of the Photographic Society of London. Between 1856 and 1860, he independently undertook three journeys to Egypt, Palestine, Nubia, Lebanon, and Syria; the photographs from these expeditions were shown in exhibitions and printed in many publications from 1858 on. In 1859, Frith founded the firm F. Frith & Co., which published more of his photographs in books. After the firm was dissolved in 1871, most of his negatives were destroyed.

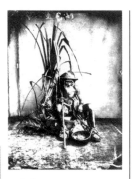

Wilhelm Burger, *Annamese Beggar*, Saigon, ca. 1869.

"Since the early days of calotypes, the odd tripod with its mysterious box and the brass muzzle has taught the natives of this land that their conquerers have invented something other than artillery cannons."

Samuel Bourne

they took three shots of the awesome panorama—a heroic performance!

Yet another kind of travel photography arose when photographers, like other business people, betook themselves to the trading centers and harbors in the 1860s to set up photography studios. Among the more successful commercial efforts of this kind were carefully posed genre scenes of foreign life, as well as photos of journeys to little-known areas and sights of distant regions. Photographs like those produced by Beato, Baron Stillfried, Bourne & Shephert, M. M. Miller, and other studios, depicting even the most strange and distant areas of the world, were highly sought-after by Europeans as souvenirs. In spite of their often high artistic quality, these became common articles—although today they are both rare and valuable. The heyday of these studios, including the Sommer studio in Naples, the Alinari brothers' studio in Florence, and the Ponti studio in Venice, came to an end in the 1890s.

It was also after 1860 that American photographers began to explore the natural beauties of the West. In large measure, the same photographers who "cut their teeth" during the Civil War began the photographic exploration of this vast frontier. They were, therefore, familiar

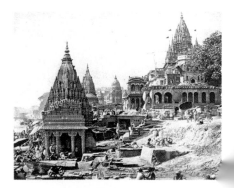

Samuel Bourne, *Hindu Temple on the Banks of the Ganges in Benares*, 1865.

with the hardships likely to attend the opening up of the West. It was they who awakened enthusiasm among Americans for the country's dramatic landscapes—an enthusiasm and interest that would eventually contribute to the foundation of the national park system.

Louis and Auguste Bisson, *The Alps: View of "The Garden" from Mont Blanc*, 1860. In order to take this photograph from Mont Blanc, 25 porters were needed to carry the large-format camera (12 x 15 in.) and approximately 500 pounds of equipment to the 15,771 ft. summit. Water was obtained by melting snow with an oil lamp. The bitter cold allowed very little time for the preparation and processing of the photographic materials.

The history begins with the magnificent panoramas of Yosemite made by Carleton E. Watkins. In 1867, the daredevil Timothy H. O'Sullivan, who had already accompanied various surveying troops of the Army Corps of Engineers, joined the geological expedition exploring the 40th degree latitude and took magnesium flash pictures of the gold mines of Nevada. Around 1871, O'Sullivan photographed the Colorado River as far as the Grand Canyon, the Canyon de Chelle in New Mexico in 1873, and later the California desert.

Alexander Gardner and William Henry Jackson accompanied the building of the eastern section of the Union Pacific Railroad, and pressed on through Colorado, New Mexico, and Arizona into the Sierra Nevada, while Eadweard Muybridge photographed the grand landscapes of the Yosemite Valley with a large-plate camera. In 1875, Jackson made twelve pictures of the Rocky Mountains with 16 x 20 in. plates. With every picture taken, another aspect of photography was irrevocably established in an area that had once been the exclusive domain of the painter—landscape.

1850 – 1880

Timothy O'Sullivan, *Ancient Ruins in the Canyon de Chelle, New Mexico*, 1873.

1880–85 Germany and Italy become colonial powers.

1884 Mark Twain, *The Adventures of Huckleberry Finn.*

1886 Erection of the Statue of Liberty, a gift from France, in New York Harbor.

1889 Construction of the Eiffel Tower for the Paris Exposition.

1890 Last stand of the Sioux Indians in South Dakota; Sitting Bull killed.

1894 Dreyfus Affair in France.

1895 Discovery of the x-ray by Wilhelm Roentgen.

1895/96 Alfred Nobel establishes the Nobel Prizes.

1896 The first modern Olympic games held in Athens

1903 First motorized flight by Wilbur and Orville Wright in Kitty Hawk, North Carolina.

1907 Picasso's first major cubist work, *Les Demoiselles d'Avignon.*

1911 Roald Amundsen is the first to reach the South Pole.

1912 British passenger liner *Titanic* sinks.

1914–18 World War I.

1915 Albert Einstein develops the general theory of relativity.

1880 – 1915

Expanding the means—Photochemistry and phototechnology

In 1880, when photography was already almost half a century old, it finally became simple enough for general use. The crucial prerequisite was the substitution of a gelatin emulsion for the original collodion vehicle. The new dry-plate negative process freed the photographer from the need to maintain a darkroom on the spot, and liberated the camera from its tripod. In 1888, the Kodak camera allowed almost anyone to photograph almost anything, anywhere.

Even before 1880, attempts had been made to produce dry collodion plates, but they lacked the light sensitivity of the wet plates, and experiments with gelatin as an emulsion vehicle had also failed—the gelatin layer washed away in the fixative bath. In the course of his bacteriological research, the English physician Richard Leach Maddox managed to break the technical impasse. In 1871, he published a new process for producing a dry photographic substance. Maddox discovered how to deposit and hold silver bromide in a gelatin layer—the same principle used today with modern photographic materials. The gelatin plate radically altered the future of photography. Maddox himself published a method with even greater light-sensitivity in the *British Journal of Photography*, but con-

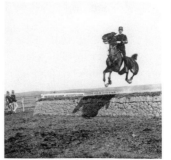

ducted no further experiments. It took seven years for the doctor's odorless process to be developed into usable technology. After improvement

Count Giuseppe Primoli, *Rider in the Tor di Quinto.* Print from a gelatin dry plate, ca. 1895.

by J. Burgess and Richard Kennett, in 1878 the Englishman Charles Harper Bennett invented a chemical-sensitization method which both increased light sensitivity and rendered the emulsion stable for a few days when it could be

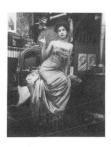

Alphonse Mucha, *Model in Artist's Studio*, ca. 1900. This important illustrator and art nouveau poster artist used many of his sensual amateur photographs as patterns for illustrations.

readied by raising its temperature. It was now possible to quickly produce negatives with an exposure time of only a fraction of a second. European and American manufacturers began industrial production of the plates, but their fragility and weight remained problematical. The Hyatt brothers were using celluloid sheets as a vehicle for the emulsion in 1869, but only in 1887 did H. Goodwin invent celluloid roll film that allowed several shots in succession.

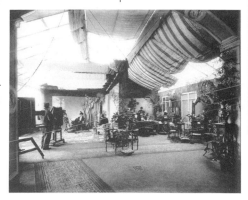

1880 – 1915

A further disadvantage of the early materials was the inaccurate translation of certain colors into tones of gray. This problem, too, was gradually overcome. In 1873, German chemist and professor of photography Hermann Wilhelm Vogel improved the emulsion layer for reception of green and yellow light. By optical sensitization—that is, by adding certain dyes to the emulsion—he created the first orthochromatic plates, which were sensitive to all colors except deep orange and red. In 1902, A. Miethe and A. Traube perfected tonal correction by adding further dyes to ⌐heir panchromatic dry plate for the proper trans-⌐tion of all visible colors into shades of gray. ⌐ese developments were significantly aided by

Waiting and posing room, Alinari brothers' studio, Florence, Italy, 1880–85. The studio (still in operation today) was already a large-scale enterprise in the 19th century, producing portraits and genre pictures. The firm excelled in photographs of museum objects, landscapes, and architecturally important buildings. The Alinari studio has provided important visual material for generations of art lovers, art historians, and preservers of historical monuments.

the simplification of the development process by F. Hurter and V.C. Driffield back in 1890.

Almost simultaneously with the introduction of the gelatin dry plate as a negative material, new ready-to-use copy paper became available. It was now possible to choose between slow printing-out paper (such as albumen paper, which produced an image without chemical development) and faster papers which required

chemical developers. Since 1867, Munich manufacturer Emil Obernetter had made a collodion emulsion coated celluloid paper that

Albrecht Meydenbauer, *The East Side of the Towers of Cologne Cathedral*. Photogram, 1889. The most important task of photogrammetry was to produce an exact image of an architectural work at a certain point in time as a document for both architectural research and monument preservation.

gradually replaced the albumen papers, and after 1885, his son, Johann Baptist Obernetter offered a similar paper with a gelatin coating. The next year, Eduard Liesegang of Dusseldorf introduced his comparable *Aristo-Papier*. This gelatin-based slow printing-out paper became the market leader of its day. Today, however, such paper is most commonly used for prints.

Parallel to these new photographic materials, new types of cameras, shutter releases, and objective lenses were also being developed. In particular, easy-to-use cameras capable of taking several photographs in a series became available, as did hand-held cameras that freed the photographer from the cumbersome need to tinker with tripods and black camera hoods. In addition, the bellows camera was improved by broadened range of adjustments and more

1880 – 1915

precise focusing around 1880. Because the improvements in cameras and light-sensitive materials enabled exposure times measured in seconds, it was no longer practical for the photographer to take the cap off the objective by hand and replace it a few seconds or minutes later. The reduced exposure times could only be attained with very fast shutter speeds. The first such shutter, fabricated by G. M. Levy in 1853, had since evolved in two directions—into the leaf (or diaphragm) shutter and the focal-plane shutter, both of which could offer precise exposure times down to 1/5000th of a second.

A particular challenge for the manufacturers of objective lenses at this time was to eliminate the aberrations, especially astigmatism, that reduced the sharpness of the image in certain areas of the picture. The Rapid Rectilinear, in use since 1866, and the Aplanat objectives possessed a relatively narrow 25° field of vision, but larger aperture settings resulted in decreased sharpness.

The most significant advance in the area of photographic optics was thus the introduction of the astigmatic lens. Inspired by E. Abbe, the Schott firm in Jena, Germany, started to produce new barium crown glasses with previously unattained refraction values and color dispersion.

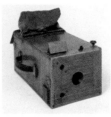

Magazine camera for twelve 3.6 x 4.5 in. plates, 1892. In this so-called detective camera, the exposed plates were moved from front to back by means of the leather sack. As a result, one could take pictures relatively unobtrusively without a camera stand or black photographic hood.

1880 – 1915

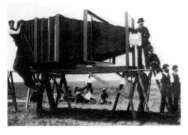

These new glasses formed the basis for the construction of astigmatic lenses that also facilitated correction of other distortions. The first such lenses were calculated by P. Rudolph in 1889 nd built by the Jena firm of Zeiss. The most ccessful were the double astigmatic Dagor

Until the beginning of the 20th century, gigantic cameras were needed to make large-format pictures. One such giant was "The Mammoth," a plate camera built in Chicago around 1900. When fitted with a 500 lb. plate, the camera weighed almost 1,400 lbs. and required 15 people to carry it. Commissioned by the Chicago and Alton Railroad Company, the camera enabled photographers to take 54 x 96 in. photographs of the company's luxury train.

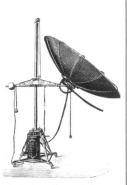

Studio lamp for arc light, ca. 1900.

1880 – 1915

lens produced by Carl Paul Goerz in Berlin, and the Tessar lens built by Zeiss starting in 1902.

Capturing movement

Toward the middle of the 19th century, as industry and commerce played an ever stronger role in society, time—and with it the capture of movement—took on a new and greater meaning. It is not surprising under the circumstances that photography was often faulted for its apparent inability to comprehend the dimensions of time and space.

In 1869, the Englishman Eadweard Muybridge (ne Edward James Muggeridge), who became famous for his landscape photographs of Yosemite Valley, invented one of the first camera shutters. His Yosemite experience was to be very helpful in his later experiments. In 1872, the owner of a large horse ranch, Leland Stanford, former governor of California and founder of Stanford University, commissioned Muybridge to photograph the leg movements of a galloping horse in order to prove that all four of a horse's hooves are suspended in mid-air under the animal's belly during one phase of the galloping motion.

Astigmatism: Parallel light rays striking the optical axis of a lens at an angle so as to produce not a point image but, according to the distance from the receiving surface, a perpendicularly or horizontally distorted line image.

Orthochromatic: Photographic materials that have been sensitized to the green and yellow portions of the spectrum as well as to the blue.

Panchromatic: Photographic materials that have been sensitized for all colors of the light spectrum; prerequisite for the correct transmission of gray values and color photography.

Gelatin plate/gelatin film: Glass plates or, later, flat or rolled celluloid film using gelatin—an extract from animal collagen—as a bonding agent for silver salts (silver bromide or iodide). Gelatin is still a primary ingredient of photographic emulsions.

Muybridge accepted the contract—perhaps because of a $25,000 wager on the results, perhaps to test the scientific theses of French physiologist Etienne Jules Marey, who had already published work on the phases of locomotion. Muybridge completed his first series of photographs for this assignment, but his work was interrupted in 1874 when he was tried for murdering his wife's lover. Despite his acquittal,

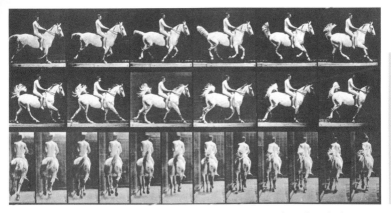

1880 – 1915

Eadweard Muybridge, *Horse in Motion*, table from *Animal Locomotion*, Philadelphia, 1887.

Muybridge dropped his work for Stanford and left the country. In 1877, however, he resumed work on his comprehensive experiments and perfected his process, using up to thirty cameras simultaneously. He published his results in 1887 in two volumes with a total of 781 collotypes titled *Animal Locomotion* and *The Human Figure in Motion*.

Muybridge's work in turn inspired Marey to intensify his study of motion with the help of a camera. To this end, in 1883 he developed his own camera that could make an entire series of exposures on a single plate, resulting in a photographic diagram of movement. He later designed a camera that produced separate exposures of every phase of movement.

Photographic weapon made by Etienne-Jules Marey. With this device, Marey was able to illustrate the ordered stages of movement within a single picture. His invention of a chronographic projector in 1889 put him in the vanguard of cinematography.

1880 – 1915

German photographer Ottomar Anschütz pursued a different goal. His earliest photographs were taken with a home-made camera with a focal-plane shutter that allowed extremely short exposures. In 1888, when he perfected the shutter, he was able to take extraordinary pictures of storks, running horses, and other animals in motion. His photographs were characterized by finely discriminated gray tones and a high degree of detail reproduction.

Chronophotography—the art of capturing movement through a series of still photographs shot at regular time intervals—inspired numerous artists and, through the time-series photographs of Italian photographer and filmmaker Antonio Giulio Bragaglia, wielded influence over many artists among the turn-of-the-century schools—the futurists, the expressionists, and the cubists. The protagonists of chronophotography, last but not least, smoothed the way for something already envisioned in 1845 by Jules Champfleury and

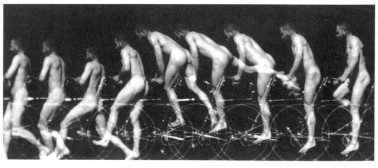

Etienne-Jules Marey, *Chronophotograph of a Man Dismounting from a Bicycle,* ca. 1890/95.

actualized by the Lumière brothers in 1892—cinema.

Meanwhile, the forms of instant photography proliferated. The dancing light plays of the American artist Marie-Louise Fuller offered a

challenge to every photographer of the 1880s, while the amateur Jacques-Henri Lartigue, who had started making photographs at the age of six, devoted himself to capturing the actions of daily life. Throughout his career, movement was less a fact to be caught by the camera than a form of poetry. His passion for photographing any form of movement led him, at the still modest age of twelve, to take some of the best early photographs of airplanes at the airfield at Issy-les-Moulineaux. To a greater degree than is perhaps true of any other contemporary photographer, Lartigue's pictures capture the spirit of his age: the Belle Epoque.

Kodak—Photography for all

Around the year 1890, there appeared on the market a light and easy-to-use camera that would forever change the history of photography and would become a symbol of its radically new availability.

Photography for everyone was the intention—an idea probably springing from American entrepreneurship. The inventor was the American George Eastman, whose vision of simplifying photography to the point where anyone could take a picture by merely pressing a button was an overwhelming success. With the debut of the Kodak Nr. 1 in 1888, the field of photography was now open to all, not just to the professional photographer.

Eastman derived his idea from the invention of the Reverend H.W. Goodwin who, in his search for an alternative emulsion vehicle to replace glass plates, had developed a flexible transparent vehicle—rolled film. An unclearly written patent application for his celluloid film coated with a silver bromide gelatin layer held

"How great our delight would be if we could experience the advances that daguerreotypy will have made in a hundred years—when it no longer captures merely a small fragment of life, but can roll forth a complete living image of life before the amazed eyes of our descendents. ... That would be the greatest art."

Jules Champfleury 1845

1880 – 1915

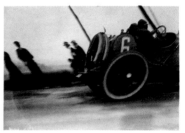

Jacques-Henri Lartigue, *Grand Prix of the Automobile Club of France.* Copy of a gelatin dry plate, 1912. Lartigue moved his camera (a Klapp-Krauss Zeiss, fitted with a focal-plane shutter) in the direction of the car's movement, thus causing the spectators to appear at a slant and the car wheels to appear oval.

George Eastman with a Kodak camera on a journey to Europe, 1890. Copy from a Kodak film negative.

up the granting of his patent until 1887— a delay that George Eastman readily exploited. Eastman deduced from Goodwin's invention that it would be possible to construct a camera simple enough for the average person, and to mass produce it inexpensively. His first step in this direction was what he called stripping film, a layered paper roll that proved to be only partially satisfactory. In 1891 Eastman replaced the paper roll with American film, a transparent film on a celluloid support.

Eastman's contribution to the popularizing of photography consisted in part of his construction of a light, portable (3.2 x 3.6 x 6.4 in.) device with a fixed-focus lens and a film roll containing a hundred round negatives, each slightly more than 2.5 inches in diameter. But equally important was the element of service that Eastman offered his customers: "You Press the Button, We Do the Rest" was his slogan. The Kodak camera came fitted with a roll of film, and the price included both developing the film and making prints. To receive the finished photos, the camera owner simply sent the complete camera containing the exposed film back to the Eastman Company in Rochester, New York—and, for another ten dollars, he or she received the camera back again reloaded with a new roll of film. Eastman invented the word "Kodak"

Paul Nadar, *Young Girl at the Place d'Opera in Paris*, 1888. Copy from a Kodak film negative, typical of the round picture produced by the Kodak Nr. 1. The stationary objective lens ensured sharp images of everything 8 or more feet away from the camera, and the round format brought the background of the object into focus.

solely on the basis of market appeal—it was a simple word, clear to pronounce in any language.

Armed with the snapshot camera, armies of amateur photographers were now shooting everything that they deemed worth a picture—and then some. Now usable by the novice, the camera became a common means for many artists and writers to record life and served as an aid to their memory. Emile Zola, for example, took hundreds of photographs from daily life; the camera became for him—as for many of his contemporaries including Edgar Degas, Pierre Bonnard, August Strindberg, and George Bernard Shaw—a particular way of seeing.

Pioneers of color photography

The history of color photography extends further back than many people realize. Even the first photo generation in the years following 1839 had lamented the fact that, although photographs certainly produced images that were true to nature, they did so only in black and white and gray.

The first colored photograph was produced by British physicist James Clerk Maxwell in 1861 to prove the theory of additive color mixing. For this purpose, Thomas Sutton prepared print diapositives that had been photographed through three different color filters. In a demonstration by Maxwell before the Royal Institution of London, the images were superimposed by a projector over one another through a red, a green, and a blue filter. The result was an almost real-looking picture of an insignia made of a Scottish tartan ribbon (traditionally a colorful plaid). For practical purposes, however, the process was useless because of its complexity.

Methods for reproducing colors were discovered almost simultaneously by two French researchers nearly ten years later. While Alphonse Louis Poitevin had successfully

"It was a purely arbitrary combination of letters ... arrived at after considerable search for a word that would answer all requirements for a trademark name. The principal of these were that it must be short; incapable of being misspelled so as to destroy its identity; must have a vigorous and distinctive personality."

George Eastman in 1906 on the creation of the name Kodak

1880 – 1915

Emile Zola photographing Lac Superieur in the Bois de Boulogne, Paris, with an amateur camera, ca. 1900.

Louis Ducos du Hauron (1837–1920). His many experiments and inventions made this pianist and researcher of optical phenomena a pioneer of color photography.

1880 – 1915

Louis Ducos du Hauron, *Birds*, 1879. Heliochrome from a three-color photograph. This picture of a brilliant stuffed rooster is one of the earliest surviving color photographs.

conducted experiments with colored pictures on paper in 1865, it was the musician and optical researcher Louis Ducos du Hauron who made the first truly decisive steps in the direction of color photography.

In 1868, after obtaining a patent for various color processes, Ducos du Hauron published them in a book. He exposed silver bromide collodion plates with extractive filters and derived red, blue, and yellow pigmented diapositives. The three partial pictures then had to be laid over one another precisely to achieve the final picture. Probably the oldest surviving color photograph by Ducos du Hauron dates from 1877. At the same time, Charles Cros, another photographer, obtained similar results independently from Ducos

du Hauron, and may thus also be considered an inventor of color photography.

Because of the complexity of the process, no practical technical use was made of the invention at the time. But, in 1888, Frederick Eugene Ives of Philadelphia developed the three-color process, which was improved and put to practical use by the German Adolf Miethe after 1903. Miethe

Interference Method: A direct color photography process based on the refraction of light waves (interference). Practically introduced in 1891 by Gabriel Lippmann in Paris.

Screen Particle (Raster) Method: Layer of randomly spread colored particles is spread in front of the photographic layer of a plate or film. Upon exposure they act as a colored filter by producing an image through an additive mixture of colors.

Three-Color Photography: Older term for photographs made of three colored shots that are recombined into an image by means of three-color projection.

was also responsible for meeting another important prerequisite of color photography—panchromatic sensitizing for accurate color reproduction.

How to reproduce colors in a single layer on the negative or print, instead of on three negatives, intrigued many researchers in Europe and North America at the beginning of the 20th century. The first truly usable method was the autochrome plate method introduced by the Lumière brothers in 1904. Their method produced a natural-looking colored picture by means of a single exposure. The principle was based on a fine screen, or raster, of transparent particles of potato starch dyed blue, green, or red that was applied to a glass plate. The light reflected by the photographed object had to pass through this filter before it could reach the sensitive photographic emulsion. The panchromatic emulsion layer was poured over the raster and the plate was then exposed from the glass side. By then exposing the plate in reverse black-white procedure, a direct diapositive was formed. Viewed through the filter layer, the image appeared colored.

Autochrome plates were produced commercially by the brothers Lumière in Lyon, France, starting in 1907, and later also by the German firm, Agfa. The plates could even be used for color reproduction. Photographers such as Edward Steichen and Heinrich Kuhn, as well as many amateurs, immediately started experimenting with the plates; however, it took another thirty years before color photography really came into its own with the development of three-layer color film by Kodak and Agfa in 1935/36.

Louis Lumière, *Young Girl Picking Lilacs*. Autochrome plate, ca. 1906–10.

1880 – 1915

Jacques-Henri Lartigue, *Landscape of Pau Region*. Autochrome plate, 1912.

Pictorialism around 1900

With the rise of art photography at the turn of the century, a debate that had been carried on since the invention of photography assumed new life—is photography art-worthy and where does it stand in relation to the arts and the art world as a whole? A central issue in the photographic debate concerned sharp versus soft focus—the straight versus the pictorial—as an article of faith.

Edward Steichen, *Portrait of Auguste Rodin*. Autochrome plate, 1907.

This polemic started with the publication in 1889 of *Naturalistic Photography for Students of the Art* by the Englishman Peter Henry Emerson, who felt strongly that the modern photographer should as a rule adopt soft focus. Emerson cited Hermann von Helmholtz's theories of perception—according to which human perception itself is not entirely consistent, but tends to be blurred in areas of the field of vision—and he vehemently rejected the montage approach of Robinson and Reijlander which he considered artificial.

A vociferous defender of soft-focus, pictorial photography, Emerson boldly claimed, "Nothing in nature has a hard outline." Robinson rejoined, in a battle played out in the pages of British photographic magazines, "Healthy human eyes never saw any part of a scene out of focus."

Peter Henry Emerson, *Gathering Water Lilies*. Platinum print, 1886.

Emerson found support in the rediscovery of the photographs of David Octavius Hill and Robert Adamson.

A recognizable school of art photography, later known as pictorialism, arose around 1890 in Vienna, Paris, Hamburg, and, almost simultaneously, in England. Naturalness and privacy were the hallmarks of this style, whose proponents preferred exterior settings to studios and wished to outlaw retouching. As a result, the themes of pictorialism were typically nature, domesticity, private leisure activities—which was also the code word for nude photography—and above all portraiture. The effect of the pictures drew largely from the hazy interplay of light and shadows; the photographs were developed as platinum prints whose rich nuances and satiny surfaces could be made to correspond closely to aesthetic preconceptions. But other laborious print procedures also found favor, such as gum, bromide-oil, and other pigmented printing processes whose complexity essentially preordained artistic manipulation. In place of manufactured papers, the artists

Hans Watzek, *Wine Glass with Apple*. Three-color gum arabicum print, 1896.

1880 – 1915

Noble Printing Processes

These processes are chiefly based on the light-sensitivity of chromium salts in combination with organic substances (colloids).

Platinum Prints (platinotypes): Developed layer of salts of platinum and iron on paper. The color of the detailed and richly toned picture is neutral to grayish black.

Pigment Print: Relief composed of exposed chrome-containing pigmented gelatin that is rinsed onto paper. Images are produced by charcoal or pigments.

Gum Print: Relief composed of exposed and dyed chrome-containing gum arabic.

Bromide-Oil Print: Raised relief on paper, created through the fading of a silver-bromide gelatin image that is later colored with oil paints.

Oil Print: Gelatin relief on paper, created through exposed chromium-salt gelatin and afterward colored with oil paints.

Robert Demachy, *Study in Red*, ca. 1898.

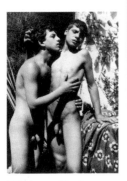

Wilhelm von Gloeden, *Youths Embracing*. Albumen print, ca. 1900.

preferred homemade products. By the turn of the century, there were more than a hundred different processes in use.

Next to Emerson, probably the strongest influence on the pictorial movement came from the banker Robert Demachy who produced particularly soft and impressive gum prints; he sometimes retouched the negatives with colored chalk. A cofounder of the Photo-Club de Paris, Demarchy drew a good deal of attention with the exhibition of his gum-bichromate photographs in the 1894 Photographic Salon in Paris. The illustrations and noble-metal prints of C. Puyo achieved a similar aesthetic effect. The International Salons that had been established in many European cities since the early 1890s generated great public interest and gave a strong boost to the art-photography movement.

The Vienna Camera Club played a central role in the development of art photography. The work of Emerson, Robinson, and Demarchy became models for the gum and combination prints that the club raised to a masterly level. Heinrich Kuhn of Innsbruck and his friends, Hans Watzek and Hugo Henneberg, who together operated under the name Trifolium, developed their own clearly defined style for halftone prints in rich blue or brown tones on raw cardboard.

Other European art centers followed the Austrians' lead. In Germany, one of those who took up the banner of the pictorial photographers was Alfred Lichtwark, director of the Kunsthalle in Hamburg, which hosted the First International Exhibition of Amateur Photographs in 1893, in which 6,000 photographs were displayed. Lichtwark was a great supporter of amateur photography at the turn of the century and wrote an important paper on the theme. It was his efforts that first acquainted Germany with pictorialism.

While Germany responded with great enthusiasm to the pictorial photography brought to them by Lichtwark, some German photographers during the same period pursued quite a different track. W. von Gloeden drew upon classical Homeric-arcadian themes and subscribed only with reservation to the obsessions of the art photographers. Von Gloeden was one of the early exponents of nude photography and concentrated primarily on the male figure. Both he and W. Pluschow rejected the convention of softening the sexuality of their subjects in the manner of the pictorialists by means of unclear focusing or a fig leaf.

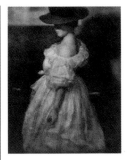

Heinrich Kuhn, *Miss Mary*. Gum print, 1908.

In 1893, a series of exhibitions under the title *The Photographic Salon* were presented in London by the Linked Ring association founded the previous year. The Linked Ring was an exclusive group of photographers who had left the Photographic Society when, they felt, it failed to properly recognize their interests. The original Salon members such as Alfred Horsley Hinton and Henry Peach Robinson soon forged ties with Robert Demachy, Frederick H. Evans, Hugo Henneberg, Alfred Stieglitz, and others. Through their good connections with both North America and the continent, the English pictorialists were open to influence from both directions. Where James Craig Annan was oriented more toward European models, Frederick H. Evans reveals the influence of the New York Photo-Secession.

1880 – 1915

Stieglitz, Steichen, and the Photo-Secession

Without doubt, Alfred Stieglitz and Edward Steichen are among the most important figures in the history of photography. The former was one of the leaders of the pictorial movement in America. More than perhaps any other 20th-century photographer, Stieglitz established

Frederick H. Evans, *The Sea of Steps—Wells Cathedral*. Platinum print, 1903.

1880 – 1915

Title page of the magazine *Camera Work*, New York, 1903–17.

himself as both artist and aesthete with an air of defiant self-assurance.

Stieglitz went to Germany in 1881 to study engineering. While there, he met Hermann Wilhelm, a proponent of both brilliant technique and artistic photography. Stieglitz first achieved recognition in England in 1887; from there he proceeded to Vienna in 1890 and finally he returned to the United States where—through exhibitions, publications, Stieglitz's own New York gallery as well as the luxurious magazine *Camera Work*, conceived by Stieglitz and published between 1903 and 1917—the so-called Secessionist movement proclaimed its own exclusive ideals. Beyond founding the Photo-Secession, Stieglitz, through his gallery and *Camera Work* opened the doors to America for the European avant-garde.

In a search for ever greater precision, Stieglitz continually refined his theory of creative photography. The increasing clarity of his theories influenced his own photographic work as well until, at the beginning of the 20th century, his efforts crystalized in the form of explicit support for the school of straight photography. Here enters a second figure whose life work was just as important to the development of photo-

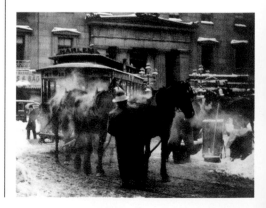

Alfred Stieglitz, *The Terminal*, New York. Photogravure, 1893.

Alfred Stieglitz (1864–1946), photograph by Heinrich Kuhn, 1904. Stieglitz studied engineering and took his first photographs in Germany; he worked from 1890 in New York. He organized important photographic and art exhibitions, published various photographic magazines, including *Camera Work*, which he began publishing in 1903. In 1902, he cofounded the Photo-Secession; between 1905 and 1917, he operated the famous Gallery 291, which played a leading role in the artistic avant-garde movement. Steiglitz married the American painter Georgia O'Keefe in 1924. He was always a defender of "genuine" photography—that is, photography that is not oriented around painting.

graphy. Edward Steichen (born Eduard J.) first became known for work submitted to the Philadelphia Salon in 1899, and was one of the cofounders of the Photo-Secession. His reputation spread to London and Paris, and he became a master in gum-bichromate printing, famed for his multiple copies in various colors. His collaboration on *Camera Work* and his connections with Gallery 291 led him, like Stieglitz, to become a prominent modern-art patron, in particular, of young photographers. In 1923, Steichen was appointed head photographer at the publishing house of Conde Nast and did work for *Vanity Fair* and *Vogue*, setting the standards for the new genre of commercial and fashion photography in illustrated magazines. In 1947, he became director of the photography department of the Museum of Modern Art.

Among the founding members of the Photo-Secession, Gertrude Käsebier and Alvin Langdon Coburn garnered especially high praise. Käsebier's simple, romantic portraits of women and children, as well as her idyllic landscapes, strongly reflected the influence of Stieglitz until she herself seceded in 1910 and founded her own association, which Coburn also joined. Coburn had already exhibited in 1900 in Paris and London, where his earliest successes were portraits, followed later by landscapes,

1880 – 1915

Edward Steichen (1879–1973), undated self-portrait. Steichen's family immigrated to the U. S. from Germany in 1881. Apprenticed as a lithographer, photography became his profession through the influence of Stieglitz. He met French sculptor Auguste Rodin during a tour of Europe. With Stieglitz, Steichen was a cofounder of the Photo-Secession, of the magazine *Camera Work*, and of Gallery 291. He was friends with many artists and in the 1920s and 30s worked as a fashion photographer. After 1946, he served as curator of the new photography collection of the Museum of Modern Art, organizing exhibitions such as *The Family of Man* in 1955.

cityscapes, and genre scenes. In 1906 he emigrated to England, where he became associated with cubism and futurism through his friendship with the expatriate American poet Ezra Pound. In 1917, Coburn began producing vortographs, a series of abstractly dismantled surfaces and forms based on cubist ideas. Frank Eugene, Clarence H. White, and Baron Adolphe de Meyer all followed the American pictorial movement until around 1920, although they never came fully under the umbrella of the elite Stieglitz academy.

Gertrude Käsebier, *The Sketch*. Platinum print, 1899.

1880 – 1915

Baron Adolphe de Meyer, *Still Life*. Photogravure, 1907.

The truth behind the objects

Somewhere among the snapshot photographers, who wanted nothing more than to fill their family albums with mementos, the art photographers who crowded the ivory towers of high art, and traditional studio photographers, a new movement was emerging that sought to explore the reality behind the appearances of the visible world.

The work of Jacob August Riis provides clear evidence of the effects of technical development and the shifting interest in reality. This Danish immigrant worked as a journalist and police reporter and used photography not for aesthetic purposes but as an effective aid in a project of social reform. Riis himself had experienced first hand the demoralizing slum life of New York—he had spent years without a job or a permanent home—and attempted to mobilize the public against such living conditions. He soon realized that printed words alone apparently had little power to convince and turned to flash photography to emphasize his message. In 1890, Riis published *How the Other Half Lives*, which included seventeen autotypes and nineteen

drawings taken from his photographs, all of which depicted the immigrants' misery. Unfortunately, the reproductions were very poor quality and Riis's work remained almost forgotten until 1947.

The social documentation that Riis translated into pictures, without artistic ambition, was in some sense later taken up by Lewis Wickes Hine. Like Riis, a photographic layman, Hine had studied sociology and education at Columbia University. He saw in the camera a helpful instrument for sociological research and the dissemination of its results. Before the First World War, Hine photographed the deplorable conditions on Ellis Island and later in the tenement houses and slums of New York City. From 1907, he worked on a penetrating documentary for the National Child Labor Committee (NCLC) on the working conditions of children in factories. Like Riis, Hine was convinced that photographs offered subjective witness and called his work "photo interpretations," because the effect could be steered by the photographer. His pictures of child labor, taken with a 5 x 7 in. camera, often showed the children working at machines that dwarfed the small laborers. For Hine, the text

Jacob A. Riis, *Home of an Italian Ragpicker, New York,* 1888.

1880 – 1915

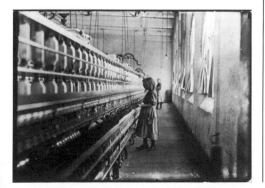

Lewis W. Hine, *Carolina Cotton Mill,* 1908.

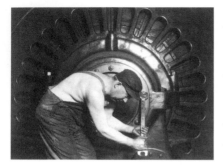

Lewis W. Hine, *Bolting Up a Big Turbine*, 1920.

1880 – 1915

accompanying the pictures was very important. His documentation played an important role in bringing about legislation that outlawed, or at least restricted, child labor. His style strongly influenced the later work of the Farm Security Administration (FSA) photographers. Where Hines's first photographs were characterized by a moral accusation against inhuman living and working conditions, both the style and the thematic emphasis of his work changed with the years. In *Man at Work* and his photographs of the construction of the Empire State Building, Hine brings out the heroic image of the worker.

The work of James van der Zee first became known to the public in 1969. Through the years he had photographed the life of the African-American population, especially in Harlem, his home. A professional photographer, van der Zee opened his first studio in 1915 and, until 1960, traced the events of his immediate surroundings. His pictures interpret the life of New York's black residents.

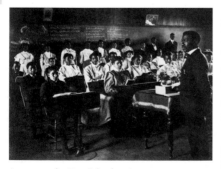

James van der Zee, *School*, undated.

Another long-unknown photographer was Ernest J. Bellocq, whose work concentrated exclusively on the red-light district of New Orleans. Until its closing in 1917, the district known as Storyville was the largest of its sort in the United States. Bellocq's photographs of prostitutes are serious and sympathetic and reveal much of the subjects' inner being. Nothing is known about Bellocq's motivation and working

conditions. Just eighty-nine glass negatives were found after the photographer's death, most showing naked and half-clothed prostitutes in their establishments.

As an ethnological observer, Arnold Genthe used the camera as a somewhat naive form of evidence-gatherer. In his search for both the exotic and the univerally human condition, Genthe documented the Asiatic life in Japan and San Francisco's Chinatown at the turn of the century. The San Francisco earthquake and fire of 1906 later occasioned his most impressive pictures.

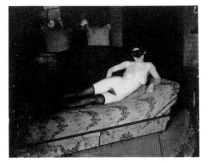

Ernest J. Bellocq, untitled, ca. 1912, from the series *Storyville Portraits*.

As the role of photography was changing in America, it was also changing in Europe. Of course, in Europe, too, photography's value in chronicling the natural environment as urbanization transformed its face had already been long recognized. Only gradually, however, did photographers come to understand the medium's potential in processes of social transformation.

European photographers had indeed used the camera to document social reality. The most striking of the early photographs are probably those of the Englishman John Thomson, who spent a long time as a documentary photographer in the Far East. Upon his return to his native country, Thomson turned his camera on the streets of London. In the 1870s he became acquainted with the journalist and sociologist Adolphe Smith, who suggested they collaborate on a book about London's slums. The result was *Street Life in*

1880 – 1915

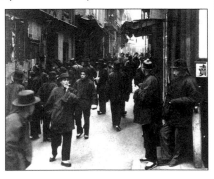

Arnold Genthe, *Street of Gamblers in Chinatown, San Francisco*, ca. 1896.

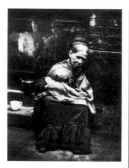

John Thomson, *The Crawlers*, ca. 1877. Woodburytype from the book *Street Life in London*.

Heinrich Zille, *Brushwood Gatherers*, 1900.

London (1877/78), the first work in the history of photography that used photographs to elucidate a social problem.

Quite different ambitions drove Heinrich Zille of Berlin to focus on the back courts of tenements and on the lives of the people who lived there in the shadow of society. Zille's photographs of the daily life of this segment of Berlin society—of its meager resources for subsistence and its modest pleasures—were not, however, detached analytic depictions of social conditions but a direct statement of emotional solidarity with the people. It is this difference that distinguishes the photographic language of Zille from that of either Riis or Hine. There is evidence that, between 1890 and 1910, Zille took pictures solely in order to stockpile images for his graphic work. That his remarkable photographs became

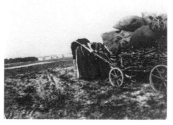

known to the public so late is at least partly due to his heirs' belief that publication of the photographs would detract from Zille's reputation as an artist.

While social reportage was producing an important body of work, interest in documenting traditional lifestyles, habits, and customs was growing. At first, August Sander probably intended simply to portray peasant milieus and lifestyles when he began to photograph the Westerwald region in Germany. His earliest pictures attempt to capture the hardships of life in the faces of his peasant portraits. Before he devoted himself to the systematic creation of a German typology, he directed his precise gaze at those people whose tradition-bound lives

were reflected in their personalities. Thanks to his sense for unfalsified reality, even his early work combined pictorial quality with precise depiction.

At the same time that Sander was launching his ambitious project of creating a photographic typology of the Germans, Edward Sheriff Curtis began an elaborate documentary of the life of the North American Indians. With financial support from the banker John Pierpont Morgan, Curtis set out to create a pictorial slice of American history on the verge of termination (as the photographer considered it). The Indian wars had recently come to an end, and Curtis now attempted to preserve the life of the "vanishing race," with its customs and traditions. In practical terms, this meant that Curtis often constructed a picture of the Indians that had little to do with the actual life of the Native Americans who stood before him as models. He therefore turned to those Indians who had already fully separated themselves from their traditions and appealed to them to don what were to them alien clothing and head-dresses for the sake of the photographs. Despite its historical dubiousness, *The North American Indian*, Curtis's twenty-volume work that appeared between 1907 and 1930, is extremely impressive for its sharp powers of observation and photographic technique.

When he set out between 1895 and 1904 to document the lives of the Hopi and Zuni Indians

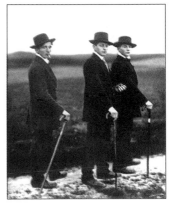

August Sander, *Young Farmers of Westerwald*, ca. 1914.

1880 – 1915

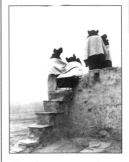

Edward S. Curtis, *Watching the Dancers—Hopi*, 1906.

"In Mr. Curtis we meet both an artist and a good observer whose pictures are pictures and not mere photographs; whose work is more than exact because it is full of truth."

Theodore Roosevelt in the Foreword to the first volume of *The North American Indian*, 1907

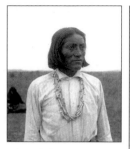

Adam Clark Vroman,
*Kopeli—The Well-Known
Snakecharmer*, 1898.

1880 – 1915

of the Southwest, Adam Clark Vroman took a quite different approach to the theme. That Vroman's work is far more sympathetic and authentic is in large part due to the trusting relationship he forged with his extremely camera-shy subjects. He was also aided by the fact that the pacifistic tribes he chose to study lived in the relatively unknown deserts, far from white civilization.

Eugène Atget—A photographer of old Paris

In spite of the general esteem for unretouched photography, the work of one of the most important representatives of the no-retouching philosophy remained uncelebrated for a surprisingly long time. When the headstrong photographer died in 1927, his work was almost unknown—his pictures had never appeared in a salon, and hardly a one of the many thousands of photographs he had taken since 1898 had ever been shown in public. From the very beginning, Eugène Atget strove in his photography to collect everything that he judged to be worth saving.

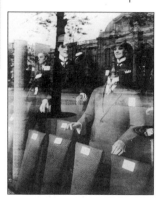

Eugène Atget, *Avenue des Gobelins*, Paris, ca. 1900.

Atget's early attempts to establish himself in Paris as an actor, and later as a painter, had failed. At the age of forty-one, he turned to photography. With neither theory nor ideology, Atget pursued a single-minded goal—to photograph Paris exactly as it was and to capture in return all that had captured his attention. Indeed, several painters used Atget's street scenes as models. Maurice Utrillo, André Derain, Maurice Vlaminck, and others painted many pictures from Atget's photos. The Surrealists, too, made use of the individualistic atmosphere of Atget's work. Atget was, in fact, a photographic collector who squirreled away everything that seemed interesting to

him. But, at the same time, he was a "picture maker," as his friends described him, who possessed a naive but unfailing eye for the hidden poetry of daily reality. Atget always worked in a rather

old-fashioned manner with a plate camera, a stand, and a short-focus objective lens. His tinted Aristo prints are traditional in their effect, even though their aesthetic is very modern. In almost all of his nearly 10,000 photographs, every detail is clear, and some of the pictures impressively demonstrate that even documentary photos can reveal more than meets the eye.

Atget's photographs are pure in the sense that they clearly refuse to rely on any principles borrowed from painting. They have character because they draw upon an aesthetic derived only from the medium of photography itself. Atget was only late in life discovered by the American photographer Berenice Abbott. It is thanks to her that he finally achieved the recognition he deserved.

Jean-Eugène Auguste Atget (1857–1927), photographed by Berenice Abbott, ca. 1926. Sailor, painter, and actor, Atget started around 1900 to make photographs for painters to copy. Self-taught, he photographed Parisian streets, parks, monuments, fountains, show windows, and people in the poorer suburbs from 1898. The surrealists published three of his photographs in their magazine. In 1926, he met the American photographer Berenice Abbott, who acquired and published parts of his unpublished work after Atget's death.

1880 – 1915

"The city in these pictures has been emptied like an apartment that has not yet found a new tenant. It is by such achievements that surrealistic photography makes a healthy alienation between environment and mankind. To the politically educated vision, surrealism opens the field in which all intimacies withdraw in favor of the illumination of detail."

Walter Benjamin, 1931

Eugène Atget, *Fête de Vaugirard*, Paris, undated.

1917 October Revolution in Russia.

1918 End of World War I

1919–33 Prohibition in the United States; Weimar Republic in Germany.

1919 League of Nations founded in Paris with seat in Geneva; Bauhaus Manifesto.

1922 Free Irish State proclaimed; Mussolini takes power in Italy.

1925 Development of quantum mechanics by Werner Heisenberg and Max Born.

1926 Fritz Lang: *Metropolis.*

1927 First talkie *The Jazz Singer* with Al Jolson; Charles Lindberg flies across the Atlantic.

1928 Discovery of penicillin by Sir Alexander Fleming.

1929 Black Friday on Wall Street—beginning of world economic crisis; founding of the Museum of Modern Art in New York.

1933 Nazis take power in Germany.

1915 – 1933

Straight photography

In the 1920s, while the pictorial scene was still flourishing in Europe and North America, an entirely different aesthetic was also developing. In the United States, the leadership of the new movement was provided by the elite Academy of Alfred Stieglitz and Edward Steichen. Although these changes in aesthetic philosophy had something to do with the aftermath of the First World War, the call to "let photographs look like photographs" had, in fact, been increasingly audible in America since 1910.

The standards of straight photography encompassed the way an object was shot, the role of light, and the power of expression achieved by the photographer's detached stance in relation to the object. This new approach reawakened the old tension between the objective appearance of the visible world in the photograph and intimations of the personality of the artist behind the appearance.

For the group of photographers around Alfred Stieglitz, Edward Steichen, Paul Strand, Charles Sheeler, and Edward Weston, the essence of the task was to formulate a pictorially clear, objective expression of the relationship between object and subject. The result of their efforts was the first

distinctly American photographic style. The driving force behind this development was Paul Strand. Although his photographic roots were clearly in

Alfred Stieglitz, *The Steerage,* 1907.

pictorialism, after 1910 Strand found his way to straight photography through his work with social documentation. Earlier, his photographs of social fringe groups had always demonstrated his willingness to pose strong formal and social questions. Stieglitz described Strand's photographs as "... brutally direct, pure and devoid of trickery."

These words were equally applicable to the attitude toward a new realism that, starting with Strand, emerged after 1917. Strand's aesthetic position grew out of his understanding of the defining characteristic of the photographic medium: The essence of photography was that it was *photographic*—that is, objective. It was almost inevitable that Strand would become one of the first to explore the aesthetic of the machine in photography.

Edward Weston was probably the most successful in pursuing a path toward a pure American photographic style, which he described as a road to self-discovery. The form and expressive power of the object intrigued Weston. His contact with photography had begun very early—he acquired his first camera in 1902, and his early work was in the pictorial tradition. He opened his first art studio in California in 1911 and, by 1915, had discovered in the abstract possibilities

Edward Weston, *Pepper No. 30*, 1930.

"Honesty no less than intensity of vision is the prerequisite of a living expression. This means a real respect for the thing (photographed), expressed in terms of chiaroscuro. ... The fullest realization of this is accomplished without tricks of process or manipulation through the use of straight photographic methods."

Paul Strand, 1917

1915 – 1933

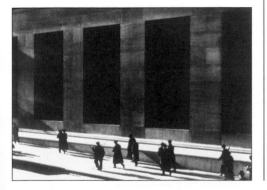

Paul Strand, *Wall Street*, 1915.

Tina Modotti, *Hands of a Puppet Player*, 1926.

Tina Modotti (1896–1942). Born in Italy, Modotti emigrated with her family to California in 1913. As a femme fatale in various Hollywood films, she traveled with Edward Weston to Mexico in 1923 after the death of her first husband, and there began to take photographs. Her friends included the poet Pablo Neruda, the painter Diego Rivera, and the Bauhaus architect Hannes Meyer. She remained in Mexico after Weston left. Modotti became a member of the Communist Party in Mexico, and in 1929 her lover, the Mexican union leader Mella, was shot to death at her side; in 1930 she was deported. Later, she lived with Mella's suspected assassin, Vidali. Modotti gave up photography in Moscow and died in 1942 in a Mexican taxi cab.

of modern art a path to self-discovery that would play a very important role in his future work. For Weston, a decisive turning point came in 1923 when he met the Mexican painter Diego Rivera. Weston's sensitivity to light and form now evolved into a style based on the principle that every photograph must preexist as a finished result in the photographer's mind in order for the intended effect to be achieved.

Like Weston, who was in fact her companion, mentor, and lover in Mexico, Tina Modotti expressed her political sympathies and proletarian engagement via photography. A socially and politically active photographer, Modotti was a role model for the women's liberation movement, and remains today a heroine of the Left around the world. Despite the similarity of her radical stylistic techniques to those of Weston, Modotti's photos clearly asserted their own identity.

Charles Sheeler, along with Strand, began gradually in 1914 to explore the the aesthetic of indigenous American architecture. Sheeler's relation to the ordinary buildings and structures around him ostensibly reflected the interest of a painter who found inspiration in photographs. Nonetheless, his interpretation of the forms and structures of industrial architecture—or of the Cathedral of Chartres—was purely photographic in precise detail, even if many of the motifs turned up again later in his painting.

A similar interest in working out the implications of form was characteristic of a number of younger photographers. At the beginning of the 1920s, Imogen Cunningham, Ralph Steiner, Paul Outerbridge, Jr., and Walker Evans quickly adopted the new aesthetic and adapted it to their own purposes. Evans became known throughout the world as a documentarist of ordinary American architecture, from wooden farm sheds to

dilapidated southern mansions, from loud and flashy gas stations to fast food stands and billboards. Even his early work in the 1920s evinced his feel for structure and abstraction, but his pragmatic sense of reality rescued him from an artificial and uncommitted photography.

In 1932 a group of young, like-minded photographers gathered around Edward Weston and adopted the programmatic name of "f/64"—referring to the lens aperture opening that allowed the greatest sharpness and depth of image, which were at the time only attainable with large-format cameras. The members, including Cunningham, Ansel Adams, John Paul Edwards, and Willard van Dyke, formulated an aesthetic that admitted only sharply detailed photographs and disallowed all manipulation. For many years, "f/64" remained the most advanced photographic association in America, encapsulating the essence of straight photography.

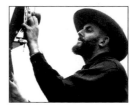

Ansel Adams (1902–1984). Originally trained as pianist; inspired by Paul Strand and Alfred Stieglitz to become a professional photographer. Cofounder of photogravure association "f/64"; first exhibition, *An American Place* in Stieglitz's Gallery in 1936. In 1940, set up the first photography department of the Museum of Modern Art. Published landscape photography and textbooks on photographic technique; deeply engaged in nature conservation movement (particularly honored by Sierra Club). Ranks among the world's most important landscape photographers.

1915 – 1933

"Photography is but one phase of the potential of human expression; all art is the expression of one and the same thing—the relation of the spirit of man to the spirit of other men and to the world."

Ansel Adams

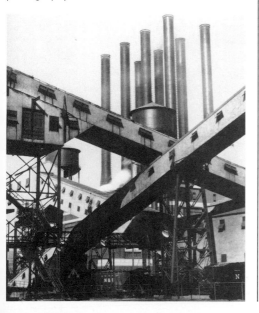

Charles Sheeler, *Ford Plant, Detroit*, 1927.

Andre Kertesz, *The Fork*, 1928.

"The work of the artist is not merely a beautiful statement about the beauty of an object, but above all also a statement about the object itself, an explanation of the object. The work of art clarifies the reality created by the object; it reports on and conveys the artist's life experiences."

Bertolt Brecht

1915 – 1933

Among Strand's disciples, after Weston, it was Ansel Adams who especially demonstrated the possibilities of expression inherent in "pure photography." As a landscape photographer, teacher, and writer on photography, Adams became acquainted with Strand and the purely photographic style in 1930. He worked with various cameras and experimented with new processes. After 1935, he became internationally known and published a number of illustrated volumes of outstanding quality. Adams sought in nature what Stieglitz called "equivalents"—visual corollaries to the photographer's intuition.

New objectivity

When László Moholy-Nagy coined the term "new vision" in 1925, European photographers had already been experimenting with the stylistic devices of the new photographic language for some time. At the end of the First World War, which had of course caused a far greater caesura in Europe than in America, photographers began using new angles of vision and unusual ways of seeing. An international language of images was making history under the expressions "new vision" and "new objectivity."

Photographers subscribing to the new objectivity turned taboos into virtues—sharp

Ansel Adams, *Moonrise, Hernandez, New Mexico,* 1914. The pictures of this photochronologist of the Sierra Nevada are highly coveted on the international art market.

upward angle shots, undershots, detail, contrast, and repetition became the hallmarks of their "photographic eye," as Franz Roh described their methods in 1929. In this respect, the European approach came closest to the objective pictorial language of America. Indeed, European photographers had also been aware of the tendency to objectification, but only at this point did the direction formally assume a name. At a contemporary painting exhibit in Mannheim, Germany in 1925, Gustav F. Hartlaub first dubbed the movement New Ob-

Albert Renger-Patzsch, *Blast Furnaces, Herrenwic, near Lübeck, Germany,* 1927.

jectivity (*Neue Sachlichkeit*). Hartlaub borrowed the phrase from painting and applied it to the cultural phenomenon of the entire epoch, for objectivity was everywhere in demand.

The real pioneer of this movement within photography was Albert Renger-Patzsch, whose beginnings as a photographer were also firmly embedded in art photography. As a leader of the photographers' union, however, he later defined his work as "photographic photography." He was vehemently against the photographic construction and montage work pursued in Bauhaus circles and just as strongly opposed to all forms of surrealism in photography. For Renger-Patzsch, the mechanical nature of photography suited it chiefly for the presentation of objects.

1915 – 1933

Albert Renger-Patzsch (1897–1966) is a major representative of objective-realistic photography of the 1920s. After World War I, he studied chemistry, and after 1922, directed the picture archive of the Folkwang School and the Folkwang Press in Essen, Germany, publishing his first book on the choir stalls of Cappenburg in 1925. He then started photographing independently, moving in 1928 to Essen and devoting himself to the photography of the Ruhr region as well as to industrial and objective photography. In 1928, he published *The World is Beautiful.* In 1944, his archive was destroyed, and he moved to the countryside where, after the Second World War, he chiefly pursued landscape and industrial photography.

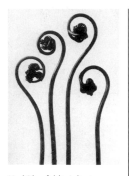

Karl Blossfeldt, *Adiantum pedantum. Maidenhair Fern*, 1915-25.

Poster for the exhibit, *Film and Photo*, Stuttgart, 1929.

"There are a few certainties within the profusion of reality—and so it is with the work of this man, who is ...so passionate. What is individual, what is objective, glimpsed from the heaving undulations of the world of appearances, isolated, elevated, intensified, imbued with significance—what else has art ... ever done?"

Thomas Mann on
Albert Renger-Patzsch

Accordingly, artistic intentions were a secondary consideration at best. This position tended to yield photographs of plants and foliage, machines, factories, and landscapes. The alternative offered by objective photography peaked in the 1928 publication of his photographic volume *The World Is Beautiful*. The book's title, forced on the author by the publisher (Renger-Patzsch had wanted to call it *The Thing*), aroused harsh criticism but the work influenced an entire generation of young photographers.

Karl Blossfeldt, the second important representative of the new objective photography, was in fact a member of the generation at work before the advent of New Objectivity. He nonetheless became one of the most eloquent photographers of the new movement. Originally an art metal caster, Blossfeldt began

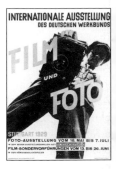

gathering and experimenting with plant forms in 1898, and took a teaching position in modeling from live plants at the Teaching Institute for Applied Arts in Berlin. Around 1900, he began, with the help of photography, delvinginto the tectonic forms and structures of nature and drew impressive analogies between natural structures and architectural building principles with his close-ups. His 1928 publication *Basic Forms of Art* elicited much praise and is still considered one of the greatest photographic achievements of New Objectivity.

That New Objectivity as practiced, for example, by August Sander and W. Mantz was not an exclusively German phenomenon became abundantly clear at the *Film and Photo* (FIFO) exhibit in Stuttgart and at the 1929 *Photography*

of the Present exhibit in Essen where the most important works from around the world were displayed. Among the exhibitors, the Swiss Hans Finsler was intensely interested in form, lighting, and spatial structures, whereas still life, stones, plants and her own children were the subjects chosen by A. Biermann, who captured daily objects objectively, with both clarity and precision.

The New Objectivity, certainly well known since the FIFO exhibit, influenced the early work of the exiled Hungarian André Kertész as well as the Renault factory photographs of Robert Doisneau and the composition of French photographers Francoise Henri and Germaine Krull. The influence of New Objectivity was even stronger among the Dutch (H. Bersenbrugge) and the Czechs (J. Funke and J. Rossler).

The experiences of straight photography in America and of the New Objectivity in Europe blazed the trail for modern photography as they advanced understanding of the nature of photography as a pictorial medium. However, even in the 1920s, as aesthetic ideals in photography were changing and pictorialism seemed to have long passed its apogee, a few photographers managed not merely to maintain the older style but even to expand it by adding

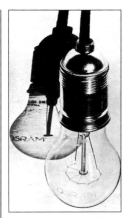

Hans Finsler, *Electric Bulbs*, 1928.

Germaine Krull, *Pont Transbordeur, Marseille*, 1926.

1915 – 1933

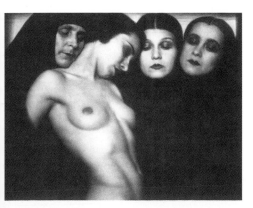

Rudolf Koppitz, *Study of Movement*, ca. 1929.

Berenice Abbott, *James Joyce*, 1926.

their own unique elements. The Belgian land-scape photographer Louis Misonne still upheld the principles of the Secession and art deco movements in the 1930s. And he was not alone in his total opposition to modern, post–World War I developments. Repeated attempts to revive pictorialism after its heyday between 1894 and 1910 showed that the basic problem of how to evaluate this style remained unresolved. In the face of accomplishments of photographers such as the Czechs F. Drtikol or J. Sudek, the Austrian R. Koppitz, or those of Misonne himself, it is difficult to consign the style entirely to history.

The renaissance of the portrait

The language of photographic portraiture combined elements of both pictorialism and modernism. To the possibilities of elevated ex-pression available in the "noble" processes of platinum, gom, and bromide oil printing, most photographers brought their personal style. One photographer whose work united individual style, a desire for self-espression, and unusual models was the German Hugo Erfurth. Born in 1894 in Halle, Erfurth's career followed the typical course of the time through commercial amateur photo-graphy and pictorialism to his establishment as a portraitist of Saxon society. Thanks to his unusual clientele, however, he became the chronicler of artistic life. While his models at first consisted of actors and actresses, opera singers, and dancers, more and more painters affiliated with the Bau-haus movement became his customers. The influence of his individualistic portrait style was felt throughout the 1920s.

Just as the political and social developments of this time were riddled with contradictory mes-sages, so the variety of portrait styles suggested no overriding, uniform style. Portraits from the 1920s are impossible to reduce to a single

Hugo Erfurth, *Marc Chagall*, 1925.

stylistic category. For one thing, the function of the portrait itself was being redefined: No longer solely works for the middle-class family album, portraits were a component of the changing worlds of the graphic arts and the other media.

August Sander, the German photographer whose work reached its highpoint in the 1920s, is a useful example of the portraiture of the time. Building on his body of portraits of farmers and peasants, Sander planned a photographic cross-section of "all professions, all classes, all social levels." With this monumental intention, Sander found a place in the history of photography as a conceptualist. Representing the objectively oriented New Vision, he became a kind of photographic sociologist who traced the appearance and body language of his contemporaries from the unemployed worker to the industrial magnate. His plan, under the working title *Man in the Twentieth Century*, was to create an inventory of the people of the Weimar Republic, and he approached his subjects with a true-to-life, unmanipulated method. His pictures always included some reference to the social position of the subject "in order to create a mirror of the times in which these people live." The first volume he produced in this project, *Face of Our Time*, is a masterpiece of portraiture and inspired

Man Ray, *Jean Cocteau*, 1926.

August Sander, *Pastry Master*, 1928.

1915 – 1933

August Sander (1867–1964), photograph by Chargesheimer. Sander worked in various photography shops, becoming an art photographer during a short term at the Painters' Academy in Dresden. In 1902, he opened his own portrait studio in Linz, Austria, and moved to Cologne in 1910; there, he completed his first objective portraits of the Westerwald farmers. Afterwards, he worked on his project, *Man in the Twentieth Century*. After World War I, he was associated with "The Progressives," a Rhine-based artist group, and later moved toward "exact photography." In 1929, his much praised photo work *Face of Our Time* appeared, but his work was later interrupted by the Nazis, who destroyed the remainder of his stock and the printing blocks of the book. During the fascist period, Sander turned chiefly to photographing landscapes, nature, and the city of Cologne. His planned project of a typology of his countrymen, which was to consist of 45 portfolios with 12 photos each, remained unfinished.

Alexander Rodchenko,
Portrait of My Mother, 1924.

"To write sociology not by writing, but by providing pictures—pictures of faces, not of folk costumes—that is what the photographer accomplishes with his gaze, his mind, his observation, his knowledge ..."

Alfred Döblin on
August Sander's
Face of Our Time, 1929

many other photographers. Though Sander planned to produce up to twenty volumes in the series, only the first was published, as Sander, like so many others, faced the repressive climate of the Nazis in the years to come.

The search for new values in the 1920s also found expression in other pictorial solutions in the work of Franz Roh, László Moholy-Nagy, and Werner Gräff. Photo magazines, exhibitions, and, increasingly, illustrated journals disseminated the new style of portrait photography. Portraits no longer merely yielded information about the famous personalities, or immortalized middle-class families in formal poses and Sunday clothes; rather, portraits were infused with artistic and journalistic efforts to express previously obscure aspects of their subjects.

Man Ray experimented with unusual lighting and various darkroom techniques, while Françoise Henri used mirrors to create multiple levels of reality; Alexander Rodchenko played with extreme perspectives, and Alvin Langdon Coburn disassembled his subjects as if in a kaleidoscope. Erich Salomon photographed people in very intimate situations, E. Blumenfeld created double faces through fade-out effects, Edward Steichen gave his subjects enigmatic expressions, while Baron de Meyer pushed them into mythical remoteness.

Glamour and fashion

With the growing popularity of the illustrated press and of motion pictures (with their embryonic star cult), a new kind of photography responded to the consumers of these new mass media. In the early 1920s, glamour and fashion photography united artistic and commercial concerns, and became a proving ground where photographers could test how far they could carry their visual concepts with the general public.

Man Ray, for example, made a living for himself with the help of fashion photography. But the actual pioneers of the genre include George Hoyningen-Huene, Martin Munkacsi, Edward Steichen, and Adolphe de Meyer, later dubbed Baron. In the arena of fashion, the stars themselves were lifted to unreal heights as products of art. The New Yorker Steichen stylized his models into art deco figures, and, during the 1930s, the Baltic Baron Hoyningen-Huene arranged photographs with women as classical statues.

Hoyningen-Huene was a member of the generation that no longer sought the exotic in strange lands; instead, as the dadaists and sur-realists had already demonstrated, alienation was everywhere present in ordinary everyday life. Whether photographing portraits or fashion, Hoyningen-Huene presented his models as god-like figures. His pictures offered an ideal image of non-existent perfect people. In this respect, his photographs resembled those of the English gentleman-photographer Cecil Beaton who managed to gain entry into high society through his photographs of artists and glamorous women in the late 1920s.

Withdrawn into unreachable remote-ness, ineffable and perfectly beautiful were the entire regiment of Hollywood stars photographed by the American C. Sinclair Bull in the 1920s and 1930s. In 1924 he became the head portraitist of the film production giant MGM. At the end of the 1920s, Conde Nast, publisher of *Vogue*, discovered Lee Miller, who first worked as a model for Hoyningen-Huene, Steichen, and others, but who later herself

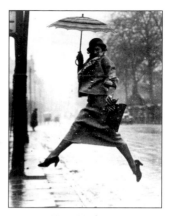

Martin Munkacsi, *Leap over a Puddle*, 1934. With this photo for the fashion maga-zine *Harper's Bazaar*, Munkacsi finally released fashion photography from the studio. He lent his models a dynamic pose, and his pic-tures became a metaphor for the energy of the cosmo-politan life of the 1930s.

1915 – 1933

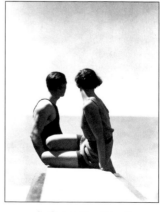

George Hoyningen-Huene, *Swimwear by Izod*, 1930.

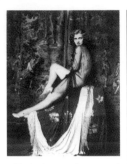

Alfred Cheney Johnston, *Drucilla Straine*, 1920. In the early 1920s, Johnston was the official photographer of the famous Ziegfeld Girls, the troupe directed and managed by Florenz Ziegfeld. Johnston also photographed many silent-film stars. He perfected the art of making his models appear naked even when fully clothed. Johnston's work was a major element in the Hollywood image of these years.

1915 – 1933

became a fashion photographer. In 1929, Miller went to Paris to study art, and became the pupil, model, and lover of Man Ray. In Paris she maintained her own studio. Her photographs of the befriended artists Andre Breton, Paul Eluard, and Pablo Picasso, like her fashion photographs, were surrealistic in tone and style. After her relationship with Man Ray ended, Miller relocated to New York where she operated a photographic studio and later pursued a second career as a photo reporter.

The work of these early fashion photographers, including Platt-Lynes, A. Cheney Johnston and Madame d'Ora, consciously embodied the type of the aesthete. As contemporaries of art deco and surrealism, they resolutely transformed fashion and glamour photography into artificially provocative theater.

The avant-garde—
The search for new forms

By the beginning of the 1920s, particularly in Europe, Western art was experiencing a sweeping surge of radical change in all forms and media. While the exchange between the continents remained at this time unequal, there was nonetheless communication between New York and Paris and the world-shattering art events of Paris could not help but have an impact across the Atlantic.

The major film studios and production companies of the 1920s and 1930s (and some of their leading stars):

Hollywood: RKO, founded 1909 (Fred Astaire, Ginger Rogers); **Paramount**, founded 1912 (Claudette Colbert, Gary Cooper); **Twentieth Century Fox**, founded 1919 (Rin Tin Tin); **United Artists**, founded 1919 (Charlie Chaplin, Douglas Fairbanks, Sr.); **Warner Bros.**, founded 1923 (Al Jolson); **MGM**, founded 1924 (Rudolph Valentino, Greta Garbo)

What Guillaume Apollinaire had called in 1913 *peinture pure*—pure painting—was taken up by the postwar avant-garde with an enthusiasm that inevitably also had an influence on photography. While there had certainly been numerous points of overlap between avant-garde art and photography before the war—as seen in the Futurist Manifestos of 1909 and 1910, as well as in the cubism of Picasso and Bracques— now something new arrived on the scene: Dada.

Photogram and photomontage

In the 1920s and 1930s, a new generation of critical, not-yet-established artists enthusiastically devoted themselves to all means whereby art could be transformed into the product of chance. This group rejected the prevailing notions of aesthetics. In a work like *Photogram*, light itself became the artist; Man Ray spoke emphatically of the "century of light." In the middle of the 1920s, the photogram took up a key position between painting and photography.

Photograms are produced without a camera; objects are placed on light-sensitive paper and exposed. The possibilities range from the original, simple form of a direct copy of a flat object— as was known from the photogenetic drawings of the early 19th century and the natural self-printing processes of Wedgewood, Talbot, and

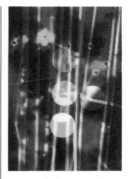

László Moholy-Nagy, *Photogram*, 1922. With everyday items, the artist tried to actualize the principles of constructivism through photographs. For Moholy-Nagy, photograms were a suitable medium for his kinetic art and his "light films," where he experimented with intermedial light.

1915 – 1933

The Photogram

"One places the chosen objects on light-sensitive paper. Depending on how long they lie there, on how close or how far away they are held, on whether they are shot sharply or dully, with stationary or with moving light sources, they give rise to haunting spheres of light with apparent spatial interpenetrations, often with wonderful transparency. Sublime gradations from the brightest white through a thousand shades of gray down to the deepest black can be produced. Overlapping can suggest extreme closeness and distance." Franz Roh, 1930

Bayard—to spatial arrangements of objects illuminated either by daylight or in the darkroom. Christian Schad, member of the Zurich Dada group, was creating abstractions in 1918 without a camera or a lens. Thus, even before the end of the war, Schad had launched the age of the modern photogram. His fellow Zurich artists called his playful inventions of dadaistic anti-art "schadographs." Together with Coburn's 1916 photograms, these schadographs marked a new development that was soon to reach its high point in the experimental work of Man Ray and Moholy-Nagy.

Man Ray, *Rayograph*, 1926. Man Ray's photogram illustrates the surrealist process of the alienation of things in its purest form. Using surrealist methods, Ray here proved himself a master at employing "psychic automatism" and conscious combination techniques.

Independently from the collage-like schadographs, the American Man Ray discovered the art of photograms himself. Unlike Schad's flat pictorial elements, Man Ray used three-dimensional materials to create imaginary visual space. Twelve of his surrealistic photograms, dubbed "rayographs" by Tristan Tzara, appeared in 1922 under the title *Les Champs Délicieux*.

Counterposed to Man Ray, the Hungarian László Moholy-Nagy stood as an experiment-happy artist with conceptual claims. As both practitioner and theoretician, he made an important contribution to experimental photography and the illumination of the interweavings of modern art with his book *Painting, Photography, Film*, as well as other works. Like Man Ray, he produced his first photograms in 1922; Moholy-Nagy later carried on his work at the Bauhaus.

At the 1929 international Deutsche Werkbund fair *Film and Photo* in Stuttgart, creative photographic art stepped permanently into the public consciousness. In fact, the circle of photographers

1915 – 1933

actually engaged with photograms was not a small one—Hausmann, Nerlinger, Lex-Nerlinger, Kepes, Lissitzky, Umbo, Zwart, and Schawinsky were some representatives of the style. Photograms, such as those of El Lissitzky, Tschichold, Man Ray, and Hajek-Halkes, were also used commercially, often appearing in product advertisements.

Whereas Zurich Dadaism had rediscovered the photogram with Schad, the Berlin dadaists George Grosz, Raoul Hausmann, Hannah Hoch, and John Heartfield were giving new energy to photomontage. More precisely, in the 1920s "phototypography" was used as a collective term for photomontage, collage, and assemblage, as well as for combinations of text and pictures. The pasting together of unrelated pictorial elements was one of the most important artistic contributions of the time; it was a new method and had nothing in common stylistically—if not technically—with the earlier combination prints of Reijlander, Robinson, or others of the nineteenth century. Supposedly, the first new photomontages can be traced back to

John Heartfield, *The Meaning of Geneva/Where Capital Lives/Peace Cannot Survive!* Title page from the *Workers' Illustrated Newspaper,* November 27, 1932. Many of Heartfield's works were printed in Germany's largest left-wing newspaper (1.5 million copies). Before it was suppressed by the Nazis, the paper was influential in developing a new, politically engaged style of photography.

1915 – 1933

Surrealism: Origin in Paris, 1918. An avant-garde literary, artistic, and cinematic movement, influenced by Freudian psychoanalysis, and seeking the explanation of reality in the unconsciousness. Major theoretician: André Breton.

Dada: Origin in Zurich and Berlin in response to World War I. Art and literary movement declaring all traditional art and aesthetic standards invalid; developed "anti-program" with chance as important element, as seen in its meaningless, infantile name. Famous dadaists: Marcel Duchamp, Tristan Tzara.

Constructivism: Dating from the first half of the 20th century, this art movement applied mathematical and technical principles of form, particularly to sculpture and painting. Founded by Vladimir Tatlin in Russia for sculpture, its principles were carried into painting by the suprematism of Kasimir Malevich.

Hannah Höch, *Da-Dandy-1919*, collage, 1919.

Hausmann, who started working with the form in 1917, followed by the Berliner Hannah Höch. What these Dada artists produced was strikingly different from the collages of the surrealists and cubists. The dadaists used montages and collages to question the "objectivity of appearance." With the help of photography, they wanted to tear things out of their usual surroundings and put them in new and sometimes striking relationships. A further and equally important aim was to demonstrate that photography was capable of producing new visionary realities.

Moholy-Nagy pursued these ideas with particular earnestness. His photomontages were as pioneering as his non-photographic art work.

Paul Citroen, *Metropolis*. photomontage, 1920. Created during his exile in Amsterdam, Citroen's photomontage served as a model for for the constricted spaces in Fritz Lang's 1926 film classic of the same name.

He went beyond the dadaist desire "to provoke, demonstrate, and experiment optically," and conceived his collages, montages, and assemblages as part of a complete whole. While Moholy-Nagy was pursuing his ends, the "photomonteurs," as they were called by the author Wieland Herzfelde (brother of John Heartfield), found inspiration in popular pictorial forms. Picture postcards in particular proved an ideal basis for the coded messages of artists like Grosz, Höch, Hausmann, Paul Citroen, and Max Ernst.

By the time that the First World War had ended and the Russian revolution had been fought and seemingly resolved in favor of the Soviet government, many of the revolutionary Russians also adopted photomontage as an ideal medium for the expression of their artistic and political intentions. Alexander Rodchenko, El Lissitzky, and Vladimir Tatlin created many

1915 – 1933

montages that were in fact stylistically close to those of the dadaists and surrealists.

That photomontages could answer to the most varied ambitions is demonstrated by the works of E. Blumenfeld and John Heartfield. Heartfield, who had Americanized his name from Herzfelde to protest the revival of German nationalism in the 1920s, used his collage and montage work for specifically political purposes. The montages of Heartfield and other dadaists were very often borrowed for book cover designs; in particular, the Berlin publishing house of Malik was one of the first to make high-quality commercial use of dadaist art.

Surrealism and Man Ray

Next to photography's documentary capability, the production of photograms increasingly dominated the spotlight of artistic interest. Both the dadaists and the surrealists welcomed the ability of photography to give them a means of expression that corresponded to their own feelings. The first photographs of the imaginists appeared in the New York circle gathered around the dadaist Marcel Duchamp. The ability of the photograms to confer a kind of reality on what is strange and unreal fascinated both

Man Ray (1890–1976). Photo: Self-portrait. Born Emmanuel Rudnitzky; studied from 1908 until 1912 at the School of the Arts in New York; contact with European avant-gardism partly through Stieglitz's Gallery 291. Acquainted with Marcel Duchamp and Francis Picabia and co-founder of New York Dada. First photos date from 1915. In 1921, Ray moved to Paris; intense relationship with Parisian surrealism. Also pursued commercial contracts especially for portraits and fashion photography. After 1940, taught photography and painting.in the United States; returned in 1951 to Paris, where he lived and worked until his death. Ray is one of the most important innovators in modern photography, especially in experimental areas.

1915 – 1933

Herbert List, The Pair, Kiel Bay, Baltic Sea, 1933. In his attempts during the 1930s to "capture the magical element in appearances" in his world of magical pictures, the Hamburg-born photographer became a master of fotografia metafisica.

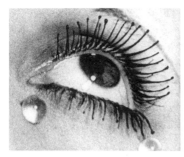

Man Ray, *Glass Tears*, ca. 1930.

"The invention of photography has dealt a death blow to the old means of expression, to painting as well as poetry—for which the appearance of automatic writing at the end of the 19th century represents a true photography of thought."

André Breton, 1924

sculptors and painters. When the idea becomes more important than the object—the theory of the surrealists—why shouldn't the artist use photography to dismantle the beautiful appearance of the objects and to give them a new meaning? In 1913, Duchamp and Man Ray met for the first time—a meeting that signified a turning point for the employment of photographic techniques within the surrealistic movement.

For Man Ray, as for Duchamp, poetry arose through action, and in photography Man Ray had discovered a valuable medium for his understanding of artistic process—a medium that would soon lead him even more strongly in the direction of automatic and mechanistic art. The accidental, the uncertain, and the unexpected became the hallmarks of his aesthetic, and at the same time clearly established his relationship to the European surrealists. Together they had discovered a new medium of expression through which they could allow light and movement—and, thus, all that was accidental, uncertain, and unexpected—to take their effect without human intervention.

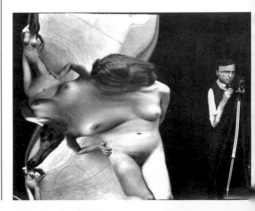

André Kertész, *Distortion No. 20*, 1933.

Surrealistically inspired photography, however, is a term that must necessarily also include all those experiments that photographers and other artists undertook in the darkroom with mechanical and chemical means in order to confront reality with their own imaginative worlds. In addition to photograms and photomontages, photographers experimented with unusual negative/positive effects (for example, the "solarization" technique often used by Man Ray), intentional graininess, distortions produced by slanting the enlarger, and special lenses, filters, and mirrors. Other techniques involved double exposures, strong overexposures, and even relief-like effects created by means of special positive/negative processes.

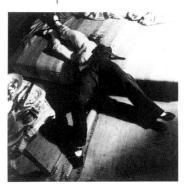

Hans Bellmer, *The Doll*, undated.

Man Ray was the most iridescent figure on the art scene of the 1920s—at once an experimental photographer, a painter, a fashion photographer, and a creator of "objects." As an American who was a close friend of the Parisian literary surrealists, he continually brought new transatlantic stimuli to American art. With him stood other artists who were also moving toward a surrealist imagination. Among them were Raoul Hausmann, who was already a central figure in the Dada movement, the Paris-based Hungarian André Kértész with his *Distortions*, the Bauhaus artist Herbert Bayer, the Belgian painter René Magritte, who, as an amateur photographer, sometimes used photography for his magical visions, and the Berliner Hans Bellmer who became known through his strange photographs of a kind of doll. In *Variations on the Assembly of a Jointed Minor*, which appeared in 1934, Bellmer developed for the first time hallucinatory pictures that were interpreted by many as fetishes in the Freudian sense.

1915 – 1933

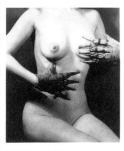

Paul Outerbridge, Jr., *Woman with Claws*, undated.

103

1915 – 1933

The Russian avant-garde

Russian photography was subject to much stricter maxims than those allowed artists farther to the west. After the deep social and economic upheavals brought by the revolution, a new artistic movement took form, expressly focused on helping to build a classless society through a revolutionary new approach that demanded the dedication and reconciliation of handwork and "head"-work, of art and technology. Many of the young Russian avant-garde artists saw themselves as representatives of the new society and understood their activities to be in the service of a new social order. These artists created magazines, book covers, posters, theater scenery, film sets, street decorations and propaganda materials for the new Soviet state. Many of the projects undertaken during this period revealed the totally independent viewpoint of the Russian avantgarde, which included many artists who were also interested in photography.

Rodchenko, Lissitzky, Ignatovich, Tatlin, Petrussov, Zimin, and other photographers all took part in the propagandizing of the Soviet revolution, which was summed up in such a programmatic formulas as: "electricity + soviet power = communism." The entire Soviet industrial culture of the 1920s and 1930s, including the propaganda, infused into the new citizens, did not result in flat

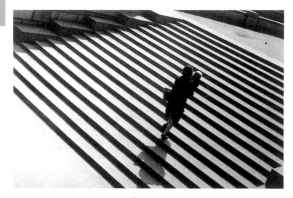

Alexander Rodchenko, *Steps*, 1930.

early-socialist photorealism. Rather, Russian photography—like Soviet film, theater, and

poetry—blossomed in a brief, but all the more energetic, renaissance. The most enduring expression of this was a characteristically altered and unusual (because extremely photographic) way of seeing, combining broadly diverse pictorial and structural elements.

A key figure in this development was Alexander Rodchenko. After initial constructivist experiments that were directed in part toward the culture of industrial production and in part toward propagandistic or even agitation art, Rodchenko began in 1924 to take pictures for himself. He brought to the process his constructivist consciousness of form and developed a style that rejected what he called the "belly-button perspective" of traditional photography in favor of an altered view of reality achieved by extreme perspectives—shots from above or below, as well as direct close-ups. The influence of the Russian avant-garde films of Eisenstein, Vertow, and Schub was considerable.

The second important protagonist of the movement was El Lissitzky, who was influenced both by constructivism and the suprematism of the Russian painter Kasimir Malevich. Lissitzky united simple geometric figures—circles, squares, and triangles—in his photographic works in a manner that was equally programmatic and symbolic. A multifaceted artist, Lissitzky used photograms and photomontages commercially in his design work for announcements, posters, book covers, and magazines. One of his largest photomontages was the photo frieze for the Soviet pavillion at the international press fair *Pressa* held in Cologne, Germany, in 1928. However, before it was barely ten years old, the intensive and far-reaching Russian avant-garde movement was brought to an abrupt end under the radical cultural-political about-face of Stalin's New Economic Policy.

El Lissitzky, *The Constructor—Self Portrait*, 1924.

Alexander Rodchenko (1891–1956). Studied at the Art Academy of Kasan and Moscow, 1910–14. Produced constructivist pictures for Tatlin's *Magazine* exhibition; acquainted with Russian supremacist painter Kasimir Malevich. In 1914, became a leading artist of Russian avant-garde; active as painter, sculptor, graphic artist, and designer. In 1922–24, involved with photomontages; some degree of fame through illustrations for Russian poet Vladimir Mayakovsky's *Pro eto*. Increased interest in photography after 1924; Lissitzky became a path-breaker for photographic constructivism. In 1927, abandonned painting for photography. Founding member of *Oktjabr* in 1930; 1933–41 worked chiefly on newspaper *Building the USSR*, which he cofounded with his wife V. Stepanova.

1915 – 1933

Photography and the Bauhaus

The establishment of the Bauhaus in Weimar, Germany, became internationally synonymous with the essence of modernism and functionalism. The Bauhaus pursued new principles of modern design, industrial culture, architecture and even building methods.

Lucia Moholy, *Bauhaus Dessau, Workshop Wing*, 1926.

Walter Gropius founded the Bauhaus in 1919 with state funding; his goal was to bring art, handicraft, and industry together. Characteristic of the Bauhaus was a new educational structure resting on preliminary training for all the students that encouraged free experimentation with color, form and material. Only after such a general introduction was complete were the students permitted to determine the course of their further education in one of the various "workshops." For a long time, photography was merely a marginal field at the Bauhaus, defined only by the activities of the Bauhaus artists themselves. But finally, with the appointment of W. Peterhans to the Bauhaus in 1929, photography became a regular part of the program. Johannes Itten, Georg Muche, and Paul Citroen had opened the door by introducing it as one of the pictorial media.

On this basis, László Moholy-Nagy developed photography into a creative medium. His name is often identified with Bauhaus photography, even though he never officially taught it at the Bauhaus. (As Johannes Ittens's successor, Moholy-Nagy was responsible for the entire preliminary program between 1923 and 1928.) The popular association of his name with photography is due to the universality of his approach: Moholy-Nagy

László Moholy-Nagy (1895–1946). Studied law until 1915; began to draw in 1917 and later turned to painting. Cofounder of constructivism, he met El Lissitzky in 1921; created his first photogram in 1922. Director of Bauhaus metal workshop from 1923, later in charge of the preliminary program at the Bauhaus in Dessau, and of the publishing of Bauhaus books. Although he considered himself a painter, he ranks among the great innovators of photography of the 1920s, and a pathbreaker within the Bauhaus. Published programmatic book *Painting, Photography, Film* in 1929, active in the Stuttgart exhibition *Film and Photo* (FIFO), where many of his photographic works were displayed. Moholy-Nagy immigrated via Amsterdam and London to Chicago in 1934 where he became active in the New Bauhaus, and, with other artists, founded their own School of Design after the closing of the Bauhaus in 1939.

held photography to be an important medium of design. Self-taught in photography, Moholy-Nagy was able to rely on the technical skill of his wife Lucia, a trained photographer, who also worked at the Bauhaus.

One cannot really speak of a unified and original photographic style at the Bauhaus because the approaches and formulations were far too multifarious; nonetheless, a certain pictorial language did evolve. The conscious use of dark and light, the reversal of positive and negative, the use of printing and textures, or unusual views came to represent this aesthetic. The Bauhaus student Werner Gräff lifted these transgressions of traditional photographic rules into an aesthetic that became the basis of the New Photography in his book *Here Comes the New Photographer* (*Es kommt der neue Fotograf*) in 1929.

László Moholy-Nagy, *Boats*, 1927.

The late dadaist montages of Marianne Brandt, as well as the surrealistic montages and photosculptures of Herbert Bayer and the constructivist montages of F. Vor-

demberge-Gildewart must all be considered in the context created by Moholy-Nagy. The comprehensive photographic work of (O. Umbehr) Umbo also drew its inspiration from the Weimar Bauhaus.

Systematic principles for photography were presented at the Bauhaus by Bayer in the areas of advertising and typography. Interest in photography, however, really only grew after Bayer and Moholy-Nagy had left the Bauhaus, and W. Peterhans stepped in as director of the photography department. Under Peterhans,

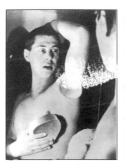

Herbert Bayer, *Self-Portrait*, 1932.

photographic pedagogy took a turn toward freer and more clearly applied design.

After the Bauhaus was dissolved by the Nazis in 1933, many of its students carried on their work using the formal language of the Bauhaus, of New Objectivity or constructivism. Among these artists, Lux and Andreas Feininger (the sons of Lionel Feininger), Josef Albers, Umbo, Gyula Pap, Irena Blühová, Xanti Schavinsky, and Anton Stankovsky went on to attain international recognition.

This hand camera for plates with a size of 1.8 x 2.4 in. created a sensation when it was introduced on the market in 1924. For its time, the Erminox's unbelievably fast 1:1.8 lens, designed by Berthele, offered a previously unimagined choice of photographic options.

1915 – 1933

The beginnings of modern photojournalism

Parallel to the continuing technical development of photography, there were many efforts to simplify ways of disseminating photographs to as broad an audience as possible. Experiments were constantly underway to find new means of reproducing photographs. But it was not until the end of the 19th century, when autotypy was developed, that mass reproduction became an economically practicable possibility. From this point onward, actual photographs, rather than mere etchings that were based on photographs, appeared with increasing frequency in the western press.

But the earliest results of mass reproduction remained nonetheless inadequate. Only in the 1920s did the process of photomechanical reproduction finally replace hand-worked illustrations. At last, photography could reach the masses. Many photographers began to work exclusively for the press, thus establishing photo-journalism.

The earliest printed photos in fact dated back to the 1880s. The first magazine opting to use reproduced pictures was probably the *Illustrated American* around 1890, and in 1896, *The New York Times* began issuing a fortnightly photo supplement. But the actual beginning of modern photojournalism can be traced to the founding of the *Berlin Illustrated* and the *Munich Illustrated* in the early 1920s.

The first small-format camera with a negative size still in use today (24 x 36 mm.), designed by O. Barnack. The first Leica Prototype of 1913 is the ancestor of a complete camera philosophy and was the quintessence of precision in its day.

At this point, not only had the requirements of technology and production been met, thus preparing the ground for the immediacy and the broad dissemination of photographs, but in addition, two further inventions made photo-journalism easier. With the 1924 appearance of the Ermanox, developed by the Ernemann

Works in Dresden, and the Lunar, developed by H. Meyer, there were now two small hand cameras offering the market what were until then unimaginable capabilities. Both cameras boasted not only extremely high-speed lenses but also previously unknown focal lengths. In addition, they were fitted with focal-plane shutters that brought exposure times down to 1/1,000 of a second. These plate cameras allowed snapshots to be taken in low-light conditions without a flash.

Both models were soon replaced by another, equally significant invention based on the work of Oskar Barnack—the Leica, short for Lei(tz) Ca(mera). Barnack, a design engineer in the optical firm of Ernst Leitz in Wetzlar, Germany, had completed two prototypes of the camera in 1913 before his work was interrupted by the First World War. Not until 1923 was a short run of 130 cameras produced, and in 1924, the Leica entered the market. In addition to easily ex-changeable lenses and flexible operation, the camera also used small-format rolled film. The phrase "Leica photography" became synony-mous with a certain kind of live photography.

In 1932, Zeiss introduced the Contax, which was similar to the Leica but with a built-in distance meter coupled with a focusing mechanism. Soon, fast f/1.5 lenses were available for both of these, as well as other small-format cameras. Some photographers prefered cameras with larger negative formats, for example the twin-lens Rollei-flex by Franke & Heidecke in 1929. A single-lens

1929 advertisement for the new Leica model by camera manufacturer Ernst Leitz in Wetzlar, Germany.

1915 – 1933

Erich Salomon (1886–1944). Photo by Lore Feininger. A member of a wealthy banking family in Berlin, Salomon was educated as a lawyer. He started photographing while working in the advertising department of the Berlin Ullstein Publishers. Salomon established a new style of pho-tojournalism with the small-format camera coupled with a high-speed lens. The photograph shows Salomon with his Erminox. Together with Felix H. Man, he had an important influence on Ger-man photojournalism. Salomon specialized in political, financial, and law reporting. In 1931 he published *Famous Contemporaries in Off-Guard Moments*. In 1933 he fled to Holland; in 1943 he and his family were sent to Auschwitz, where they were killed in 1944.

mirror reflex camera for larger negatives did not appear until the Swedish Hasselblad in 1948.

Erich Salomon, *"Ah, le voilà! Le roi des indiscrets!"* ("Aha, there he is! The king of the indiscrete!") 1931. French politicians with Foreign Minister Aristide Briand in the foreground, pointing to the photographer.

Originally equipped with an Ermanox and later with a Leica, Erich Salomon was one of the first pacesetters of photojournalism. Jurist and gentleman-photographer, he photographed important figures and events with a finely honed sensitivity for situations and an unerring reporter's instinct. From 1928, he worked for various large illustrated newpapers—his reports conveyed a slice of contemporary history and offered spectacular insights into the dramatic political events toward the end of the 1930s. Trusted by prominent statesmen, he was permitted to photograph during high-level negotiations and conferences. The legend that many a diplomat was heard to proclaim, "We can't begin—Dr. Salomon isn't here yet!" demonstrates the esteem in which the "father of photojournalism," (or the "king of the indiscreet," according to one French foreign minister) was held. Salomon was surrounded by the aura of the court chronicler, but in the 1930s, and in Germany's Weimar Republic, attitudes toward photographers and the press in general were other than they are today. The phrases "exposé" and "tabloid journalism" had not yet entered everyday vocabulary.

By late 1920, Germany boasted more illustrated magazines and newpapers than any other nation—probably around 5 million copies weekly with a readership of up to 20 million. This market became the foundation of "photojournalism." The *Berlin Illustrated Newpaper*, founded in 1890, played an important role in this development, as did the *Munich Illustrated Press*, founded in 1923, and the socially critical photography of the *Workers'*

Illustrated Newspaper, founded in 1921.

Felix H. Man's approach in his photo reports for English, German, and American illustrated papers was similar to Erich Salomon's, but Man kept the gestures and body language of his subjects more strongly in view than did Salomon. His most famous photo series, *A Day in the Life of Mussolini*, was an assignment for the *Munich Illustrated Press* in 1931.

Among the pioneers of photojournalism, besides Tim N. Gidal, is *Life* photographer Alfred Eisenstaedt, who earned the nickname "the eye of the century." His career began in Berlin with the newly founded illustrated papers and photo agencies. With his Leica, he took precise, unpretentious pictures of, for example, a League of Nations meeting in Geneva in 1933, the meeting between Hitler and Mussolini in Venice in 1934, and the Ballet of the Paris Opera in 1930.

Like the fate of surrealism and imagism under the Stalin regime, the significant first phase of European photojournalism came to an abrupt end with the takeover of the National Socialists in Germany. Many of the German photoreporters emigrated to England or the United States, where they contributed to the continued expansion of the medium; others, like Erich Salomon, perished under the Nazi rule.

André Kértész, *Window, Paris*, 1928.

1915 – 1933

Felix H. Man, *A Day in the Life of Mussolini*, photo reportage for the *Munich Illustrated Press*, 1931.

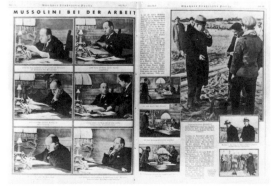

1933 Hitler becomes chan-
cellor of Germany;
Franklin D. Roosevelt
begins implement of
New Deal.

1935 Nuremburg Laws for
the prosecution of the
Jews in Germany.

1936-39 Spanish Civil
War.

1937 Pablo Picasso,
Guernica.

1938 Otto Hahn achieves
the first splitting of the
atom.

1939-45 World War II.

1940 Winston Churchill
becomes prime
minister of England;
Russian revolutionary
Leo Trotsky murdered
in Mexican exile.

1941 Japanese attack on
Pearl Harbor.

1944 Allied invasion of
Normandy.

1945 Atom bomb dropped
on Hiroshima;
founding of United
Nations.

1930 – 1945

Portraying life

By no later than the beginning of the 1930s, the harshest realities of life pushed their way once more into the camera's viewer. The worldwide economic crisis and its social and political ramifications prompted many photographers to take a more comprehensive look at their surroundings. An altered sense of life led to a change in photographic themes—more and more photographers began to focus in on the details of daily life.

From its inception, live photography was at the philosophical heart of the newly founded weekly magazine *LIFE*, which launched its first issue in 1936. Its claim, written in a prospectus two years before the new magazine premiered, "To see life—to see the world" could easily be the motto of live photography in general. Henry Luce, publisher of the established magazines *Time* and *Fortune* and now of *LIFE*, did not invent this approach to the world—similar attempts had repeatedly been made since the late 19th century—but what did distinguish Luce's endeavor was the fact that he organized his new publication around an incomparable team of first-class photographers who had already contributed in important ways to live photography in Europe and America. At the same time, in France and England, though with less weigh and effect, similar endeavors were launched by the leftist publisher Lucien Vogel with *Vu* and by the London-based Stefan Lorant with the *Picture Post* and the *Weekly Illustrated*.

Outside the arena of the great illustrated magazines, other photographers very quickly discovered the appeal of live photography in capturing life in its fullness and revealing its multifaceted richness. Thus, photography became a kind of visual diary for the flaneur—the idle well-to-do—as well as an uncorruptible eye for the

critical observer of politics and social life, and a reporter of contemporary events. In varying degrees, all of these aspects played a role in the photography of a number of photographers including Brassaï (born Gyula Halász), who came from the Siebenburgen area of Hungary and moved to Paris in 1924; the Frenchman Henri Cartier-Bresson; the Paris-based German emigrée Gisèle Freund; the Hungarian-born André Kértész; and the brothers Robert and C. Capa. For Brassaï, an ardent Francophile, everything French became the target of his photographic passion, especially the city of Paris. The balance of light and dark in his pictures, his self-made prints showing the outcome of his nightly patrols through the city, are neither studies of a milieu nor reportage of Parisian nightclub and red-light districts. They are, rather, poetic black-and-white pictures that condense the ordinary into the eternal. His 1933 book *Paris de nuit* generated as much interest as had his pictures from the previous year of the graffiti on Parisian walls and his portraits of famous writers and artists.

Henri Cartier-Bresson was a "flaneur" whose roving eye sought out "the decisive moment" that charmed him or stirred his sensibilities. He was

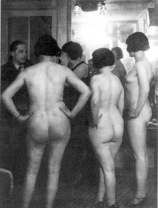

Brassaï, *In the Suzi*, Paris, 1932.

1930 – 1945

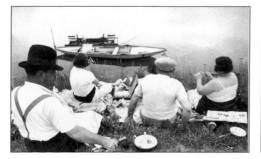

Henri Cartier-Bresson, *Sunday on the Banks of the Marne*, 1938.

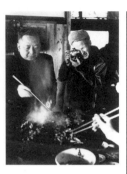

Henri Cartier-Bresson (b. 1908) began his career as a photographer in 1931. In 1935 he studied film technology with Paul Strand, and was camera assistant to Jean Renoir. As a volunteer in the Spanish Civil War, he made a documentary in Spain in 1936 and was returned to Germany in 1940 as a prisoner of war. With Robert Capa, he founded the photo agency Magnum in 1947. He published many books, including *The Decisive Moment*, and worked as a reporter for most of the world's large newspapers; by the 1950s and 1960s he had become a living legend. Eventually, he gave up photography to devote himself to painting.

1930 – 1945

also a curious observer of the lives of people all over the world—the sensational events of history meant little to him. His interest was always in the everyday, the small details of life and the moments on the edge of life. For Cartier-Bresson, everything was worthy of being photographed. To catch these characteristic moments, he always set out without a concrete plan, but armed with the attention of an observer who wants to capture with his Leica exactly that fragment of life that most people would never otherwise see. What distinguished Cartier-Bresson from many other live photographers was his ability to visualize the beauty of ordinary moments.

In contrast, Robert Capa grasped reality in an entirely different manner. Born André Friedmann in Hungary, Capa emigrated to Berlin and finally to Paris, where he worked with D. Seymour, Cartier-Bresson, Kertész, and Freund. Capa never had a settled home; he was, rather, the quintessestial adventurer of the first half of the 20th century. His work for *LIFE*, *Time*, *Picture Post*, and *Vu* sent him all over the world. At 19, he photographed Leon Trotsky, and later the horrors of the Spanish Civil War; he and his camera bore witness to the rise of fascism, the Second World War, and the revenge of the victors at its end. His photograph of a Spanish Republican soldier at the moment he was hit by

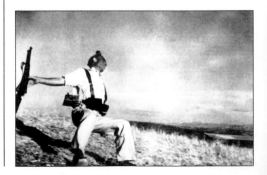

Robert Capa, *Death of a Militiaman*, Spain, 1936.

a bullet secured Capa's reputation as a politically engaged photographer. He went on to photograph conflicts in Israel and Vietnam (then known as Indochina), where he was killed.

Among the circle of those who lived in exile in Paris—some for a long time, some for less—were J. Breitenbach, F. Henle and the 1934 refugee from the Nazis, Gisèle Freund. To her fellow German exile, writer Walter Benjamin, Freund was that "little talkative person" who had published her Sorbonne dissertation on *Photography and Bourgeois Society* in 1936. Despite Benjamin's opinion, Freund's work has become one of the standard works of photographic history. From 1934, she systematically reported for *Vu*, and later for *Time*, *Paris Match*, and *Picture Post*. In 1935 she photographed the unemployed in the depressed areas of northern England and the congress of Writers Against Fascism; in 1950 she photographed the "Angel of the Poor," Evita Peron. Her major work consisted of her live photographs that characteristically reached beyond the moment itself and her portraits of artists and writers. Freund intended to create a noncommercial collection of portraits of the intellectual elite of France, similar to the "Panthéon Nadar," and used the new 35 mm. film which had just become available on the French market. She was an enthusiastic color portraitist, and her portraits of Walter Benjamin, James Joyce, Frida Kahlo, and Virginia Woolf have an intimate yet uniquely withdrawn effect as a result of the coloring peculiar to early color film.

The work of the English photographer Bill Brandt bears a hint of the surrealistic from his days as an assistant to Man Ray in Paris. Between 1931 and 1935, Brandt concentrated on the social life of the English, but among his most powerful photographs are his pictures of the

Robert Capa (1913–54). Photo by Henri Cartier-Bresson. Born André Friedmann in Hungary, Capa studied and worked as a photo assistant in Berlin but fled in 1939 from the Nazis to Paris, where he took the name Robert Capa. He began his career as a photo-reporter in the Spanish Civil War and was later active in all the important war zones of the world. Capa was killed by a land mine in Vietnam during the Indo-Chinese War.

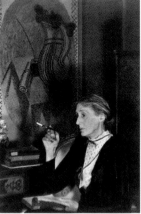

Gisèle Freund, *Virginia Woolf*, London, 1939.

1930 – 1945

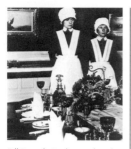

Bill Brandt, *Parlormaid and Under-Parlormaid Ready to Serve Dinner*, ca. 1933.

"I could not save my people, but the memory of them. ... The whole world watched—even those under the safety of other nations, including the Jews living in the U.S.—and did nothing to put an end to the massacre."

Roman Vischniac

1930 – 1945

empty London streets and the air-raid shelters during the Second World War. From the 1940s, Brandt's reputation grew as a portraitist of artists and writers; at the same time, he discovered nude photography, which, after the war, he pursued with a fresh eye.

"My work was a search for truth and eternity," claimed Roman Vischniac. Having once escaped from the Nazi genocide of the east European Jews, he undertook extremely dangerous journeys to Poland, the Baltic countries, Russia, and Hungary to portray the Jewish world of the shtetls—the people murdered, a civilization destroyed—a human world vanquished. Vischniac, who immigrated to the United States in the 1940s, was able to save 2,000 of the photographs he took between 1936 and 1939; the rest were confiscated, and he himself was accused of espionage.

American life

The early live photos made it clear that the ability to capture a slice of life is an essential aspect of photographic work. For the American photographers of the 1930s, their task became one of distilling the interesting moments from the general dynamics of life; this was, after all, a task specifically suited to the medium of photography.

The development of powerful but portable lighting systems allowed photographers much greater freedom to select and shape their own lighting effects, to respond flexibly to various situations, and to catch even the fastest movements in poorly lit conditions. Paul Vierkötter's 1925 development of a new and practical flash lighting system readied the ground for J. Ostermeier's 1929 invention of an aluminum-filled flash bulb. This silent, smokeless flash allowed photographers to take pictures everywhere, with only a battery, flashbulb and reflector. Live

photographers everywhere immediately adopted it.

By these means, the New York newspaper photographer Weegee (Arthur Fellig) was able to take photos of a previously unattainable directness that actually proved shocking. Calling himself "Weegee the Famous," he created a style of live photography that can be reasonably considered the forerunner of the photo tabloids. Weegee proudly claimed he had photographed more than 5,000 crimes in New York between 1935 and 1945. In truth, no one had portrayed and criticized violence in the city more often or more ruthlessly than he did. Fed by the vitality of Weegee's tabloid genius and success, a distinctly American genre of live photography emerged—the rainbow, or gutter, press. From the middle of the 1930s, Edward Weston as well as Paul Strand also extended their rigorous approach to focus on daily American life.

Taking his cue from straight photography, Manuel Alvarez Bravo photographed life in his native Mexico, and his pictures were often compared with the poetic Mexican symbolism of Malcolm Lowry's *Under the Volcano*. Over the years, since he started to take photographs in 1923, Bravo's pictures tended to portray the ordinary as a surrealistically pulsating reality filled with mysterious constellations.

The multifarious work of Walker Evans illustrates the rich comprehensiveness of the term "live photography." Evans's photography included social documentary as well as reporter-

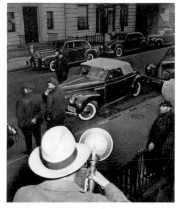

Weegee, *Harry Maxwell, Shot in an Auto*, New York, 1936.

The work of Manuel Alvarez Bravo is "a soft rain that gradually soaks into our nerves so deeply that it gets into our marrow."

Diego Rivera, 1945

1930 – 1945

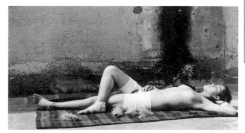

Manuel Alvarez Bravo, *She Rests on her Fame*, 1938/39.

Walker Evans (1903–75). Photo: H. Levitt. Evans discovered his interest in photography at the end of the 1920s. Even his early photographs are marked by an analytic view with great precision of detail. This way of seeing made him one of the most famous documentary photographers of the 1930s and 1940s. He was recruited in 1935 to join the team of the Farm Security Administration (FSA) photographers. In 1940, he worked with a hidden camera in New York, chiefly on his *Subway Portraits*, and as a picture editor for *Fortune*. His photographic style had a strong influence on American photography.

1930 – 1945

like snapshots. In his cool look at the signs and symbols of the American way of life—as opposed to his portraits—Evans employed entirely different photographic methods, but his pictures share an unparalleled attraction. His position toward the American "reality" was removed but not impartial. He reveals, but rarely comments, and developed a style of live photography that, by uniting exactness with a nonsubjective vision, used images themselves as language.

Like Gisèle Freund, Lotte Jacobi represented the sort of educated photographer who saw herself chiefly as a chronicler of intellectual and artistic life. Her Berlin portraits of the early 1930s are legendary. After her 1935 immigration to the United States, as she, too, fled the Nazi regime, she sought to re-create in her new home the same intellectual climate she left in Berlin. In this sense, Albert Einstein served for her as a connection between the two worlds, and she is chiefly known for her portraits of the famous physicist.

The photography of high fashion

Between the two world wars, haute couture enjoyed a heyday that accompanied the popularity of the fashion magazine. Now, however, it

was not enough for magazines merely to show the clothing; the fashion magazine itself had to become the voice of a certain class of society. Eccentric, elegant, the quintessential aesthete—in short, the Lord Byron of

Lotte Jacobi, *Albert Einstein*, 1938.

photography—the British photographer Cecil Beaton earned a place in high British society with his photographs. At once author, stage and costume designer, painter and friend of artists, Beaton posed and directed his models. His eye sought the total aesthetic impression of the picture. He also established kitsch—something so tacky as to be appealing—as a stylistic tool, at first in moderation in his fashion photography, but later in his wholesale photographs of the British royal family.

When the German-born Horst P. Horst became an American citizen in 1943, he was already famous as an illusionist—a master of slick elegance, dramatic lighting, and the perfect pose. Introduced to fashion photography by Hoyningen-Huene, Horst P. Horst always arranged his pictures according to a classical pattern. His photographs reflect a cool austerity that nonetheless reveals the artist's personal style in the combination of masterful composition and a staged beauty containing hints of both luxury and eroticism.

Also linked with the aesthetes of the first generation who had turned fashion photography into an artistically provocative drama was Erwin Blumenfeld, whose photographic language derived from both dadaism and surrealism. His express aesthetic intention was "to distill the unreal out of the real," and in the 1940s he was the highest-paid fashion photographer in America, filling more than 100 title pages of *Vogue* alone. Well into the postwar years, Blumenfeld remained one of the most influential photographers of that new phenomenon of the mass society—the glossy illustrated magazines and fashion journals.

Technical advances

From the beginning, both Kodak and Agfa—the two firms at the center of technical photographic

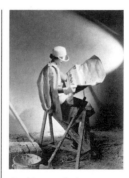

Cecil Beaton, *Fashion*, ca. 1935.

1930 – 1945

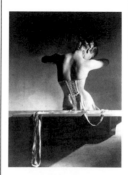

Horst P. Horst, *Mainboucher Corset*, Paris, 1939.

Erwin Blumenfeld, *Projection of a Line on a Face*, 1945.

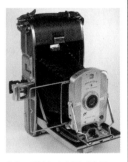

Polaroid Model 95, 1948. Edwin Land's three-year-old daughter Jennifer triggered the invention of the camera when she asked, "Daddy, why can't we look at the pictures right now?" Land's Polaroid process is based on the method developed by A. Rott and E. Weyde for office copiers—unexposed and undeveloped silver salts are diffused from the negative onto the positive.

1930 – 1945

progress—were determined to create a color process suited to mass use. This goal, however, did not really come within their grasp until the early 1930s when the two film giants came up with a new, multi-layered film based on chromogen development for color positives, the "Kodachrome" and "Agfacolor-New." The films contained three emulsion layers, fit every camera, and required only a single exposure per picture. The chromogenic process of color development invented in 1912 by Rudolf Fischer relied on the use of "color couplers." The new films captured the three primary colors simultaneously as latent images. The absence of a negative, however, meant that only a single print could be produced of any given shot. The negative-positive process did not come into common use until 1941, with the introduction of Kodacolor film. This color film technology, with improvements in light sensitivity and color quality, is still used today.

Because the photographic industry of the time was immediately able to produce large quantities of the new films for the market, color photography spread quickly. Enthusiasm for colored pictures knew no bounds, and color photography quickly emerged as a domain for amateurs.

During the same years, there was another revolution in photographic technology: the invention of self-developing film. In 1943, the American Edwin H. Land hit upon the "simple" idea of moving the darkroom into the film itself. The black-and-white Polaroid film which Land invented and then introduced to the market in 1948 contained a negative material, a positive printing paper, and a developer which was carried in what was originally a rather thick sack between the two film layers. When the exposed picture was drawn out of the camera, the sack

was pressed between two rollers, the chemicals were squeezed out, and the picture was developed. A positive image was formed through a so-called diffusion transfer. Land, who garnered more than 500 patents for a wide variety of processes and inventions and founded the Polaroid Corporation in his garage in Cambridge, Massachusetts, introduced instant color photos in 1963 but failed in his attempts to apply his principle to moving pictures.

Attempts to record the phenomena of movement and speed, which had fascinated photographers since the experiments of Eadweard Muybridge in the previous century, were raised to a new level by the development of the gas discharge tube by Harold Edgerton at the Massachusetts Institute of Technology in 1939. Originally stimulated by his interest in engineering, Edgerton put the tube to use in exploring fast-moving machine parts.

This so-called strobo-photography is a process for recording movement by breaking it down into phases. Flashing strobe lights synchronized with cameras in a darkened room allowed Edgerton to make several exposures per second, for the first time allowing even the fastest movement to become visible. Among the milestones of high-speed photography are Edgerton's pictures of the movement of objects traveling at several times the speed of sound.

Social documentary

In 1929, "Black Friday" on Wall Street set loose an economic and social crisis of theretofore unknown dimensions. The entire world was hit by what would be forever known as the Great

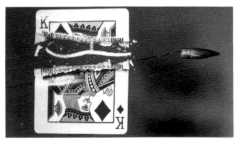

Harold Edgerton, *King of Hearts and a Bullet*, undated. The high-speed photography practiced by Edgerton since the 1930s allowed exposure times as short as one-millionth of a second. The movement captured—here, the just-fired bullet—has an almost surreal effect in his pictures. Even though it is moving at three times the speed of sound, the bullet seems to be hovering in the air.

1930 – 1945

Berenice Abbott, *Corn Seller*, Manhattan, 1938.

Depression, but the joblessness, hopelessness, and misery were especially great in Europe and the United States.

Within so-called live photography were working photographers who regarded the photograph as a social document and kept their eyes trained on the face of the Depression. Margaret Bourke-White had a fine reputation in the 1930s as an industrial photographer for magazines like *LIFE* and *Fortune*. Although she was to a certain extent one of the first female media stars, she developed a sharp eye for social contrasts and explosive themes. Together with author Erskine Caldwell, Bourke-White produced a comprehensive photographic study of the South in 1937. Her documentation of the Louisville flood was just as striking as her later photographs of the Nazi concentration camps, the ruins of German cities, and the empty faces of their inhabitants.

Margaret Bourke-White, *After the Louisville Flood*, 1937.

The American Berenice Abbott had learned the pictorial vocabulary of photojournalism in Europe. Until 1929, she maintained her own studio in Paris where she took portraits of many artists and writers. After returning home, she took up the self-appointed task of interpreting the city of New York by capturing its essence and its people in photographs. Abbott was particularly interested in architectonic alterations, in new construction and demolition, skyscrapers and slums. Her New York pictures reveal a special feeling for the ambiguity of so-called progress. A selection of her work appeared in her 1939 book *Changing New York*.

1930 – 1945

The rise of fascism in Europe also forced the Austrian Lisette Model to emigrate to the United States. When Model arrived in New York in 1938, her direct expressionistic style attracted a good deal of attention. Expressionism, which was quite opposed to American social-documentary tendencies, was found fascinating, and Model soon found work as a photographer for the glossy *Harper's Bazaar*, where she specialized in controversial and, for *Harper's*, atypical scenes. She photographed delinquent youths, did a series on the washed-up souls of the Lower East Side, and reported on the conditions of the immigrants on Coney Island.

Lisette Model, *Bather, Coney Island*, 1941.

War pictures

With the rise of fascism and the outbreak of the Second World War, photography became an instrument for information and documentation, with the large newspapers and illustrated magazines playing a considerable role. The photographic image was increasingly used as a kind of universal language requiring no further explanation: a picture was, indeed, worth a thousand words. Photography enabled the exchange of authentic—but also selective—information on the course of the war.

Interest in war reporting grew stronger as more and more people were directly confronted with the war or were affected by war activity. On the one hand, war photographers provided visual information to people who were not directly involved, but whose family members might be on the front. On the other hand, war photography naturally served the propaganda interests of the political powers.

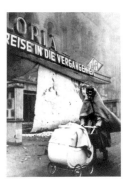

1930 – 1945

Wolf Strache, *Berlin, Kurfürstendamm after an Air Raid*, 1942.

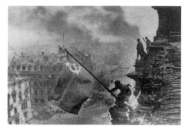

Yevgeny Khaldey, *Berlin, May 2, 1945*. A Soviet soldier raises the flag of victory on the German Reichstag.

"One's first encounter with the photographic inventory of ultimate horror is a kind of revelation: a negative epiphany. For me, it was photographs of Bergen-Belsen and Dachau which I came across by chance in a bookstore in Santa Monica in July 1945. Nothing I have seen—in photographs or in real life— ever cut me as sharply, deeply, instantaneously."

Susan Sontag,
On Photography

Depending on political and ideological positions, very different styles of war photography emerged. The Axis powers were chiefly interested in celebrating their early victories with heroic photographs and in banishing all the horrors of war from the war pictures. Those responsible for photoreporting for the Allies, on the other hand, had little call for beautifying or glorifying the war. The most dramatic and eloquent pictures were thus often provided by the American and British magazine photographers, or under their influence.

There was also a respectable body of Russian photojournalists including Yevgeny Khaldey, who photographed the war from the first day of Hitler's attack on the Soviet Union until the end, when the conquered flags and field symbols of the German troops were paraded across Red Square in Moscow and thrown into a big heap. After the end of the war, he went on to photograph the Potsdam Conference, with Truman, Stalin, and Churchill, and the Nuremburg trials.

LIFE magazine mobilized a complete armada of army photographers and, especially after the United States entered the war, sent many reporters to the various battlefields. Perhaps most memorable of all are Robert Capa's pictures of the invasion of Normandy. Capa, the archetypal war photographer, landed along with the American paratroopers and marched with the army into Germany.

Capa was a front-line photographer with a soldier's frame of mind. He photographed the battle of Leipzig as well as the triumphal procession of Charles de Gaulle into liberated Paris. However, Capa revealed the war not only through battles and the faces of the soldiers, but

1930 – 1945

also, since the days of the Spanish
Civil War and later in Vietnam
(during the French conflicts in that
area, before the later American
involvement), in the countenances
of the suffering civilian population.

During the war, Edward Steichen
served as a director of the photo-
graphic department of the U.S.
Navy, Margaret Bourke-White photographed
the terrible results of Nazi domination in Italy,
Russia, and finally Germany itself, and W.
Eugene Smith shot photographs of the Pacific
theater, where he was seriously wounded. The
English Bill Brandt documented the streets of
London during the German air raids as well as
the people who waited out the *blitz* in air-raid
shelters. The British fashion photographer Cecil
Beaton took remarkable hospital pictures of the
victims of the air raids. Other important English
war photographers included George Rodger,
Bert Hardy, and Humphrey Spender

Erstwhile glamour girl Lee Miller, who
resumed her career as a photographer in
1939, became one of the period's most
outstanding war reporters. Lee Miller neither
stylized not beautified. After she became an
accredited photo reporter for the
U.S. Army, she followed the
troops to the front, reported on
bombings, on the wounded in
field hospitals, on the liberation
of Paris, and on the capitulation
of Germany. In 1945, Miller
was among the first of the
photographers to enter the
concentration camp at Dachau.
The simple title of her report
on the unfathomable was
"Believe it."

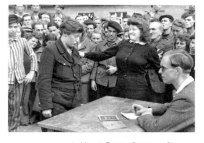

Henri Cartier-Bresson, *Prison
Camp, Dessau, Germany,*
1945.

Lee Miller, *Concentration
Camp Buchenwald,* 1945.

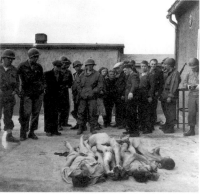

1930 – 1945

125

The term "social documentary," used to describe a particular style of photography especially before the Second World War, is perhaps most usefully applied to the work of the Farm Security Administration photographers. When Franklin D. Roosevelt was elected president in 1932 and confronted with the serious long-term effects of the Depression, he established a network of government agencies to deal with the worst of the crisis. One of these organizations was the FSA, which subsidized the prices of agricultural products and assisted farmers with seed, fodder and equipment, or

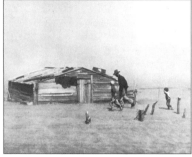

Arthur Rothstein, *Sand Storm*, Cimarron County, Oklahoma, 1936.

supported their relocation. The director of the FSA, Undersecretary of Agriculture Rexford G. Tugwell, set up a Historical Section within the FSA to document the living conditions in America's agricultural regions. Tugwell commissioned the chief of the section, Roy E. Stryker, to do a large-scale photodocumentary. Stryker, who was not a photographer himself, gathered a group of first-class photographers including Walker Evans, Dorothea Lange, Ben Shahn, Arthur Rothstein, Russell Lee, Carl Mydans, and Marion Post Wolcott, who together generated an archive of rural America during the Depression. They produced an estimated 75,000 actual prints from a pool of 130,000 to 270,000 shots.

Walker Evans was one of the first recruited in the project. He described his work—his precisely calculated pictures of Southern landscapes, buildings, and people— as a "documentary in style." He neither glorified nor idealized his subjects. Evans's dual concentration on form and people lends conviction to the pictures. In 1936, he collaborated with the author James

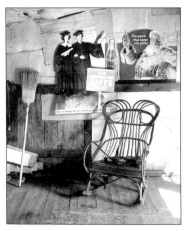

Walker Evans, *Miner's Living Room*, West Virginia, 1935.

Agee, also employed by the FSA, on what became a famous narrative-cum-photodocumentary of the people of Appalachia, *Let Us Now Praise Famous Men*.

In contrast to the approach of Walker Evans, with his emphasis on visual illumination and rejection of photographic ideology, Dorothea Lange's photographs of the countenance of poverty were generally much more emotional. For this reason, her photographs tended to be better suited to the propagandistic aims of the entire FSA project. Lange's photographs, chiefly shot in Arizona and California, deliberately suggested moral conclusions. Her pictures of migrant workers, with their ramshackle vehicles, their miserable housing, and their backbreaking labor, became a moving commentary on the plight of the rural farm worker.

Unlike Lange and Evans, painter Ben Shahn tried to capture his subjects unnoticed with a small-format camera whose viewfinder was set at a 90-degree angle. In this way, Shahn took many unposed portraits, snapshot-like in effect. His pictures are reminiscent of Cartier-Bresson, whose work he knew and admired.

The masterly photos produced by the FSA after 1935 form a unique presentation of the social misery of the time. The results of the photographers' work, today in the archives of the Library of Congress, bear witness to an amazing sense of unity, though they are at the same time distinctly individual. The

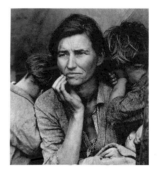

Dorothea Lange, *Migrant Mother, Nipomo, California*, 1936.

photographers offered their subjective results as a piece of a social panorama that in turn formed a solid basis for political, economic, and moral reform in American thinking. In 1942, with the FSA's funding reallocated to the Office of War Information, the work of the FSA came to an end.

"My own approach is based upon three considerations: First—Hands off! Whatever I photograph, I do not molest or tamper with or arrange. Second—a sense of place. Whatever I photograph, I try to picture as part of its surroundings, as having roots. Third—a sense of time. Whatever I photograph, I try to show as having its position in the past or in the present."

Dorothea Lange

1945 Atom bombs dropped on Hiroshima and Nagasaki.
1946 Nuremburg Trials.
1948 Assassination of Mahatma Gandhi.
1949 Signing of North Atlantic Pact from which NATO emerges; Mao Tse Tung proclaims Peoples Republic of China.
1950 Start of Korean War.
1951 First color television in the United States.
1952 Ernest Hemingway, *The Old Man and the Sea.*
1952 Death of Stalin; Khrushchev becomes head of Soviet Communist Party, initiates de-Stalinization at 20th Party Congress in 1956.
1954 Federico Fellini, *La Strada.*
1956 Soviet troops suppress revolt in Hungary.
1957 Treaty of Rome establishes the European Economic Community.
1961 Erection of Berlin Wall; first manned space flight by Russian cosmonaut Yurii Gagarin.
1962 Cuban Missile Crisis.
1963 Assassination of President John F. Kennedy.
1966–69 Cultural revolution in China.
1968 Martin Luther King, Jr., assassinated in Memphis, Tennessee; Richard Nixon elected president.
1969 Woodstock pop festival; Neil Armstrong and Buzz Aldrin walk on the moon.

1945 – 1970

Human interest

At the end of the Second World War, Europe was in a catastrophic state. Cities had been destroyed and millions of people "displaced"—a gentle way of saying left homeless, either by destruction of their homes or by deportation. Throughout Europe, material need was almost overwhelming, the political future was uncertain, and awareness of the extent of the Nazi terror was relentlessly dawning. All this oppressed the populations of Europe with a leaden weight of hopelessness.

However, with surprising speed, the immediate postwar years also gave rise to growing interest in the cultures, lifestyles, and characters of other peoples. This openness toward human exchange and communication was reflected in photography, where a broad field designated as "Human Interest" arose, no doubt spurred on by the large newspapers and illustrated magazines. With the introduction of the rotogravure press in the 1950s, the popular media experienced an unprecedented boom which naturally advanced the spread and popularity of photography and generated increased demand for photos. In the face of the many directions that were available to photography at that historical moment, it became incumbent on photography as a medium to define its direction clearly, and the choice fell to live photography.

Although there were in fact few changes in the actual working methods of creative photographers, their approach to the subject changed radically. Moreover, thematic fields of specialization were beginning to be defined among the growing pool of photojournalists. The photographers of the Magnum agency, in particular, changed the face of journalistic live photography. For these photographers, it was not the sensational effect that should dominate a photograph for a news story or human-interest report,

but personal intention embodied in pictorial thought; this intention was to lead the reader into a psychological-philosophical, and at the same time, humanistic dimension.

This guiding principle was adopted by many photographers outside the Magnum agency, as well. Thus the French photographer Robert Doisneau photographed the environs of Paris with both sympathy and wit. His pictures hardly required commentary. As a "street photographer," he was the equal of Brassaï, W. Ronis, and Izis, and his many photographs documented the life of Paris in a style at once humorous and melancholy. Some of his shots, such as *The Kiss in Front of City Hall*, became icons of French life. Doisneau in fact became the eye of daily life. His foray into the world of fashion in 1949 ended after only a few years in 1952 when he returned to his preferred milieu.

Robert Doisneau, *Hell's Gate, Boulevard de Clichy, Paris*, 1952.

Life on the streets and in the plazas, in the bistros and bars of the outskirts of the city and the provinces, as well as in other lands, also inspired photographers such as E. Boubat, S. Weiss, M. Riboud, and J.-P. Charbonnier.

Many of the remarkable photographs of the time were created thanks to magazine commissions. As a *LIFE* photographer, W. Eugene Smith

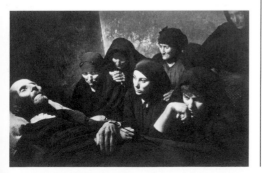

W. Eugene Smith, *Death Watch*, from the series *Spanish Village*, 1951.

1945 – 1970

Alfred Eisenstaedt, *V-Day*, 1945. This snapshot, one of Eisenstaedt's most famous pictures, was taken during the victory celebration in Times Square after the end of the Second World War.

was a passionate reporter and moralist. He demanded from himself absolute engagement in his subject. One of his projects was a photographic essay on the life of a Spanish village and, although the pictures are of a single village and its residents, they are typical of the humanistic approach of live photography and exemplify its universal appeal. The same approach was to be found in Smith's photo essays on a country doctor or on the terrible effects of an environmental catastrophe on the people in a Japanese fishing village.

After the end of the war, Alfred Eisenstaedt not only photographed portraits of famous personalities but also turned his camera on people in everyday situations. In so doing, he became a pioneer of available-light photography, after having earlier decided that he would work without flash bulbs. Another *LIFE* photographer, Margaret Bourke-White, traveled to India in 1946 to record the fight for independence, and later to South Africa to capture the conditions of the mine workers on film.

Gordon Parks, who had worked for the FSA in its later years, also made a name for himself at *LIFE*, where he worked for a quarter of a century. His ascent to the position of the leading photoreporter of his time was fast and steep, but his real interest was to document Black America, and he put his camera to work in the interests of black American fellow-citizens. Photos such as *American Gothic* and *Harlem* became icons of engaged journalism.

The work of two quite different photographers—American David Douglas Duncan and

Englishman Bert Hardy—on the theme of the Korean War reveals two wholly different perspectives. The American Duncan concentrated on penetrating closeups of the troops, but Hardy reported on the Korean civilians for the *Picture Post*.

Both Vietnam (then Indochina) and Korea were important stations for the Swiss photographer Werner Bischof in his work for the *Paris-Match*. Bischof's primary interest—which was not always shared by his employers at *LIFE* or the *Observer*—was people, their individual fates, and the glimmer of hope in the face of devastation. Although Bischof

Hiroshi Hamaya, *Children on the Way to a New Year's Celebration*, 1956.

photographed the Indochinese War, he was not a typical war photographer; he invariably shot from the perspective of the victims, never the victors. His famous 1954 picture of a native Peruvian boy playing a flute is an icon of photojournalism; it became a kind of legacy when Bischof was killed in an accident en route to an expedition in the Andes a few weeks later.

From the middle of the 1950s, Bischof's fellow Swiss photographer, René Burri, also worked mostly for international magazines. His themes ran the gamut from political reports, to landscape and architecture pictures, to portraits. Burri achieved recognition with his series on the Cuban revolutionary Che Guevara in 1963, and his 1962 volume of photographs, *The Germans*.

Many photographs from the 1950s and 1960s became so popular that the identity of the photographers was forgotten—the pictures simply entered the iconography of the time. Among these are surely the photographs of the Viennese E. Lessing and the reports of the *Stern* photographer T. Höpker on the work of doctor

Werner Bischof, *Flute-Playing Boy near Cuzco*, 1954.

1945 – 1970

T. Binder and his hospital for the Peruvian Indians or on the training of United States Marine "Leathernecks." Among the classics of the genre is also the work of R. Lebeck and H. Pabel, who remains somewhat controversial in the history of photography because of his work during the Third Reich.

Robert Lebeck, *The Stolen Sabre*, Leopoldville, 1960. On the last day of his rule over the Belgian Congo, the Belgian king Baudouin was riding in an open car with the new president Kasavubu through the city. A man tore the sword, the symbol of royal power, from the king—a symbolic picture for the new beginning of the African continent.

In 1955, the Museum of Modern Art in New York mounted an exhibition that must certainly be considered a landmark of photography in the 20th century. Organized by Edward Steichen, *The Family of Man* toured forty-four large American and European cities, becoming possibly the most successful exhibition in history and breaking all visitor records of the time. The book that accompanied the exhibit is still in print, and still sells well.

The great success of *The Family of Man* also marked the final acceptance of photography as an independent pictorial medium. The photographs culled from the immense range of live photography were meant to show the universal role of photography and convey the humanistic ideal of a great, peace-loving world community. According to its creators' intentions, *The Family of Man* was supposed to give new energy to the postwar hopes for a more humane world. The subtext behind the photographs was clearly a utopian vision of the American way of life.

Realism and subjectivism

The 1950s brought another change in American photography. Although almost 30 years had

1945 – 1970

passed, something akin to the Photo-Secession of the 1920s was started by photographers who wanted to emphasize and cultivate the uniqueness of this medium as a branch of art. Even at the end of the 1920s, the marks of differentiation and the split between "lower" and "higher" photography had diminished until, at the beginning of the 1950s, the differences were negligible. Moreover, many American photographers were intent on using photography as a tool in their search for "truths." But now, the numbers of photographers who preferred a move toward abstract pictorial ideas began to grow, in reaction to the established mode of looking at reality. Thus, it behooved photographers to seek new possibilites, to move away from pure illustration and toward the pictorial creation of ideas. This new concept exerted considerable influence on American photography in the ensuing years, and its influence on photography extended beyond the borders of the United States.

From this background emerged two fundamentally different paths: the approach of the experimental photographers and that of the photographers with expressly subjective contents and pronouncements who used excerpts from reality to visually convey their private meditations.

Harry Callahan, *Weed against Sky*, 1948.

Margaret Bourke-White, *Mahatma Gandhi*, 1946.

1945 – 1970

133

Minor White, *Male Nude*, 1948.

1945 – 1970

"The material of mythology and the substance of the earthly atmosphere are beyond comprehension. The wonder that pictures conjure up—like that of the unicorn—may also be found in those places that we call reality."

Paul Caponigro

The clear and austere pictures by Detroit-based photographer Harry Callahan are of peculiar beauty and testify to the precision of his vision. His focus is turned outward to the world, but his images are of a personal meditation in which a simple image of a blade of grass or a tree branch may convey an entire world of thought. Equally striking are his female nudes.

Minor White, whose stylistic rigor resembles that of Callahan, was one of the most important American photographers of this period. Known particularly for his severe landscapes, and strongly influenced by the theories of Stieglitz, White attempted to use the medium of photography according to his equation "photography + observer = picture in the imagination" to give expression and visible form to the supersensual.

In this, Minor White resembled Ansel Adams, whose outstanding landscapes grew out of a similar purpose. White's goal was to create photographs whose reference transcended their own objects. The external reality was necessary, but its role as itself was subordinate to its role as the conveyor of ideas. While White photographed landscapes in order to develop his skill working with the accidental or serendipitous in life, he also worked in the realm of nude photography.

Paul Caponigro, *Stonehenge*, 1967.

Paul Caponigro, who was strongly influenced by Minor White in the early years of his photographic career, almost exclusively photographed landscapes. His impressively effective pictures of the megalithic monuments of northern European pre-Christian culture (the most famous of which is Stonehenge) suggest something of the spiritual meaning of the monuments—a meaning certainly not alien to the photographer.

Masters of the street

There also were a number of photographers emerging from disparate backgrounds and styles who never set out to become masters and yet became such in spite of themselves. In the second half of the 1950s, for many photographers the vision of prosperous postwar America had begun to crumble, but their reactions to the fading of the American dream took strikingly different forms. Common to all, however, was their challenge of the documentary character of photography.

Bruce Davidson, *Young Couple*, 1959.

Now more than ever, photographers began to work with greater awareness of the growth and spread of American cities with all the shadows and alarming events of urbanization. They reported on the social developments of these years, each with his or her own unique voice. The subject was the streets of America. Irreconcilable with the more common ideals and images of the time were D. Weiner's pictures of suburbia and Bruce Davidson's photographs of ghostly-looking teenagers.

The peak of this period, and the keystone for the decades to come, was Robert Frank's book

1945 – 1970

135

"People have often accused me of intentionally distorting the nature of my subject in order to make it conform with my own point of view. First of all I know that the photographer cannot look at life with an indifferent eye. Every view contains a portion of criticism. But the criticism can also be made with love. It is important to see what remains hidden to others, whether it is a shimmer of hope or whether it is sorrow."

Robert Frank

The Americans, first published in France as *Les Américains* in 1958 and in the United States the following year. Born in Switzerland, Frank emigrated to the United States in 1947, bringing with him the immigrant's sure sense for pictures, a critical eye for money and arrogance, and a sensitivity for political campaigns. In the post-war culture of prosperity and conspicuous consumption, Frank saw a temporary egalitarian alliance of social classes that were not intrinsically equal.

All across the United States, he took photographs that showed hope, indifference, innocence, and evil. That such pictures fundamentally conflicted with the United States' popular self-image (if any such thing can be said to exist) explains the violent reaction to *The Americans*, which contained a foreword by Jack Kerouac. Not only was Frank's book accused of "distorted objectivity," it was also excoriated on formal, stylistic, and technical grounds: Frank's pictures lacked sharpness and balanced composition; they rather tended toward the opposite extreme—everything remained open and unfinished. The book, however, served as a signpost, not only becoming a classic but also inspiring an entire generation of American photographers. At the same time, Frank's *The Americans* marked the starting point of a movement that increasingly placed more emphasis on

1945 – 1970

Lee Friedlander, *Galax, Virginia*, 1962.

136

the personal work of the photographer.

The legacy of Walker Evans, carried on in the work of Robert Frank, was now picked up by other photographers who attempted to wrest different convincing symbols from what they found all around them. The expression of this transformed openness and authenticity was the sacrifice of exact description of photographed objects in favor of the blurriness and graininess of pictures taken in passing, or, alternatively, a seemingly merciless capturing of the photographed object.

Garry Winogrand began his photographic studies in 1964 in the tradition of Frank and Evans. The irritatingly banal photos of this classicist of recent photographic history, whose work also challenges the distinction between documentary and creative photography, were often shot with a tilted or slanted camera. Winogrand sought to see how the world appeared when it was photographed: "I photograph to find out what something will look like photographed." This approach, which rejected the notion of the photographer's initial visualization of his or her subject, linked him with another American photographer, Lee Friedlander, whose work is replete with portraits of an anesthetized society, lacking bearings and backbone, wandering without a clear goal in search of security for its own existence. Friedlander's strange, silent cityscapes of an apparently forsaken land form an interesting

Robert Frank (b. 1934) Photo: L. Faurer. Born in Switzerland, Frank emigrated to the United States in 1947. A 1955 Guggenheim fellowship enabled him to produce the photographs collected in *The Americans,* published in 1958 in France and the next year in the United States. Frank worked as a commercial and fashion photographer and photojournalist and established his own photographic style, "subjective realism." Since the 1960s, he has concentrated on the medium of film.

1945 – 1970

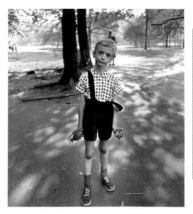

Diane Arbus, *Child with Toy Hand Grenade in Central Park,* New York, 1962.

137

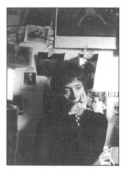

Diane Arbus (1923–71). Photo: S. Leitner. Educated at the School of Ethical Culture in New York City, Arbus married Allan Arbus when she was 18. She and her husband worked together as fashion photographers for *Vogue, Harper's Bazaar, Esquire,* and other magazines. In 1959, she studied photography with Lisette Model, and from that point on began to concentrate on new themes. She was the recipient of a Guggenheim Fellowship from 1963 to 1966, and achieved recognition for her participation in the "New Documents" exhibit at the Museum of Modern Art. In 1970–71, she was an instructor at the Rhode Island School of Design, until her suicide in 1971. In 1972, Arbus became the first American photographer whose works were exhibited at the Venice Biennale.

1945 – 1970

contrast with the photographs of William Klein, another member of the so-called School of New York. Klein's pictures seemed to reject the principles of central perspective and the golden section. What remained is a kind of seemingly distorted black-and-white picture, usually taken in the middle of a crowd with a wide-angle lens set at a 90-degree angle to the camera.

The most daring of these photographers was, however, the New Yorker Diane Arbus. For Arbus, the camera was a sensitive quill of the social seismograph—her photographs were set off by internal shocks. Her portraits contain a touch of something apocalyptic and seem to be at once the pictorial expression of mass culture, war, and commerce. Arbus worked for almost twenty years as a fashion photographer and photojournalist until she removed herself from the realm of fictitious beauty to devote herself to her unusually powerful portraits. Her subjects were almost always outsiders—mentally ill, cripples, sideshow freaks, grotesque loners. Her photographs, which she took mostly during the period of the Vietnam War, reflected the mood of America at the time, and her success clearly showed that her perspective was not an isolated one.

The portrait as icon—
Photographic memorials

Owning a photograph of Shakespeare—so mused the American writer Susan Sontag—would be almost like having a nail from the Holy Cross. Photographs of prominent contemporaries are icons of the epoch, and nothing so satisfies the interest in the famous more than a photographic portrait. This desire, together with efforts to establish a new postwar attitude toward portraits based on the theory of "differentiated personality structures," according to which every

person is unique, determined the approach of the most important portraitists of the time.

Photographers now sought to distill the individual inner tuning of the subject, his or her psychological "being-thus-and-not-other." For this purpose, portraits of the rich and famous seemed the best vehicle, and it was with portraits of the famous that the image of portrait photography was essentially bound through the early 1970s. The postwar portrait studies of Gisèle Freund, whose subjects included politicians and philosophers as well as famous authors and painters, are typical of this approach.

Among the great portrait photographers of this period we must certainly count Arnold Newman. For half a century, this American photographer made pictures of his famous, and not so famous, contemporaries. Sometimes it was a single eye—Pablo Picasso's, for example—that was enough for him to catch the whole character. More often, though, Newman won recognition as an artist for his refined compositions. His portraits constituted an act of worship of artists through a medium that was itself a work of art. One of his masterpieces, a photo of the Russian composer Igor Stravinsky, was taken in 1946. As a rule, Newman's portraits were calculated formal compositions consciously drawing on the setting of the subject.

That a portrait must first and foremost be a good photograph was an underlying maxim for the portrait photographers of this generation. Ernest, worthy, sincere—such were the apparent attributes of almost all the greats of politics, economics, and art photographed by Yousuf

Arnold Newman, *Igor Stravinsky,* 1946. Newman began his career in New York with this classic Stravinsky portrait at a piano whose lid floats above the composer like a huge note. Artists remained his favorite models. By rigorous cutting, Newman gave the photograph its panoramic brightness. The careful weighting of the composition as a whole resembles the balancing act of a Piet Mondrian painting or an Alexander Calder mobile.

Yousuf Karsh, *Ernest Hemingway,* 1957.

1945 – 1970

139

John Deakin, *Francis Bacon*, 1952. The painter Bacon despised working with models in a studio and often used Deakin's photographs as models for his pictures, as in his 1963 *Portrait of Henrietta Moraes*.

Richard Avedon (b. 1923). Photo: G. Krewitt). Avedon originally studied philosophy in New York City and was self-taught as a photographer. In 1959, he published a highly successful volume of portraits, *Observations*, with a foreword by Truman Capote. He later became popular as a fashion photographer and continued to publish volumes of portraits and large photographic screens.

Karsh. Born in Armenia, Karsh moved to Canada in 1924 and opened a portrait studio in 1932. His trademark, "Karsh of Ottawa," later stamped on every picture, became something akin to the Good Housekeeping Seal of Approval. His first triumph was his world-famous 1941 portrait of Winston Churchill—then British prime minister—one of the "Men Who Make the World," according to the title of his programmatic first large touring exhibition; the description is equally fitting for his portrait work as a whole.

The personality of Latvian-born Philippe Halsman expressed itself in a wholly different direction. Halsman's formidable results grew out of his intense personal contact with his subjects. In part, his pictures depended on what he called the "speech of the eyes." Born in Riga, Halsman finally arrived in the United States in 1941 after a decade in Berlin and Paris. He is perhaps best known for his "jump pictures"—unusual photographs of famous people whom he asked to jump in front of the camera, or placed in an effectively surrealistic situation by special shooting techniques to create an alienating effect, which he felt better revealed the underlying personality.

The more psychologically-oriented early pictures of Richard Avedon have their own characteristic effect. Avedon photographed his ailing father, and also well-known figures, usually against a blank white background that isolated the subject and directed the viewer to look intensely into the face and mind of the sitter.

A comparably direct, unbeautified approach to portrait-making was that of the exalted

bohemian John Deakin. Commissioned by illustrated magazines in the 1950s, Deakin photographed the London art and intellectual world. He moved his camera in very close to his subjects' bodies and high-lighted wrinkles and skin pores by light undershots and stark contrast between white and black.

Bert Stern, *Marilyn Monroe*, 1962.

Masters of beautiful illusion

Amid the general structural changes in Western society that followed the Second World War, even fashion was affected by a broad trend of democratization. By the 1950s, the printed media had popularized fashion, and the constantly rising number of fashion magazines inevitably brought fashion to the hands and eyes of the full spectrum of social classes. Thus, conditions were ripe for fashion and glamor photography, and for advertising in general. In response, advertising increasingly called upon photography.

Most of the fashion photographers active at the beginning of the 1950s operated with a formally classic conception. They placed their models in luxurious salons, at a picnic in castle gardens, or in other similarly staged rolls and settings, in the same way that the stars of stage and screen were handled by glamour photography.

In America, however, Irving Penn developed a completely independent approach. In 1943, he supplied his first cover for *Vogue*, a still life. In the decades after, together with Avedon, his great contemporary and seeming alter ego, Penn's work had an important influence on the style of photography in both fashion and

Irving Penn (b. 1917). Photo: A. Libermann. After studying design, Penn worked as a graphic artist with Alexei Brodovitch (as did Avedon). Moved to New York in 1938 as an independent photo-grapher; first *Vogue* cover in 1943. After 1950, Penn accepted private commis-sions but remained a studio photographer. He published a series of respected books and worked as commercial photographer for all the biggest agencies.

1945 – 1970

141

Irving Penn, *Advertisement photo for Jell-O-Pudding*, ca. 1953. Though he was famous as a fashion photographer and portraitist of public personalities, Penn's commercial work involved all kinds of products. His photograph of Jell-O pudding was supposedly so enticing that millions of Americans foreswore their traditional dessert to try the new product.

advertising. Penn photographed his models in empty rooms before a neutral background. In contrast to the fashion photography of that time, which generally distanced itself from reality, Penn rejected luxurious decors and theatrical lighting, and instead developed his "own" light to help him express what would become his personal style. Penn's photographs were direct, strong in optical effect, and clear in statement. His lighting contrasts remained as impressions in the visual memory of the observer. His vision corresponded with a view of luxury as a kind of asceticism, as a reduction to the essential. He had already demonstrated this lean economy of means in his portraits and, from the 1950s, in a series of illustrations of simple craft professions.

While Penn set up his fashion photographs as an expression of beauty almost exclusively in the studio, his great counterweight in photography, Richard Avedon, sought to depict activity outside in the living, real-to-life world. Avedon, though largely known for his studio portraits, built his reputation in the mid-1950s with his fashion photographs, which he shot on public streets, in plazas, in cafes, bars, and at revues. Once he left the studio behind, his fashion photographs thrived from the excitement of unusual places

and contrasts combined with great elegance of presentation. In the 1960s, Avedon limited his work in fashion photography to concentrate on his portraits.

Richard Avedon, *Cover of Harper's Bazaar*, October 1955.

The prosperity of the 1950s led to a proliferation not only of fashion magazines in America and Europe, but also of advertising agencies, and lifestyle and

home magazines, all of which fueled the increased demand for more original and attractive pictures. This was a fertile and prosperous climate for new commercial photographers. And it was the beginning of the era of commercial color photography. The growing corps of professional photographers and the ever widening range of markets for their work demanded a growing corps of models, and—for better or for worse—the days of the fashion model were born.

The influence of abstraction

Although the roots of abstraction in art, and especially in painting, stretched back to the beginning of the 20th century, the movement did not become truly important until after the Second World War. Realistic approaches to art receded further and further into the background, and abstract formal thought became a defining aspect of postwar art. It is not surprising that the photographers of the period followed this development with interest. Experiments with abstraction in photography were not entirely new: Alvin Langdon Coburn, for example, had already experimented with his vortography, and photograms also clearly moved in this direction. But the vehemence with which nonobjective photography was pursued after the war was indicative of a turning away from pure humanism to a subjective, creative search for new visual forms. The photographer lacked one important precondition of pure abstraction, however—the possibility of letting go of reality, liberation from objective connections. Photographers were in a dilemma. Daily realities had to be transformed into abstract compositions that followed their

Ara Güler, *Edirne, Turkey,* 1956.

1945 – 1970

143

Aaron Siskind, *Martha's Vineyard*, 1954.

own autonomous laws by freeing elements of reality from context, and thus enabling them to be looked upon in a new way.

A second avenue of development, experimental photography, looked on the other hand to the fascinating possibilities of light, light effects, photochemistry, and optics. Photographers like Heinz Hajek-Halke, Peter Keetmann, Pierre Cordier, Frederick Sommer, Minor White, Mario Giacomelli, and Aaron Siskind sought their truth in subjectivity. Their work grew out of a scepticism about the objective world and was driven by a search for universal truths, for the reality *behind* the reality.

Subjective photography

The search for subjectively determined truths was not restricted to any one clearly definable group, but was "the universal signature of a whole epoch." One area where this approach might be said to have crystalized was in the 1950s circle of the German photographer Otto Steinert. Steinert helped define a new path for photography through all the confusing possibilities and experiments of the postwar period. This natural scientist opposed both the corny sentimentalism

Otto Steinert, *One-Foot*, 1950.

of the time and the surviving imagistic language of the Nazis, and undertook the development of a creative photography based on personal experiment. The formally strict concept of subjective photography was supposed to meet the challenge. He was the head of the group "fotoform," which included Peter Keetmann, Siegfried Lauterwasser, L. Eindstosser, Christer Christian, and Heinz Hajek-Halke, among others. Steinert drew from abstract art, the Bauhaus, and the once-outlawed art of Man Ray, Hausmann, and Moholy-Nagy. His concept, presented in exhibitions in 1951, 1954, and 1959, aimed at a broad international effect. He thus became an unwitting cofounder of the Higher School of Abstraction in photography. His structures—of both material and people—became a model for a school that named itself after him, even if not all its representatives, such as Heinrich Riebesehl, Andre Gelpke, Gerard Klijn, and Guido Mangold, were oriented toward the strict principles of its teacher.

Steinert's goal was to draw out "personalities," to convey general form, and to draw upon teachings from the history of photography to attain a valid, lasting image, and, at the same time, to produce a technically perfect print. For the missionary zeal of Steinert, the perfect enlargement was the zenith of an endless process that reached from the initial intellectual grasp of an image to the composition of the print. According to Steinert, modern photography was a process consisting of five phases:

choosing and isolating the subject from nature
setting the view in photographic perspective
determining the photooptical image
translating the view into photographic tones
(and colors)
erasing the picture from time through
photographic exposure.

"Photography is the creation of pictures by technical and formal means; both requirements must be addressed diligently and systematically, and processed under qualified leadership with sufficient time. Modesty and self-criticism help more than belief in one's own talent; talent is extremely rare.

Otto Steinert

To this process the photographer brought his or her full strength and knowledge, and, when photographing human beings, sought to capture some sort of a psychological quality.

Art as photography

Although a number of photographers confined their subjectivity to the appearances of reality, other photographers, including Jan Dibbets, Floris M. Neusüss, Jerry Uelsman, Bernd and Hilla Becher, Gjen Mili, and Marcel Broodthaers, concentrated on more experimental methods. They used filters, multiple exposures, interventions in the printing process, serial runs, and classical photogram and photomontages in their efforts to shape a reality out of their imaginations and to define new pictorial possibilities for photography. Luminograms, pseudo-solarizations, prisms, sandwiching techniques all filled out the experimentalists' repertoire.

In a 1968 show entitled "Generative Photography," held in Bielefeld, Germany, Kilian Breier, Pierre Cordier, Hein Gravenhorst, and Gottfried Jäger presented their works based on Max Bense's theory of "generative aesthetics." Through their pictures, the artists argued

Floris M. Neusüss, *Untitled*. Photogram with chemical painting, 1965.

1945 – 1970

Pierre Cordier, *Chemigram, 21/9/72*.

that photography could be released from the constrictions of reality and supported "conscious and methodical production of aesthetic structures through photographic means and processes." This fundamental photographic aesthetic was later continued by Jäger and culminated in the op-art-like dotted-light grids produced by field aperture cameras. Underlying these experiments was the optical phenomenon of point-based human visual perception which results in the illusion that an image moves when it is looked at for a prolonged time through a certain grid.

Richard Hamilton, *Just what is it that makes today's homes so different, so appealing?* 1956.

1945 – 1970

Pop art and hyperrealism

During the 1960s, photography as a documentary medium was superseded by other visual media—mostly film and video. In addition, both technical and commercial trends rendered much popular photography increasingly banal. the face of these trends, it was the artists who used photography with a new raison d'être enabled it to take on new tasks. Photohy was functionally redefined in many

areas that were directly linked with pop art and the new kind of realism in painting. A few years later, in the 1972 "documenta 5" in Kassel, Germany, photography finally won absolute and irrevocable recognition as an artistic visual medium. But pop art found its true dimension at the beginning of the 1960s when seriography enabled the direct production of multiple copies.

Common to almost all pop artists was some use of photographic pictures. Not necessarily photographers as such, the artists sought to import pictures into other spaces, times, and connections by means of repetition, accumulation, arrangement in rows, or contrasting placement. The results were montages, collages, and serial works, such as those of Andy Warhol. With the help of photographic patterns, Warhol produced repetitive rows

Pop art: Art movement that developed independently in England and the United States in the late 1950s. Pictorial themes including the urban masses and industrial society were given an alienating effect by highlighting the banality of their subjects through glaring sharpness, exaggerated size, and repetition.

Op art: Short form of the "optical art" of the 1960s, deriving from the experimental formal purity of Mondrian, Malevich and Albert. Op art uses calculated regularity of lines, surfaces, forms, and colors to produce illusionistic optical effects.

Hyperrealism (photorealism): International movement of the late 1960s and early 1970s based on the principle of the extremely sharp presentation of reality, often achieved using photographic patterns and models.

Conceptual art: Offshoot of the minimal art movement of the 1970s. Conceptual artists rejected the actual implementation of artistic projects and concentrated on the presentation of ideas. The concepts often transcended the possibility of portraying them (as in land art, for example) or the realization of the work might be dispensed with altogether.

Body art: Movement dating from the end of the 1960s in which the artist's body becomes an art medium. The art might also consist of bodily actions (fluxus) or draw the audience into the art (happening). Body art might also include forms of manipulation of the body

of the same star—Elvis Presley or Marilyn Monroe, for example—or pinups, but, like Rauschenberg, also used the camera in the traditional manner.

Like the pop artists, the hyperrealists also exploited the possibilities of photography in their art. Starting in the 1960s, one could point to painting copied directly from photography and to artists such as Richard Estes, David Par-

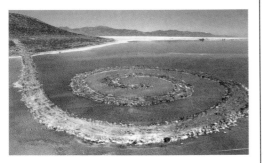

Robert Smithson, *Spiral Jetty*, Great Salt Lake, Utah, April 1970. Series of six photographs. In addition to the flooded filling material, text, film, and photograhy together comprise the irreplaceable components of this temporary work of land art; the artistic action itself is transitory and can never be repeated. Photography thus serves as a "trace of memory."

rish, Tabea, Gerhard Richter, and Chuck Close, who smelted together the real and the fictive. Photography became absolutely necessary for artistic forms of expression like hyperrealistic painting. But, in contrast to the pop artists who readily absorbed the detritus of mass culture into their work, the hyperrealists concentrated on reproduction and in the process stressed artistic virtuosity.

Art and document

The desire to fuse art with life appeared at approximately the same time as the resurrection of objectivity in art. Whereas pop art never questioned its own direct relationship with art as a millennia-old tradition, a new "anti-art" movement, parallel to pop art, also arose in the 1960s. This form of expression set itself up against the traditional practice of art and attempted to bridge the chasm

between the practitioners of art and the public.

The creative actions of happenings and fluxus were supposed to advance this aim. A. Kaprow used the term "happening" for the first time in 1959 to describe an event/action at the Reuben Gallery in New York where he staged certain seemingly unconnected events

Duane Michals, *The Re-Found Paradise*. Series of six photographs, 1968. In addition to excellent portraits (among others, of Belgian artist René Magritte), Michals became known for his conceptual work with staged photo sequences with which he hoped to surmount the limitations of individual photographs, and afterwards provided hand-written titles or texts. Through this serial work, Michals tried to increase the recognition of photography and to raise it intellectually above the limitations of the individual picture.

and at the same time actively drew in the public. This action-art, staged by artists such as Wolf Vostell, H. A. Schult, Arnulf Rainer, the Vienna Aktionists, and to some extent also Joseph Beuys, was really a limited process, and only traces of it remain. The job of documenting happenings fell to photography. The photography itself assumed no particular artistic character in the process; it served solely to refer to the actual work of art, which was itself transitory.

Uniqueness and transitoriness were also typical of the fluxus movement, although no audience participation was involved. But for

fluxus, as for happenings, the action was the work of art, and photography's role—of no small significance—was to document the action. Film, video, and photography were the only lasting witnesses, and thus became an integral part of the actions. In part, the pictures, or series of pictures, were later augmented by artists' statements, or were newly and repeatedly mounted, or served as the building blocks and raw material for new events or undertakings. Artists from a wide variety of directions turned to photography for their purposes. Among them were Yves Klein and Wolf Vostell (body art), Mike Heizer and Robert Smithson (land art), Walter de Maria (earth art) and Christian Boltanski ("traces of evidence" art).

Creating an aesthetic product was clearly not the primary aim of this photography. The art of the camera was intended to document attitudes, feelings, and concepts, and to allow artistic experiences to be understood. This basic principle in the transmission and reception of art also applied to conceptual art, which sought to do away with the classic forms of artistic production. Conceptual art separated the idea, or concept, from the object; that is, the concept was itself a work of art. Photography then provided visual evidence of a concept or a simple document of artistic expression; for example, Joseph Kosuth photographed a chair for his *One and Three Chairs* in 1965, and then opposed the life-sized enlargements with the chair itself, along with a photocopy of a dictionary definition of the word "chair," so that the reality, the illustration of the reality, and its description were united in a single work of art. Other conceptual artists used photographic series, rows, and sequences to convey their ideas.

"The serious camera artist should produce a self-made psycho-drama by showing how he sees and experiences things. ... The artist is in a condition in which he senses something, and he holds on to this condition. ... Advanced art can be defined as social software."

Les Levine, 1975

1945 – 1970

The seeds of the founding of the most famous photographic agency in the world were planted in 1934 when Henri Cartier-Bresson met the Pole D. Szynim (who would later change his name to David Seymour) and the Hungarian Robert Capa in Paris, even though the agency itself was not actually founded until 1947 in New York.

George Rodger, *Victorious Tribal Warrior on the Shoulders of a Tribe Member, Cordofan, Sudan, 1949*

1950s were the golden age of live photography. Everywhere, new newspapers were being founded and they had to give their readers pictures from all over the world. The sheer numbers of photos demanded by editors could no longer be managed by a single person. Thus, Magnum was founded chiefly to assist with the work of evaluation and organization of its members' photographs and to provide for the safe storage of the negatives. With time, however, the agency's photographers developed a signature style that had a lot to do with the availability and capability of the Leica camera.

The aim of what was in the beginning a simple group of common interests was totally practical in concept. The postwar years and the

David Seymour, *Prostitutes in Essen*, 1947. The Warsaw-born photographer fled Poland from the Nazis in 1939 to Paris, and from there to the United States, returning to Europe as a U.S. Army photographer. He was shot by an Egyptian soldier while on assignment at the Suez Canal in 1956.

Out of the spirit of Magnum, a new kind of live photography was born. Magnum in itself embodies an important piece of half a century's history of photojournalism. Magnum photographers showed that true photographers not only met the demands of their assignments by turning a theme into pictures, but also generated and followed through on their own ideas. In so doing, they were always guided by the overriding standard of high

photographic quality.

In due course, Magnum managed to assemble an illustrious group of photographers. In addition to the founding members—Cartier-Bresson, Seymour, and Capa—its roster boasted W. Bischof, E. Haas, M. Riboud, R. Burri, E. Lessing, M. Franck, D. Stock,

Jean Gaumy, *A Worker Confessing to a Roman Catholic Priest on the Street, Gdansk, Poland*, 1980.

"To photograph means to hold your breath when, in a fleeting moment of reality, all of our abilities unite. Head, eyes, and heart must be aligned in the process. To photograph—is a way to cry out, but not to show proof of its originality. It is a way of living."

Henri Cartier-Bresson

E. Erwitt, I. Morath, L. Freed, and E. Arnold, to name only a few.

It soon became common knowledge in the industry that Magnum photographers were always on the scene whenever anything important was happening in the world. Usually it was Capa, the well seasoned war photographer, who sent reporters to the right place at the right time. Yet Magnum still seems to have this knack today, as the work of the newer generation demonstrates emphatically. There always was and there still is a Magnum "program," as revealed in the newer works of S. Salgado, J. Koudelka, J. Nachtwey, S. Meiselas, C. Manos, J. Gaumy, and G. Peress.

There are Magnum branches in New York, Paris, and London, a number of bureaus that represent Magnum throughout the world and a holding company that regulates important issues for members internationally. And yet, Magnum remains an exclusive club. Although it receives more than fifty applications for entry into the agency every year, membership remains limited to thirty-six.

Ernst Haas, *Rose*, 1970. Haas, who became famous for his reports on the zero hour (1945) in his native city of Vienna, Austria, turned largely to color in 1951. During the 1950s, he was a member of Magnum but, in addition to reporting, he devoted himself to landscape in order "to protect it through visual praise," as his book *The Creation*, published in 1971, demonstrates.

1965 United States enter Vietnam War.

1968 Stanley Kubrick, *2001: A Space Odyssey*; Prague Spring; student unrest on college campuses around the world; killing of four students by National Guardsmen at Kent State University; assassination of Robert F. Kennedy.

1970 Outbreak of civil war in Northern Ireland; socialist Salvatore Allende elected president of Chile.

1972 Break-in at Watergate Hotel in Washington, DC, launches investigation into illegal activities within the Nixon campaign and administration.

1973 Death of Pablo Picasso at age 92.

1975 End of Vietnam War.

1986 Catastrophe at Chernobyl nuclear reactor.

1989 Fall of Berlin Wall; violent end to mass demonstration for democracy and human rights in Beijing.

1990 German reunification.

1991 Persian Gulf War; collapse of Soviet Union.

1992 Outbreak of civil war in parts of the former Yugoslavia; Bill Clinton elected president of the United States.

1965 – today

Eddie Adams, *Brigadier General Ngyuyen Ngac Loan, National Police Chief of South Vietnam, executing the suspected leader of a Vietcong commando unit, Saigon, Vietnam, February 1, 1968.*

Photojournalism

From the middle of the 1960s, if not earlier, social, cultural, and political changes were afoot that would radically and violently change the western world. The reaction to the Vietnam War, student protests and revolts, the Prague Spring, the revolution in the media, and the politicizing of society were all facets of the change. But "1968" signifies far more than a period of social confusion; it heralds the start of a long-term social, intellectual and cultural crisis that is still going on today. It was during this time that photography was largely supplanted by television as the primary documentary medium.

In other words, photography no longer needed to play the role assigned to it since its invention—to inform and describe. Freed from such responsibility, photography sought to define new tasks for itself in three areas: in its use as a medium for artists; in the establishment of the "image" of photography, as one of the visual media; and as a means of conveying reality itself through pictures.

The gradual process of finding a new definition issued its first visible results in reports on the war in Vietnam. Until this point, governments had more or less successfully controlled photographed war reports, but during Vietnam, the United States was no longer able to do this. The result was that many photographers, like

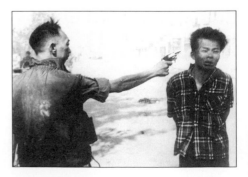

Larry Burrows, Donald Mc Cullin, and Eddie Adams, who were already opposed to the war, found nourishment for their positions and expressed the moral failure of the political leadership in searing pictures.

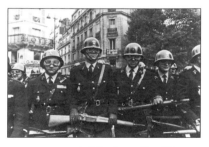

Gilles Caron, May '68.

No photographer captured the wars and catastrophes of the last decades in such horrifying pictures as the Englishman Donald Mc Cullin. His images of the misery of children in the north of England, Bangladesh refugees, the civil war in Northern Ireland, and the Gulf War are models of the new style of photographic documentary.

The representatives of the so-called "new photojournalism"—Susan Meiselas, K. Wessing, Alex Webb, J.-M. Simon, Peter Magubane, James Nachtwey, Gilles Peress, and H. J. Burkart—are documentarists in the best sense of the word. Avoiding the anecdotal, they are able to convey both a powerful and a politically aware picture of reality.

> "All the young photographers running around the world ... dedicated ... to catching the momentary reality don't realize that they are the agents of death."
> Roland Barthes

Although news photography today seems hopelessly behind in the race to "be there live"—at best, it is the third runner-up after radio news and live TV—important photo-reporting continues to be done, as the work of Gilles Peress demonstrates. Peress documents the sites of recent

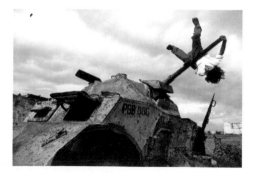

James Nachtwey, *Managua, Nicaragua*, 1983.

1965 – today

155

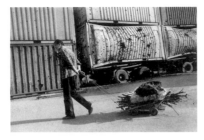

Gilles Peress, *Untitled*,
Bosnia, 1993.

and immediate history, along with its victims. His work clarifies the impact of nationalism and racism, whether in Bosnia, Rwanda, or Northern Ireland. His reputation, however, does not rest on sensationalist scenes of cruelty and horror, but on the compactness and eloquence of the testimony offered by his photographs. Since the revolutions of 1968, Peress has sought an instrument between language and reality to translate into pictures the powerful words of the structuralists and the Maoists, who were at the time generally formulating their goals theoretically. From his first reports on the results of the Decazaville miners' strike in southern France or on Bloody Sunday in Northern Ireland, this effort, bound with a high sense of social engagement, has defined all of Peress's work. Partly subjective, partly narrative, his documentary approach to photography links Peress with the English photographers Chris Killip and P. Graham and the American Mary Ellen Mark.

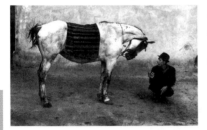

Josef Koudelka, *Romania*,
1968.

Social engagement

Among those photographers engaged with social and political themes is Josef Koudelka. Born in the former Czechoslovakia, Koudelka photographed the Soviet invasion of 1968 in powerful pictures. A loner who went into English exile in 1970 and now lives in Paris, Koudelka has always cultivated his own style, free from any theories bound to a certain time. His photographs mostly portray wanderers and the homeless, of whom he is probably himself an example. He became famous for his pictures of the life of east European Gypsies. As a rule, Koudelka's photographs are

1965 – today

untitled, and contain reference only to a place and date. The photographer himself, for whom the theme of exile has become a creative principle, always remains present in his depressive, heavy-hearted pictures and uses this theme as a form of commentary on the general homelessness of mankind.

"To photograph the enigmatic, true, and magical soul of traditional Spain" is the aim of Spanish photographer Cristina Garcia Rodero. In her reports on the "hidden Spain" unknown to many today, Garcia Rodero searches out the cultural springs of life and the reality of feelings. Thus, feasts and festivals stand solidly at the heart of her photographic interest; they are among the few remaining occasions when isolation, alienation, and lack of communication are overcome.

Human relations and behavior, distance and nearness, political events and their protagonists, as well as foreign locations are typical of the works of M. Ruetz, D. Reinartz, and Barbara Klemm. As a reporter for the *Frankfurter Allgemeine Zeitung*, Klemm developed a keen sense of historical signposts. Her photographs are more than a captured instant; they are analyses of a moment of history.

From the beginning of the 1980s, the Brazilian Sebastião Salgado has produced symbolically

Christina Garcia Rodero, untitled, Puente Genil, Province of Cordoba, 1976.

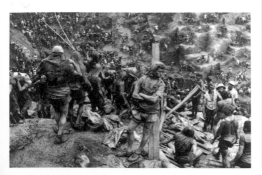

Sebastião Salgado, untitled, Serra Pelada Mine, Brazil, 1986.

1965 – today

1965 – today

> "Sebastião Salgado was the first to show us with pictures that allow no escape how little we know of the men and women on whose shoulders the burden of the world rests."
>
> Nadine Gordimer

rich photographs of elemental human labors in the age of high tech. Salgado possesses a rare ability to grasp both the right moment and the generalized reality behind it in his photographs. His figures, always taken in uncompromising black and white, seem like monuments of human greatness. Salgado's project *Archeology of the Industrial Age*, a moralizing pictorial epic completed over the course of years, expresses the photographer's vision of the forgotten, the miserable, and the outcast, and has become a world success.

The photographer as *auteur*

Photographers' search for new fields of activity and function for photography, combined with their rethinking of the premises of their work, served to stimulate a new consideration of photographic perception and even of the medium itself. The concrete result of this introspective process was a rejection of belief in the truth of the individual image and the disintegration of the cult of aesthetic form for its own sake.

Reinhard Wolf, *New York*, 1979.

The single picture was expanded into sequences and series, and dialogues between text and picture were created. The wide-angle lens and special large-grain but highly sensitive film supported the development technically. These developments in turn opened up new forms of documentation in which the photographer became an *auteur* in the sense of becoming the creator of a personal oeuvre. Many photographers also rejected the traditional distinction between amateur, professional, and avant-garde photography in favor of a common understanding of the photographer as a creator in his or her own world of images. In Germany, this

approach found expression particularly in the Steiner school, dating from the middle 1960s.

Originally both schooled and stimulated by Otto Steinert's rigorous pictorial aesthetic, photographers like A. Gelpke and H. Riebesehl began to migrate away from Steinert's characteristic peep-hole perspective and define their own visual worlds. The resulting works were never pictorial stories, but precise photographs arising from the curious and interested eye of the photographer who drew into the photograph both human beings and the spaces between them.

Coolly and exactly to capture the lonely individual, caught between rejection and attraction, but also to locate the traces of modern civilization in places devoid of people became the quest of photographers such as G. and H. Nothelfer, M. Schmidt, W. Schürmann, Reinhard Wolf, A. Neuke, and Bernd and Hilla Becher. All shared an interest in learning and revealing more about the condition of the modern world.

Bernd and Hilla Becher, *Blast Furnaces*, Germany, Luxembourg, USA, 1980.

The leading question of the 1970s and early 1980s might well have been, "How have I not yet looked at the world?" The answers, of course, were quite varied. For some, this meant the complete replacement of individual photographs with series of images. The Bechers, for example, were fascinated by (among other structures) industrial towers—towers for water, towers for electric cables and junctions, towers for gas. According to a completely defined and objective scheme, they photographed, apparently dispassionately and impersonally, the

1965 – today

quintessential monuments of industrial culture. Their work thereby established an objective photographic approach still discernible today in the large-format photographs of T. Ruff, the tableaus of A. Gursky, the architectural and museum photographs of Thomas Struth, and the bunker photographs of E. Schröter.

What all these photographers share is a vision that registers, but does not participate in, reality. Rejecting the outward appearance of the masses, the individual in his or her most differentiated appearance defines the focus of *auteurs* such as B. Katz, H. Koelbl, W. McBride, and the shooting stars of the 1990s, J. Teller and W. Tillmanns, whose photographs vacillate between carefully produced arrangements and clearly casual photographic notes.

International developments

Nicolas Faure, *Col du Grand St. Bernhard*, 1988.

The seemingly endless possibilities of developing the photographer's own concepts are clearly reflected in the pictures of other European, Japanese, and American photographers. They offer new visions of the world. For example, A. Serrano's gigantic colorful photographs of daily life in Budapest present a contrast between their very colorfulness and their subject. Other approaches appear in the work of Swiss photographer Nicolas Faure who brings the viewer close-ups into the tourists' playground and leisure paradise of the Alps; or of the Bolzano photographer W. Niedermayr who executes a cynical analysis of the mountain world of the southern Tyrol.

In the 1970s, the Italian photographer Franco Fontana reduced the landscape to isolated elemental structures and filled them with a glowing colorfulness. In contrast, Fontana's countryman

160

O. Barbieri sought to reveal places whose significance has been forgotten. He has photographed, for example, a dim film palace from the golden age of movies, illusional rooms, and other paradoxes of daily life. Since the end of the 1970s Barbieri has photographed chiefly in color, while many other photographers, including French H. Guibert, L. Clergue, M. Franck, and P. Virilio, continued to limit themselves to black and white.

Franco Fontana, *Italian Landscape*, 1979.

Photography was not even at the heart of the work of some of the pictorial *auteurs*. An early victim of AIDS, H. Guibert was both a writer and a photographer, though he never saw his photographs as a by-product of literature. Instead, Guibert used photography to explore his own being and the traces that it left behind.

Photography has similarly been a means of exploration for French philosopher and architect P. Virilio. Virilio's "bunker archeology," which includes photographs from the Atlantic line of defense from the world wars, is of equal standing with his philosophical and architectural work.

A number of contemporary photographers decided to turn their cameras on their own bodies. Among them is the Dutch artist T. Frima, who started with the Polaroid SX 70 and later moved on to larger, multiple works that show the woman as complete universe. S. Neshat is similarly the theme of her own work. By means of poetically inscribed photographs, this Iranian photographer explores the position of woman in Islam, as well as western stereotypes of it, from alternating viewpoints. The search for her own identity and subjective truth also defines the photographic self-analyses of the German K. Elle and the New Zealander K. Webster.

1965 – today

Nabuyoshi Araki, *Tokyo*, 1995.

Such personal, introspective work forms a stark contrast to the drastic changes of the modern world in the media caught by Japanese photographer Nabuyoshi Araki, whose works reflect the chaos and superfluity of the pictorial worlds of the 1990s. Apparently without unifying concept, his photographs comprise a mixture of nudes, cityscapes, cloud images, cherry blossoms, and other subjects. But the confusion of his pictorial cosmos, which he gathers together into "photo-novels," reveals in an extreme manner the wild coexistence of opposites in the industrial and media culture at the end of the 20th century.

Impressive casualness

B. Gilden has been photographing the streets of New York for half a century. In the 1980s, he often used a technique that has produced amazing results. With a wide-angle lens and flash bulb, Gilden approaches his human subject in extreme close-up. The result is normally a blurry photograph, but the flash bulb brings out a single detail in unnatural sharpness. William Klein, who started to take photographs again in the 1980s after a twenty-year hiatus, works in a similar manner.

The horror of the moment is replaced by the color documentarist William Eggleston by the boredom of the American quotidian—an empty gas station, a room with nothing more than a bare lightbulb on the ceiling—everything "perfectly boring." Eggleston, as well as Stephen Shore and Joel Meyerowitz, are picking up here

1965 – today

where Walker Evans in the 1930s and Robert Frank in the the next generation left off—the documentation of the everyday banality of America.

A similar sort of laundromat depression dominates the work of Robert Adams, whose black-and-white photographs from the 1970s and 1980s reveal both inner and outer desolation and reflect the monotony of life lived between automobile, shopping mall, factory, and motor home. His more recent series of color pictures also pursue similar themes.

The photographs of Danny Lyons also present a malicious reflection of reality. His pictorial language is infused with the rhythms and themes of the beat generation, and his deep scepticism toward the objectivity of photographic images lands him in the ranks of Lee Friedlander, Robert Frank, and Garry Winogrand.

William Eggleston, *Main Street, Greenville, Tennessee,* 1983–86

R. Gibson used photographs of insignificant and ordinary scenes to create strongly individualistic pictorial compositions. Along with Diane Arbus, Garry Winogrand, and Larry Clark, who attracted so much attention in the 1970s with his shocking series *Teenage Lust* on sex-obsessed and drug-addicted kids, Gibson is one of the most prominent members of the New York photography scene.

Sally Mann specializes in photographing her children, though not quite in the same way as most parents do. Her approach is simultaneously idealistic and emotionless, suffused with a flair for nostalgia, reminiscent of the child-world of Lewis

1965 – today

Carroll, and has led many critics to see nothing in her photographs but easily consumable objects.

In contrast, the photographs of Nan Goldin leave no room for such speculative interpretation. Goldin's language is clear and unambiguous. Her pictures have been described as showing no intimacies, but rather improprieties. Her photos are not insulting, but are certainly nothing for the family album. As an artist, Goldin moves in the milieu of prostitutes, transsexuals, and junkies. Since the 1970s, her photographs of these garish subcultures have posed a wordless but powerful dialogue between the photographer and her subject.

With his homoerotic motifs and his radical association of sexuality and violence, all of which is portrayed with exquisite aesthetic quality and technique, Robert Mapplethorpe was always good for launching a scandal in the United States' more puritanical strata. His work is often invoked in the highly heated debates about federal funding and moral standards (through the National Endowment for the Arts, among other grant-giving authorities) for the arts, even after his death from AIDS in 1989. Mapplethorpe's male nudes are almost hyperrealistic, but his insistence on strict compositional order and the high technical quality of his prints—usually produced by the expensive dye-transfer process—gave him the distinction, it has been said, of being the first modern artist to bring unveiled sexuality into American museums.

Erotic photography—The language of lust

Not since the 1960s has the interest in the erotic been so great as it is today. The human body is in itself, in an erotic perspective, a field for experimentation and, in the classical sense, both the

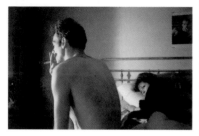

Nan Goldin, *Nan and Brian in Bed*, New York City, 1980.

"Nan Goldin's effort at honesty toward what she photographs and toward herself is what makes her pictures exciting. They are direct and yet not hurtful, they are unsparing yet not cold. They are pictures that say something, over and above the form of relationships of the young generation, about the time in which we live."

Andy Grundberg

object and the symbol of longing. While erotic images have never evaded photographers' viewfinders, as a rule, there have always been several protagonists in the genre who brought the image of the erotic to the public, and thereby defined it. In the process, the style of the photography no longer invariably conforms with classical models of innocent nakedness. Instead, the pressure to publish, and to publicize, intimate wishes, secrets, and preferences has grown ever greater.

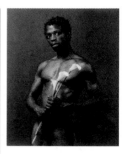

Robert Mapplethorpe, *Dennis Speight with Callas*, 1983.

The body presented in simple nakedness as an ideal of eternal youth or the veiled views of sexual arousal portrayed in soft focus were replaced in the 1960s by a photography standing somewhere in the middle of the extremes of documentary and consciously set stage. Characteristic of most of this photography, however, was that it never showed "all." Female pubic hair did not appear in photography publications until the 1970s; male genitals appeared even later. These taboos, however, were eroded

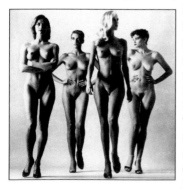

bit by bit in the works of photographers such as David Bailey, John Thornton, Cheyco Leidmann, Christian Vogt, Jeff Dunas, Deborah Turbeville, Karin Székessy and Jeanloup Sieff.

Helmut Newton, *They Are Coming*, 1981.

Increasingly, location and ambience played a critical role. Whereas Sieff reduced all to the economy of studio interiors in which his models rather restrainedly, but artfully, charm their way

1965 – today

onto the film, Helmut Newton shows no such restraint. Variously looked upon as a tamer of the elite and as a photographer of the prominent, the beautiful, and the eccentric, Newton has cultivated a style that has influenced not only erotic photography but also fashion and commercial photography. His strong women usually move in a stage-like reality and often pose like ice-cold angels, even when completely naked. His preferred showplace is a hotel room or other ornamental setting. Many critics, however, find his hotel photographs to be cynical, arrogant, and voyeuristic.

French photographer Bettina Rheims confronted the male erotic imagination with that of the female and realized her vision with aesthetic mastery. Rheims has photographed both famous and not-so-famous women in various surroundings, both worldy and simple. Hotel rooms also play a role in her photography; their elegance and eroticism correspond to the elegance and eroticism of her models. On the other hand, Rheims operates less like a theatrical director than Newton does, and she allows much more of a conversational, individual dynamic between model and camera; the same is true of her portraits. In this approach to the genre, she stands apart from her contemporaries A. Watson, Herb Ritts, O. Martens, E. von Unwerth, P. Lindbergh and I. van Lamsweerde, all of whom have influenced the photography of the 1990s. Their work has finally done away with the boundaries between fashion, commercial, and erotic photography.

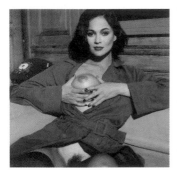

Bettina Rheims, *7 novembre, Paris*, undated.

The arranged image—Photography as construction and staging

Since the 1970s, a sense of discomfort has grown with so-called authentic photographs. On

the one hand, there was some anger at the expanding media society which had gradually begun to engulf the entire pictorial culture for itself; on the other hand, it began to be understood that, without these pictures, there might no longer be any "reality."

From this position arose a new "directorial mode," in the words of photography critic A. D. Coleman. In 1979, a San Francisco exhibition of works by young photographers was titled *Fabricated to Be Photographed*. Both Coleman's term and the exhibition title reflect a change in photography that culminated in the 1980s. Photography ceased to be concerned with interpreting reality, but instead addressed the construction of new, unknown pictorial realms. Complete worlds were created just to be photographed. Claims to "originality" ranged from authentic pictures of the world to the arrangement of tableaus.

The ways of setting up an arrangement were diverse: from a dramatic perspective, in which objects were placed in a scene according to their pictorial effect, or from a concept that might be planned and carried out independently of the

Bernard Faucon, *The Banquet*, 1978/79. In photographic reproduction, Faucon's paintings closely resemble documentary photographs. Only at second glance can one see the artificiality of the certain film-like effect of the picture. The supposed slices of reality take on an exaggeratedly real character that also contains a hint of the mystical.

Jeff Wall, *Milk*, 1984. In this large and elaborate stage setting, every detail is carefully arranged and each gesture rehearsed in order to confront the photographic myth of the decisive moment with an absolutely artificial world. The pedantic staging of loneliness, social downfall, and spoiled worlds in beautiful pictures gives the photograph an oppressive aura.

1965 – today

167

immediate appearance of the scene—the sense would be found in the process of reflection that was necessary to reconstruct the concept. The visual presentation simply provided information about the underlying concept.

These new worlds of images can be divided into five or six groups, beginning with the self-presentations of U. Lüthi, J. Klauke, Manon, Colette, or Gilbert & George, to the role-plays of Cindy Sherman, J. Koons, T. Sixma, and T. Hocks;

Les Krims, *Untitled*, 1984. In his so-called "narrative tableaus," Krims stages sexual fantasies with provocatively grotesque exaggeration and binds them with the clichés of the American dream.

further, to the construction of frame stages on which photographers like R. Boonstra, T. Drahors, H. Tas and L. Gerdes build fictitious miniature worlds in a distinctly theatrical tradition.

Life as theater in the form of "tableaux vivants" is clear in the arrangements of E. Broocks, Bernard Faucon, B. Webb, and J. Gantz, while another group, inspired by D. Michals and Les Krims, and represented by A. Tress, J. P. Witkin and W. Wegman, pursues rhetoric as rhetoric in the form of "narrative tableaus." Similarly, H. Villinger and Fischli & Weiss create photosculpture and installations.

Yet another group of artists use the world of photography reflexively; this group includes Clegg & Guttman, B. Blume, Jeff Wall, or those who roam the space between photograph, text and other visual phenomena, including such photographers as V. Burgin, B. Kruger, J. Gerz, J. Kosuth, and J. Baldessari.

The 1980s were characterized by heterogeneous styles and pluralistic attitudes toward photography, as indicated by the sheer number of names listed here. The anarchistic, irreverent

rejection of photographic pictures at one extreme, and the construction of individual picture worlds at the other may certainly be seen as two of the most innovative recent developments.

Becoming pictures—
Photography in contemporary art

Amid the discussions in the late 1960s about the specific artistic contributions of photography, a conviction that photography has a right to produce pictures according to its own laws gradually emerged—a premise which is today basically undisputed. However, this is not to say that photography cannot also be used in other art forms, as was demonstrated by Robert Rauschenberg's use of photographs in his *combine* paintings to enhance the effect of his painting.

The Austrian Arnulf Rainer painted over photographs in his effort to move from the particular to the general and thereby to uncover underlying principles. That is, he stated his artistic position by painting over concrete photographs. Most of all, Sigmar Polke deserves mention for his infiltration of the classical rules of photography with manipulative painting techniques in the 1970s. G. Richter also treated the traditional photographic image in a similarly destructive manner.

In recent years, the visual arts have experienced some interesting developments. Some of the newly revived art form of panel paintings—often large-format diptychs or triptychs—emerged from the darkroom. Noteworthy here is the strict, yet on the whole suggestive, use of the medium. The photographic image is treated less as a dynamically playful activity; instead, the rare descriptive power of the

Sigmar Polke, *Color Changes among Flatfish*, 1981.

Christian Boltanski, *Odessa Monument*, 1991

1965 – today

169

camera is emphasized. For example, where Joseph Beuys once evoked the mythic power of photography, many subsequent photographers have moved into other directions where photography no longer serves as a sort of citation of reality in a dialogue with painting.

Instead, artists like Barbara Kruger, Isa Genzken, Katharina Sieverding, Astrid Klein, Christian Boltanski, Annette Messager, and Mike and Doug Starn use photography to approach both the essential and the apparent possibilities of human beings, that is, to visualize these possibilities through a technical medium.

Recent trends

Of course, the traditional photograph—the framed (or the borderless) paper print in black and white or color—still has its legitimate place; it remains oriented around reality. But the artistry of the photographic medium and the nonphotogenious aspects of the pictured object are still emerging, evolving, altering.

Presentations of the self, images of the human form, and the portrait have all staked out a fairly vast and varied territory. J. Coplans, for example, repeatedly places his body at the center of his work. Parts and fragments of the body play important, though different, roles in the work of

Digital Photography: In the digital photography process, in contrast to traditional photography, the image in not brought by a camera onto a film but is saved on a light-sensitive chip located in the camera housing. One still needs a photographic lens, but the pictures, which are transformed and stored by the chip as binary data, can be sent by a cable from the camera directly into a computer and delivered to an integrated picture-processing program. Professional photographers can, for example, check their pictures on the screen of a notebook computer and transmit the picture directly by cable. At present, only the extremely expensive digital cameras provide really satisfactory pictures, and top quality pictures can be achieved only by a "high-end" digital studio camera.

1965 – today

T. Florschütz and J. Hilliard. As an expression of the loss of individuality in the 1990s, the digitally altered and dissolved faces produced by Aziz & Cucher may have an oppressive effect, but they do allow us to envision—and perhaps to invent—the possible future of digitalized photography.

Photography's self-involvement is today a broad field. The widespread claim that photography illustrates reality is being ever more strongly contradicted, and the relation between the real and the artificial is constantly questioned. Canadian photographer Jeff Wall pursues such questions in his pictures by means of an artificial dramatic form. For all their realism, the artificiality of his Cibachrome light boxes is unmistakeable—just as the artist intends it to be. Wall's pictures are only one example of this kind of pronounced artifice. Other artists dabble in the same territory: The photography of Gregory Crewdson or of Yasumasa Morimura indicates repeated attempts to provide a substitute for reality, or to explore the relationship between reality and artificiality.

At the same time, there are other photographers—many of them nostalgia seekers—who are experimenting again with the primitive pinhole camera, the photogram, or 19th-century photographic processes in an attempt to conjure up a seemingly lost dimension of the art of photography.

Aziz & Cucher, *Chris*, undated.

Advanced Photo System (APS): This method of classical silver-halogen photography still uses an easily changed film capsule, especially developed for the hobby and amateur photographer. Smaller APS cameras shoot film from which the photo lab produces "thumbnails." These are small contact prints with a pre-inscribed number which the consumer receives instead of negatives. The numbers allow the photographer to order prints later, and the film cartridge is numbered as well. The film contains a magnetic strip with all the pertinent laboratory information needed for fully automatic processing of the film and later for making dependable reprints in a large laboratory.

1965 – today

Glossary

Abstract art: Nonrepresentational art style emerging around the end of the First World War in which forms and colors operate autonomously according to the inner logic of the picture rather than from the laws of reality. Abstractionism was first promulgated especially by the Bauhaus, de Stijl, Abstraction-Création, and, after the Second World War, by the Ecole de Paris and the abstract expressionists, among others.

Additive color: Optical combination of colors of light by means of variously superimposed beams of red, yellow, and/or blue light whose simultaneous effect on the retina produces a third color. In photography, used in particular in the screen process and three-color projection.

Albumen: Egg white. Used on glass as a binder for the light-sensitive silver salt emulsions and as a surface coating on photographic paper.

Cabinet card (*carte de cabinet*): Cardboard-mounted photographs (approx. 6 x 4 in.) from the second half of the 19th century, a prestigious alternative to visiting card pictures.

Collodion process: A wet plate process using a mixture of nitrocellulose dissolved in ethyl ether and ethyl alcohol as a vehicle for coating a glass plate with potassium iodide, which becomes light sensitive when bathed in silver nitrate.

Contact print, contact copy: Positive image produced by direct contact with the negative; i. e., negative and positive formats were identical, requiring correspondingly large, heavy cameras and lenses to produce large-format pictures in the 19th century; enlargements were hardly possible. Today one-to-one prints from negatives are still known as contact prints.

Copyout paper: Special paper on which a photographic image forms during exposure and requires only to be fixed (not developed) afterwards. The light-sensitive paper is placed together with the negative in a copying frame and exposed to light (either natural or artificial) to produce a positive print through the so-called copying-out process. Most 19th-century positives were produced on this kind of paper.

Dye-transfer process: Copying process invented by Kodak in which multiple nonfading copies can be made from a negative or a diapositive through a color dispersion process on either paper or film.

Fluxus: International art movement that worked in particular with "staged" accoustic and visual arrangements. Beginning in the early 1960s, fluxus attempted to break through the distances among the various media and between the aesthetic and real, and to draw wit and spontaneity into art.

Futurism: Reform movement of the early 20th century in literature, music, and the pictorial arts, in part politically motivated. Beginning with the *Futurist Manifesto* by E. F. T. Marinetti in 1909, the movement spread from Italy to Russia. Basic principles stressed radical renewal of life and art as well as recognition of a world dominated by science and technology; formal expression in the pictorial arts involved the dissection of images, colors, and light.

Heliography: Process developed by J. N. Niépce in 1826–27 to fix images produced by the camera obscura. His attempts to produce an image on stone, glass, and especially silver-coated copper plates resulted only in weak positive images, but were the basis for the invention of the daguerreotype.

Informal art (abstract expressionism, action painting, Tachisme): Stylistic phase of European and American art of the 1950s and 1960s that emphasized the process of creation, the spontaneous gesture of the painter, and the intrinsic values of color in place of formal principles of painting.

Modern print: Term for prints made considerably later (at least one year) than the

Glossary

shooting date; the process of printing is either carried out by the photographer or commissioned and supervised by him or her.

Narrative art: Movement of the late 1970s in which drawings, photographs, pictures, and text "tell" a story, or in which several pictures are arranged in sequence. In photography, "narrative tableaus" convey stories and artistic messages by means of arranged pictures.

Negative-positive process: Copying process in which a positive is created on paper or film from a photographic negative normally paper prints from negatives. (In color photography, a color positive is produced from a color negative, in contrast to the reverse process where a positive film is produced from a negative film.)

Objet trouvé: Everyday objects or throw-aways found by chance "discovered" by dadaists or surrealists (such as Man Ray or Marcel Duchamp) as new artistic materials. The artistic use gave the objects a new, aesthetic function.

Photogram (Schadograph, rayograph, photogenics): A photographic image made without a camera, usually by placing objects on the sensitized ground (film or paper) and exposing the arrangement to light.

Photomontage (montage): A composite image made by joining and printing selected images from more than one negative to produce an image not actually found in reality.

Reprint: Print made from the original negative, without the knowledge or control of the photographer, usually after his or her death. Term also valid when the print is "authorized" by the estate of the photographer.

Repro: Print made from an intermediary negative produced from a vintage print, a modern print, or a reprint without the knowledge or control of the photographer. Term does not include copies made by the photographer from his or her vintage prints; see *modern print*.

Salt paper: Paper containing silver chloride for calotypes /talbotypes (prints from paper negatives dating from 1840 to ca. 1855).

Seriography (screen print): Graphic flat printing process used for making fliers, posters, decorative pieces, etc. A fine mesh screen (typically made of silk) is covered in part with lacquer or templates to prevent absorption of color where none is wanted, and the color is then rolled or scraped over the screen, and transferred onto the paper or other material to be printed.

Silver halides: Silver salts functioning as light-sensitive substances which, upon exposure, deposit metallic silver turning black during the development process.

Silver-salt diffusion process: Special copying process in which the complete halide salts of silver diffuse as a positive layer to form an image. Used especially in office copiers and "instant pictures" (Polaroids).

Subtractive color process: Color mixture of bright yellow, purple (magenta), and blue-green (cyan) colors that function as a filter. In contrast to the additive process, the actual mixture is achieved through subtraction as the colors reduce the intensity of the light. In photography, especially found as the basis of the chromogene process.

Vintage print: A print where the actual shooting and printing of the photograph coincide. The print is either made directly by the photographer, or is at least initiated and controlled by him or her.

Visiting card photograph (*carte de visite*): 1854 invention of the French photographer Disdéri, consisting of black-and-white paper pictures (approx. 2 $\frac{1}{2}$ x 4 in.) produced in a semi-industrial process, affixed to cardboard, and distributed like calling or business cards.

Chronology

Chronology

1798 The brothers Claude and Joseph Nicéphore Niépce perform their first experiments to chemically fix the images produced by the camera obscura.

1802 In London, Thomas Wedgewood publishes an *Account of a method of copying paintings upon glass and of making profiles by the agency of light upon nitrate of silver.*

1816 Niépce produces the first paper photographs with a homemade camera set up in his studio window.

1819 English scientist John F. W. Herschel discovers the ability of sodium thiosulfate to dissolve silver salts.

1822 Niépce uses asphalt-coated glass to create the first nonfading heliographic copy of a graphic plate.

1826 Niépce makes the acquaintance of Louis Jacques Mandé Daguerre, owner of the spectacular Paris diorama, through the optician Vincent Chevalier.

1827 Niépce produces the first surviving nonfading photograph (a direct positive) by exposing a tin plate coated with light-sensitive asphalt for eight hours from his study window.

1829 Business contract between Niépce and Daguerre for the utilization of the photographic invention.

1834 English scholar William Henry Fox Talbot begins photographic experiments on light-sensitive paper at Lacock Abbey.

1835 Talbot photographs his library window from inside, thereby producing the first negative. With his small cameras ("mousetraps"), he produces several negative shots of his estate. In spite of early success, Talbot sets aside his experiments until after Daguerre's process becomes known in 1839.

1837 Daguerre discovers table salt as a fixative after long experimentation, and without knowledge of Talbot's research.

1839 François Arago, physicist and astronomer, reports briefly on Daguerre's invention to the Académie des Sciences in Paris. Hippolyte Bayard's photomechanical experiments in a direct positive process on paper are successful, and shortly thereafter he publicly exhibits 30 photographs in an auction hall. Carl August von Steinheil and Franz von Kobell begin experiments in Munich. The French government decides to purchase Daguerre's discovery. Arago reveals the details and explains the results of Niépce and Daguerre's discovery at a joint session of the Académie des Sciences and the Académie des Beaux Arts in Paris.

1840 Talbot invents calotypy (a positive printing process using a paper negative) which allows unlimited numbers of copies to be made. Alexander S. Walcott opens the first portrait studio in the United States.

1841 Richard Beard opens the first European portrait studio in London. Noël-Marie Paymal Lerebours produces 1,500 portraits in France's first commercial studio.

1842 Hermann Biow and Ferdinand Stelzner photographically record the great fire in Hamburg, Germany, thus creating the first photo report.

1843 David Octavius Hill and Robert Adamson complete approximately 1,800 calotypes

Chronology

in four and a half years.

1844 Talbot publishes *The Pencil of Nature*, the first book illustrated with photographs (glued-in calotypes).

1847 Sir David Brewster invents the double-eye stereo camera. Abel Niépce de St. Victor produces negatives on albumen-covered glass plates.

1850 Louis Désiré Blanquard-Evrard coats paper with albumen.

1851 Frederick Scott Archer publishes a description of the wet-collodion process, which becomes the most important photographic process until 1889. Gustave Le Gray improves the transparency of the paper negative through an immersion bath.

1852 Englishman Roger Fenton produces the first photographic travelog as he tours Kiev, St. Petersburg, and Moscow.

1854 André Adolphe Eugène Disdéri patents his visiting card portraits.

1855 Roger Fenton produces the first photographed war report with his 350 photographs on the Crimean War. French chemist J.M. Taupenot publishes his dry-collodion process in September.

1858 Gaspard Félix Tournachon, known as Nadar, completes the first aerial photographs.

1860 Nadar photographs the Paris catacombs with a portable light source.

1861 American photographer Mathew B. Brady equips a number of mobile photographer teams to document the Civil War.

1862 French pianist Louis Ducos du Hauron publishes studies on color photography processes.

1868 Ducos du Hauron presents the first colored pigment prints.

1871 Communards in Paris allow themselves to be photographed on the barricades; the pictures are later used by the authorities to identify and punish revolt participants. Richard Leach Maddox describes his invention of the gelatin dry plate.

1873 Hermann Wilhelm Vogel, professor of photochemistry in Berlin, announces the orthochromatic sensitizing of negative material.

1877 Eadweard Muybridge completes his first photographic series of motion.

1879 Johann Sachs (Berlin), Friedrich Wilde (Gör-

litz, Germany), and Carl Haack in Vienna produce gelatin silver bromide plates that allow almost instantaneous exposure times. Karel Klič develops the photogravure process in Vienna.

1880 Stephen H. Horgan publishes a screened half-tone photograph in the New York *Daily Graphic*, followed by Georg Meisenbach in the Leipzig *Illustrierte Zeitung* in 1883.

1888 Kodak No. 1, the first camera to take roll film, appears on the market; the device is light and inexpensive, and contains a "strip" film roll for 100 pictures.

1889 Peter Henry Emerson promotes the antiromantic attitude in his textbook *Naturalistic Photography*.

1891 Gabriel Lippmann publishes his *Methode der Photographie in Farben mittels Interferenzmethode* (Method of Photographing in Color by Means of the Inference Method).

1892 Founding of the Linked Ring, a splinter group from the Royal Photographic Society in England.

1894 Conrad Bernitt invents the Bosco-Automat for ferrotypes—a predecessor of automatic cameras.

Chronology

1896 Edward S. Curtis begins his twenty-volume photographic work on the Indian tribes of North America. By 1930, he produces 40,000 negatives.

1898 George Grantham Bain founds the Montauk Photo Concern—probably the first photographic agency.

1902 Adolph Miethe and Arthur Traube improve the photographic sensitivity for orange and red—an important requisite for color photography. Alfred Stieglitz and Edward Steichen found the Photo-Secession in New York, and its official mouthpiece *Camera Work*.

1904 Founding of the International Society of Pictorial Photographers under Craig Annan; first attempt at a worldwide association of art photographers.

1907 The Lumiére brothers begin manufacture in Lyons of the Autochrome process. The Dresden firm Ernemann announces an automatic Panorama Round Camera, able to photograph in 360 degrees.

1908 Introduction of the flash lamp for nitrate paper by Agfa. After improvements, the bulb is used for decades. Start of production of fire-resistant safety film based on cellulose acetate.

1912 Frank Eugene assumes the first teaching chair in Europe for art photography at the Royal Academy of the Graphic Arts in Leipzig, Germany.

1913 Oskar Barnack designs the first prototype of the Leica with the new 24 x 36 mm. film format.

1916 Linking a distance meter with the photographic lens allows more exact and faster focusing.

1922 Man Ray publishes his Rayograms in a folder entitled *Champs Délicieux*.

1924 The Ermanox camera, built in Dresden and equipped with the powerful Renovator lens, revolutionizes photojournalism. Alexander Rodchenko illustrates Mayakovsky's poem *Pro eto* with sensational photomontages.

1925 Introduction of the Leica onto the market after a number of hand-finished models had been released in a market survey in 1923, and had been largely rejected by professionals. Paul Vierkötter builds the Vacublitz, a bulb-like glass cylinder filled with magnesium powder to provide flash exposures. Moholy-Nagy's *Painting, Photography, Film* is published as part of the Bauhaus book series.

1928 Albert Renger-Patzsch publishes his picture volume *The World Is Beautiful*. The American photographer Berenice Abbot buys negatives from the estate of Jean Eugène Atget, thus securing the work of the posthumously recognized photographer. Founding of the photographic agency Dephot. Publishing of the plant study by Karl Blossfeldt in the illustrated book series *Urformen der Kunst* (Primal Forms of Art).

1929 Franke & Heidecke present the Rolleiflex, the first twin-eyed 6 x 6 mirror reflection camera. Exhibition of the world's most modern photographic works at the German Werkbund (Workers' Union) *Film and Photo* (FIFO) show in Stuttgart, Germany.

1931 Publication of Erich Salomon's illustrated volume *Famous Contemporaries in Off-Guard Moments*: Harold Edgerton develops a device for the production of extremely short electronic flashes that allow stroboscopic pictures to be made.

1932 Founding of "f/64," a group of photo-

Chronology

graphers centered around Edward Weston, initially in San Francisco.

1933 First small-format color-slide film, Agfacolor, based on the raster-line process.

1935 President Franklin Roosevelt establishes the Farm Security Administration (FSA) which employs many famous American documentary photographers.

1936 First color-slide film with chromogene development in the United States (Kodachrome) and Germany (Agfacolor New). The Ihagee firm in Dresden designs the first small picture mirror reflection camera. Gisèle Freund concludes her studies at the Sorbonne in Paris with a dissertation on the sociology of photography, which later becomes a standard reference in photographic literature. First issue of *LIFE* magazine appears. Walter Benjamin's *The Work of Art in the Age of Technical Reproduceability* is published in Paris.

1928 Edith Weyde and André Rott invent the silver halide diffusion process as the basis for office copiers and instant photography.

1942 Introduction of the negative roll film

Kodacolor and of color print paper for amateurs in the United States. Announcement of Agfacolor paper in Germany, but war prevents its introduction on the market.

1946 Introduction of the photographic process in the polygraph industry.

1947 After a series of improvements, Land's instant Polaroid camera is introduced to the worldwide public. Edward Steichen assumes the directorship of the photographic collection of the Museum of Modern Art in New York. Founding of the Magnum Agency by Cartier-Bresson, David Seymour, Georg Rodger, and Robert Capa.

1948 Denis Gabor invents holography, which becomes practical only in combination with laser technology in 1960.

1949 The Autoreflex T introduces the principle of light metering through the objective lens.

1950 First *photokina* fair in Cologne, Germany.

1955 Edward Steichen organizes the influential international exhibit *The Family of Man*.

1956 Robert Frank publishes his illustrated volume *The Americans*, which meets with fierce criticism.

1959 The Voigtländer firm develops a zoom lens for cameras.

1960 Presentation of the first instant color pictures, Polacolor, by Edwin Land.

1962 Publication of the Cibachrome process (silver dye and bleach) in Switzerland.

1963 Simplification of film insertion through cassette systems introduced by Kodak and Agfa. Canon introduces a camera with automatic focusing. Lennard Nilsson photographs in color a living, eleven-week-old fetus within the womb. Introduction of the Polaroid SX 70.

1972 Introduction of the 16 mm. cassette camera for still shots (pocket camera).

1973 Introduction of the first fully electric camera, the Rolleiflex SLX; marketed in 1978.

1981 Sony presents, but does not market, the first still video camera, the Mavica.

1991 Introduction of the high-resolution Kodak Digital Camera System DCS for professional electronic picture making.

1995 The Casio QV 10 introduces the first digital camera affordable to amateurs.

1996 Kodak introduces Advanced Photo System (APS) to enable more accurate processing.

Galleries and Museums

Galleries and Museums

Berlin
Berlinische Galerie
Martin-Gropius-Bau
Stresemannstr. 110
10693 Berlin
Germany
Tel. (30)25 48 60

Deutsches Historisches
Museum (DHM)
Unter den Linden 2
10117 Berlin
Germany
Tel. (30)215 02 0

Fotogalerie
am Helsingforser Platz
Kulturamt Friedrichshain
Helsingforser Platz 1
10243 Berlin
Germany
Tel. (30)588 62 I3

Studio Bildende Kunst,
Kommunale Galerie Kultur-
amt Treptow
Baumschulenstr. 78
12437 Berlin
Germany
Tel. (30)532 97 37

Neue Gesellschaft für
Bildende Kunst e. V.
(NGBK)
Oranienstr. 25
10999 Berlin
Germany
Tel (30)615 30 31

Cologne
Museum Ludwig/Wallraf-
Richartz-Museum mit dem
Agfa Foto-Historama
Bischofsgartenstr. 1
50667 Köln
Germany
Tel. (221)221 23 81

Sparkassenstiftung Kultur
Im Mediapark 7
50670 Köln
Germany
Tel. (221)226 59 00

Frankfurt am Main
Fotografie Forum Frankfurt
Leinwandhaus Weckmarkt 17
60311 Frankfurt am Main
Germany
Tel. (69)29 17 26

Frankfurter Kunstverein e. V.
Markt 44
60311 Frankfurt am Main
Germany
Tel. (69)28 53 39

Hamburg
Museum für Kunst
und Gewerbe
Steintorplatz 1
20099 Hamburg
Germany
Tel. (40)248 626 30

Galerie der Landesbildstelle
Hamburg
Kieler Str. 171
22525 Hamburg
Germany
Tel. (40)549 93 06

Lausanne
Musée de l' Elysee
Avenue de l'Elysee 18
1014 Lausanne
Switzerland
Tel. (21)617 48 21

London
Photographer's Gallery
5/8 Great Newport St
London WC2H 7HY
Great Britain
Tel. (171)831 17 72

Camerawork
121 Roman Rd
London E2 0QN
Great Britain
Tel. (181)980 62 56

National Portrait Gallery
St. Martin's Pl.
London WC2H 0HE
Great Britain
Tel. (171)306 00 55

Hayward Gallery
South Bank Centre
London SE1 8XZ
Great Britain
Tel. (171)928 31 44

Victoria & Albert Museum
Tel. (171)938 85 00
Natural History Museum
Tel. (171)938 91 23
Cromwell Rd
South Kensington
London SW7 2RL
Great Britain

Los Angeles
Jan Kesner Gallery
164 N. La Brea Ave
Los Angeles, CA 90036
Tel. (213) 938-6834

Malibu
J. Paul Getty Museum
17985 Pacific Coast H'way
Malibu, CA 90265
Tel. (310) 459-7611

Munich
Fotomuseum im Münchner
Stadtmuseum
St.-Jakobs-Platz 1
80331 München
Germany
Tel. (89)233 229 48

Galleries and Museums

Galerie Mosel & Tschechow
Winterstr. 7
81543 München
Germany
Tel. (89)651 56 21

New York
International Center
of Photography (ICP)
1130 Fifth Avenue
New York, NY 10128
Tel. (212) 860-1777 and
1133 Ave of the Americas
Tel. (212) 768-4680

Museum of Modern Art
11 West 53rd St
New York, NY 10019
Tel. (212) 708-9480

Metropolitan Museum of Art
1000 Fifth Avenue
New York, NY 10028
Tel. (212) 535-7710

Howard Greenberg Gallery
120 Wooster St
New York, NY
Tel. (212) 334-0010

Pace, Wildenstein, MacGill
32 East 57th St
New York, NY 10022
Tel. (212) 759-7999

Paris
Musée d' Orsay
1, rue de Bellechasse
75007 Paris
France
Tel. (1)40 49 48 14

Centre National d'Art et de
Culture Georges Pompidou
19, rue Beaubourg
75191 Paris
France
Tel. (1)44 78 12 33

Maison Européenne de la
Photographie
5-7, rue Fourcy
75004 Paris
France
Tel. (1)44 78 75 00

Bibliothèque Nationale de
France
Département des Estampes
et de la Photographie
58, rue de Richelieu
75002 Paris
France
Tel. (1)47 03 83 80

Société Française de
Photographie
Passage Colbert entre
2, rue Vivienne et
6, rue des Petits Champs
75002 Paris
France
Tel. (1)47 03 75 39

Centre National de la
Photographie (CNP)
11, rue Berryer
75008 Paris
France
Tel. (1)53 76 12 32

Musée d'Art Moderne
de la Ville de Paris
111, avenue du
Président Wilson
75116 Paris
France
Tel. (1)47 23 61 27

Salzburg
Galerie Fotohof
Erhardplatz 3
5020 Salzburg
Austria
Tel. (662)849 29 60

Österreichische Fotogalerie
im Rupertinum
Wiener-Philharmoniker-
Gasse 9
5010 Salzburg
Austria
Tel. (662)804 225 68

San Francisco
Fraenkel Gallery
49 Geary St
San Francisco, CA 94108
Tel. (415) 981-2661

Ansel Adams Center
for Photography
250 Fourth St
San Francisco, CA 94103
Tel. (415) 495-7000

Santa Monica
G. Ray Hawkins Gallery
908 Colorado Ave
Santa Monica, CA 90401
Tel. (310) 394-5558

Gallery of Contemporary
Photography
Bergamot Station Arts
Center, Building D-3
2525 Michigan Ave
Santa Monica, CA
Tel. (310) 264-8440

Zurich
Kunsthaus Zürich und
Schweizerische Stiftung für
die Photographie
Heimplatz 1
8024 Zürich
Switzerland
Tel. (1)251 67 65

Galerie zur Stockeregg
Stockerstr. 33
8022 Zürich
Switzerland
Tel. (1)202 69 25

Magazines ... Selected Bibliography

Magazines

American Photo: Magazine for amateurs, dealing with all areas of photography. Appears every two months.

Aperture: American magazine for people interested in photography as well as art. Appears irregularly.

European Photography: International art magazine for contemporary photography and new media. Appears every six months.

Creative Camera: English magazine mainly presenting the British avant-garde of photography. Appears six times per year.

Popular Photography: American magazine for amateurs as well as professionals, focuses on technical topics. Appears monthly.

Selected Bibliography

Adams, Ansel. *The Camera.* Boston: Little, Brown, 1980.
Adams, Ansel. *The Negative.* Boston: Little, Brown, 1981.
Adams, Ansel. *The Print.* Boston: Little, Brown, 1983.
Barthes, Roland. *Camera Lucida: Reflections on Photography.* New York: Farrar, Straus and Giroux, 1981.

Beaton, Cecil, and Gail Buckland. *The Magic Image: The Genius of Photography from 1839 to the Present Day.* London: Pavilion, 1989.
Bernard, Bruce. *Photo-discovery: Masterworks of Photography, 1840–1940.* New York: Harry N. Abrams, 1980.
Buerger, Janet E. *French Daguerreotypes.* Chicago: University of Chicago Press, 1989.
Bunnell, Peter, ed. *A Photographic Vision: Pictorial Photography, 1889–1923.* Salt Lake City, UT: Peregrine Smith, 1980.
Collins, Douglas. *The Story of Kodak.* New York: Harry N. Abrams, 1990.
Coote, Jack H. *The Illustrated History of Colour Photography.* Surbiton, UK: Fountain, 1993.
Eskind, Andrew H., and Greg Drake, eds. *Index to American Photographic Collections*, 2d ed. Boston: G.K. Hall, 1990.
Ewing, William A. *The Body: The Human Form.* San Francisco: Chronicle, 1994.
Fabian, Rainer, and Hans-Christian Adam. *One Hundred Thirty Years of War Photography.* London: New English Library, 1985.
Freund, Gisèle. *Photography & Society.* Boston: David R. Godine, 1980.
Galassi, Peter. *Before Photography: Painting and the Invention of Photography.* New York: Museum of Modern Art, 1981.

Galassi, Peter. *American Photography 1890–1965: From the Museum of Modern Art, New York.* New York: Museum of Modern Art, 1995.
Gernsheim, Helmut. *A Concise History of Photography.* New York: Dover, 1986.
Great Photographic Essays from Life. Commentary by Maitland Edey, pictures ed. by Constance Sullivan. Boston: New York Graphic Society, 1978.
Green, Jonathan, ed. *Camera Work: A Critical Anthology.* New York: Aperture, 1990.
Kingslake, Rudolph. *A History of the Photographic Lens.* London: Academic Press, 1989.
Life: Sixty Years: A 60th Anniversary Celebration, 1936–1996. New York: Time, Inc., 1996.
Lyons, Nathan, ed. *Photographers on Photography: A Critical Anthology.* Englewood Cliffs, NJ: Prentice-Hall, 1966.
Manchester, William. *In Our Time: The World as Seen by Magnum Photographers.* New York: American Federation of the Arts/W.W. Norton, 1989.
Newhall, Beaumont. *Photography: Essays & Images.* New York: Museum of Modern Art, 1980.
Newhall, Beaumont. *The History of Photography.* New York: Museum of Modern Art, 1982.
Newhall, Beaumont. *From Adams to Stieglitz: Pioneers*

of Modern Photography. New York: Aperture, 1989.

Rosenblum, Naomi. A History of Women Photographers. New York: Abbeville, 1994.

Rosenblum, Naomi. A World History of Photography, 3d ed. New York: Abbeville, 1997.

Sontag, Susan. On Photography. New York: Anchor, 1990.

Stryker, Roy, and Nancy Wood. In This Proud Land: America 1935–1943 as Seen in the FSA Photographs. Greenwich, CT: New York Graphic Society, 1973.

Szarkowski, John. Looking at Photographs. New York: Museum of Modern Art, 1973.

Szarkowski, John. The Photographer's Eye. New York: Museum of Modern Art, 1980.

Wells, Liz. Photography: A Critical Introduction. New York: Routledge, 1997.

Wurman, Richard Saul. Polaroid: ACCESS Fifty Years. Cambridge, MA: Access Press, Ltd./Polaroid Corporation, 1989.

Zakia, Richard, and Leslie Stroebel. The Focal Encyclopedia of Photography, 3d ed. Boston: Focal Press, 1993.

Monographs

Abbott, Berenice: Berenice Abbott: Photographs.

Foreword by Muriel Rukeyser, introduction by David Vestal. New York: Horizon Press, 1970. Reprint, Washington, DC: Smithsonian Institution Press, 1990.

Adams, Ansel: Ansel Adams: An Autobiography. Boston: Little, Brown, 1985.
Yosemite and the Range of Light. Boston: New York Graphic Society, 1979.
Ansel Adams: Images 1923–1974. Foreword by Wallace Stegner. Boston: New York Graphic Society, 1974.

Arbus, Diane: Diane Arbus. New York: Aperture, 1972.
Diane Arbus: A Biography, by Patricia Bosworth. New York: Alfred A. Knopf, 1984.

Atget, Eugene: The Work of Atget, 4 vols., ed. by John Szarkowski and Maria Morris Hambourg. New York: Museum of Modern Art, 1981–85.

Avedon, Richard: Portraits. Essay by Harold Rosenberg. New York: Farrar, Straus and Giroux, 1976.
An Autobiography. New York: Random House, 1993.

Beaton, Cecil: Cecil Beaton: A Retrospective. Boston: Little, Brown, 1986.

Bellocq, E.J.: Bellocq: Photographs from Storyville, The Red-Light District of New Orleans. New York: Random House, 1996.

Bourke-White, Margaret: The Photographs of Margaret Bourke-White,

ed. by Sean Callahan. Greenwich, CT: New York Graphic Society, 1972.
Margaret Bourke-White: 1904–1971: Photographs. Introduction by Terrence Heath. Toronto: Jane Corkin Gallery, 1988.

Brady, Mathew B.: Mathew Brady's Portrait of an Era, by Roy Meredith. New York: Norton, 1982.

Brandt, Bill: The Shadow of Light: A Collection of Photographs from 1931 to the Present. Introduction by Cyril Connolly and notes by Marjorie Beckett. London: Bodley Head, 1966.

Brassaï: Brassaï. Introduction by Lawrence Durrell. New York: Museum of Modern Art, 1968.

Cameron, Julia Margaret: Julia Margaret Cameron, 1815–1870. Boston: Little, Brown, 1984.

Capa, Robert: Robert Capa: Photographs. Foreword by Henri Cartier-Bresson. New York: Aperture, 1996.

Carroll, Lewis: Lewis Carroll, Photographer, rev. ed., by Helmut Gersheim. New York: Dover, 1979.

Cartier-Bresson, Henri: The Decisive Moment. New York: Simon and Schuster, 1952.
Henri Cartier-Bresson: The Early Work. Introduction by Peter Galassi. New York: Museum of Modern Art, 1987.
Henri Cartier-Bresson and the Artless Art, by Jean-Pierre Montier. Boston: Little, Brown, 1996.

Monographs

Coburn, Alvin Langdon: *Alvin Langdon Coburn: Photographer: An Autobiography*, ed. by Helmut Gernsheim and Alison Gernsheim. New York: Dover, 1978.

Doisneau, Robert: *Robert Doisneau: A Photographer's Life*, by Peter Hamilton. New York: Abbeville, 1995.

Evans, Walker: *Let Us Now Praise Famous Men*, by Walker Evans and James Agee. Boston: Houghton Mifflin, 1988.
Walker Evans. Introduction by John Szarkowski. New York: Museum of Modern Art, 1971.
Walker Evans: A Biography, by Belinda Rathbone. Boston: Houghton Mifflin, 1995.

Fenton, Roger: *Roger Fenton: Photographer of the 1850s*. London: South Bank Board, 1988.

Frank, Robert: *The Americans*. Photographs by Robert Frank. Intro. by Jack Kerouac. New York: Aperture, 1978.
Robert Frank, by Sarah Greenough and Philip Brookman. Washington, DC: National Gallery, 1994.

Friedlander, Lee: *Letters from the People: Photographs by Lee Friedlander*. New York: Museum of Modern Art, 1993.

Goldin, Nan: *Nan Goldin: I'll Be Your Mirror*. New York: Whitney Museum of American Art, 1996.

Haas, Ernst: *Ernst Haas: A Colour Retrospective*. London: Thames and Hudson, 1989.
Ernst Haas in Black and White. Boston: Little, Brown, 1992.

Kertész, André: *André Kertész of Paris and New York*, by Sandra Phillips, David Travis, and Weston J. Naef. New York: Thames and Hudson, 1985.
André Kertész: His Life and Work, by Pierre Borham. Boston: Little, Brown, 1994.

Klein, William: *Close Up*. New York: Thames and Hudson, 1990.

Lange, Dorothea: *Dorothea Lange: Photographs of a Lifetime*, by Robert Coles. New York: Aperture, 1982.
The Photographs of Dorothea Lange, by Keith F. Davis. New York: Hallmark/Harry N. Abrams, 1995.

Liebovitz, Annie: *Photographs: Annie Liebovitz, 1970–1990*. New York: HarperPerennial, 1991.

Mapplethorpe, Robert: *Robert Mapplethorpe*, by Richard Marshall. New York: Whitney, 1988.

Mark, Mary Ellen: *Mary Ellen Mark: 25 Years*, by Marianne Fulton. Boston: Little, Brown, 1991.

Modotti, Tina: *Tina Modotti: Photographs*, ed. by Sarah M. Love. New York: Harry N. Abrams, 1995.

Moholy-Nagy, László: *Moholy-Nagy: Photographs and Photograms*, by Andreas Haus. New York: Pantheon Books, 1980.

Muybridge, Eadweard: *Muybridge: The Human Figure in Motion*. New York: Dover, 1955.
Muybridge's Complete Human and Animal Locomotion, 3 vols. Introduction by Anita Ventura Mozley. New York: Dover, 1979.

Nadar (Gaspard Félix Tournachon): *Nadar*, by Nigel Gosling. New York: Alfred A. Knopf, 1976.
Nadar, by Maria Morris Hambourg, Françoise Heilbrun, and Philippe Néagu. New York: Metropolitan Museum of Art, 1995.

Newton, Helmut: *Portraits*. New York: Pantheon, 1987.

Penn, Irving: *Irving Penn*, by John Szarkowski. New York: Museum of Modern Art, 1984.

Ray, Man: *Self-Portrait*. Boston: Little, Brown, 1963.
Perpetual Motif: The Art of Man Ray, by Merry A. Foresta, et al. New York: Abbeville Press, 1988.

Renger-Patzsch, Albert: *Albert Renger-Patzsch: 100 Photographs*. Essays in English, German, and French by Fritz Kempe and Carl Georg Heise. Cologne: Galerie Schurmann & Kicken, 1979.

Rheims, Bettina: *Modern Lovers*. Paris: Paris Audiovisuel, 1990.

Robinson, Henry Peach: *Henry Peach Robinson: Master of Photographic Art, 1830–1901*, by Margaret F. Harker. Oxford: Basil Blackwell, 1988.

Rodchenko, Alexander: *Alexander Rodchenko, 1891–1956*, ed. by David

Monographs

Elliot. Oxford: Museum of Modern Art, 1979.

Rodero, Cristina Garcia: *España Oculta: Cristina Garcia Rodero*, 2d ed. Washington, DC: Smithsonian Institution Press, 1995.

Salgado, Sebastiago: *Workers: An Archeology of the Industrial Age.* New York: Aperture, 1993.

Sander, August: *August Sander: Photographs of an Epoch, 1904–1959.* Preface by Beaumont Newhall. Historical commentary by Robert Kramer, with excerpts from writings by Sander and his contemporaries. New York: Aperture, 1980.

Seymour, David: *Chim: Photographs of David Seymour*, by Inge Bondi, intro. by Henri Cartier-Bresson. Boston: Little, Brown, 1996.

Shahn, Ben: *The Photographic Eye of Ben Shahn*, ed. by Davis Pratt. Cambridge, MA: Harvard University Press, 1975.

Sherman, Cindy: *Cindy Sherman*, essays by Peter Schjeldahl and Lisa Phillips. New York: Whitney, 1987. *Cindy Sherman, 1975–1993*, by Rosalind Krauss and Norman Bryson. New York: Rizzoli, 1993.

Steichen, Edward: *Steichen the Photographer.* New York: Museum of Modern Art, 1961. *A Life in Photography.* Garden City, NY: Doubleday, 1963.

Stieglitz, Alfred: *Alfred Stieglitz: Photographs &*

Writings, ed. by Sarah Greenough and Juan Hamilton. Washington, DC: National Gallery of Art, 1983. *Alfred Stieglitz and the Photo-Secession*, by William Innes Homer. Boston: Little, Brown, 1983. *Alfred Stieglitz: A Biography*, by Richard Whelan. Boston: Little, Brown, 1995.

Strand, Paul: *Paul Strand: The World on My Doorstep: The Years 1950–1976.* New York: Aperture, 1994.

Talbot, William Henry Fox: *Fox Talbot and the Invention of Photography*, by Gail Buckland. Boston: David R. Godine, 1980. William Henry Fox Talbot, *The Pencil of Nature.* Reprint. New York: Da Capo Press, 1961.

Vishniac, Roman: *To Give Them Light: The Legacy of Roman Vishniac.* New York: Simon and Schuster, 1993.

Weegee: *Naked City.* Reprint. New York: Da Capo Press, 1975.

Weston, Edward: *Weston's Portraits and Nudes*, by Theodore E. Stebbins, Jr. Boston: Museum of Fine Arts, 1989. *Edward Weston: The Flame of Recognition. His Photographs Accompanied by Excerpts from His Daybooks and the Letters*, ed. by Nancy Newhall. New York: Aperture, 1993.

White, Minor: *Minor White: The Eye That Shapes*, by Peter Bunnell. Boston: Little, Brown, 1989.

Winogrand, Garry: *Winogrand: Figments from the Real World*, by John Szarkowski. New York: Museum of Modern Art, 1988.

Zille, Heinrich: *Heinrich Zille, Photographien Berlin 1890–1910*, by Winfried Ranke. Munich: Schirmer/ Mosel, 1975.

Monograph Series:

Aperture Masters of Photography:
No. 1, *Paul Strand;*
No. 2, *Henri Cartier-Bresson;*
No. 3, *Manuel Alvarez Bravo;*
No. 4, *Roger Fenton;*
No. 5, *Dorothea Lange;*
No. 6, *Alfred Stieglitz;*
No. 7, *Edward Weston;*
No. 8, *Man Ray;*
No. 9, *Berenice Abbott;*
No. 10, *Walker Evans;*
No. 11, *André Kertész.*
New York: Aperture, 1983–.

Subject Index

Subject Index

Aberration 61
abstract photography 85, 143–144
achromatic lens 12
additive color 67
advanced photo system (APS) 171
aerial photography 37
aesthetic 13, 21, 25, 38, 45, 47–48, 85, 87–88, 90–92, 97, 99, 133, 143, 145–147
Agfa 69, 120
albumen 30, 60
alienation 95
allegory 43
amateur 67, 72, 158
ambrotype 32–33
American film 66
American style 84–86, 89
American way of life 132, 135–136
ammonia 15
anastigmatic lens 33
anilin dye 31
anti-art 149
aperture 61, 87
Aplanat lens 33, 61
APS, see advanced photo system
arc lamp 62
architectural photography 26–27, 44, 60, 86–87, 135, 160
Aristo paper 60, 83
arranged photography 166–168
art deco 92
art nouveau 47, 59
art photography 70–73, 85
artistic aid 11, 13, 15, 26
assemblage 99
astigmatic lens 61
astigmatism 61–62
autochrome plate 69
automatic art 98, 102
autotypy 52–53, 108

avant-garde 37, 96–97, 99, 104–105, 158

Banality 137, 147–148, 162–163
barium crown glass 61
Bauhaus 86, 89, 92, 106, 107, 145
Belle Epoque 65
bellows 29
Belly-button perspective 105
binary data 170
binocular stereoscope 35
bitumen 16–17, 53
body art 148, 151
bromide 92
bromide-oil prints 71

Cabinet photo 40
calotype 21, 41, 56
camera 61
camera lucida 13, 15
camera obscura 10–11, 15–18
cartes de visite 39–40
celluloid sheets 59
chromogenic process 120
chronographic projector 64
chronophotography 64
Cibachrome 171
cinema 64–65, 99
cityscape 162
collage 99–101, 148
collodion process 28–32, 48, 53–54, 58
collotype, see phototypy
color 67–69, 120
color dispersion 61
color sensitivity 59
color, inference method 68
combination technique 45, 72
commercial photography 94, 105, 141–143
composite prints 43–45
conceptual art 151
constructivism 97, 105, 107
contact print 22, 30–31
Contax 109

contemporary photography 169–171
copy paper, ready to use 60
cost 13, 23, 25, 36, 40, 50, 66, 108
cubism 64

Dada, dadaism 97–99, 101, 103, 119
Dagor lens 62
daguerreotypes 15–16, 24, 30, 32, 43, 48, 65
dark room 29, 50, 53–54, 58
demand 51, 128
detective camera, see magazine camera
Deutscher Werkbund 98
diaphram shutter 61
diapositives 68
digital photography 170
diorama 13–14
diptych 169
direct positive process 22
directorial mode 167
documenta 5 (exhibition) 148
documentary photography 86, 121–122, 126, 135–137, 149–150, 156, 167
double exposure 103
dry plate, see collodion
dye-transfer process 164–165

Earth art 151
electric light 37
enlargers 31, 103
Ermanox 108–110
erotic photography 41–42
etching 16–17, 108
ethnology 41, 54–55
expeditions 53–55
experimental photography 146
exposure 44, 48–49, 59, 61

Subject Index

exposure time 19, 21–24, 26, 30, 32
expressionism 64, 123

Farm Security Administration (FSA) 78, 118, 126–127, 130
fashion photography 75, 94–96, 103, 118–119, 141–143
ferrotype 32–33
FIFO (Film and Photo Exhibit, Stuttgart, 1929) 90–91, 98, 106
film 66
filters 67–68, 103, 146
First International Exhibition of Amateur Photographs 72
fixative 15, 19
fixed-focus lens 66
flash lamp 22
fluxus 148, 150
focus 48, 61, 109
focal-plane shutter 61, 64–65, 109
Freudianism 99, 103
futurism 64

Gallery 29, 74–75, 101
gallic acid 22
gelatin dry plate 60
gelatin emulsion 58
gelatin film 62
generative aesthetics 146–147
Generative Photography 146–147
glamour photography 94–96
glass negative 30
glass plates 16, 29–30, 50
Great Depression 122, 126–127
Great Exhibition (London, 1851) 28, 35
gum-bichromate prints 72
gum prints 71–72, 92

Halftone reproduction 50–53, 72

halogen salts 31; see also chlorine, bromine, iodine
happening 148–150
Hasselblad 110
heliochrome 68
heliography 16, 19
heliogravure 52–53
high speed photography 63–64, 121
Higher School of Abstraction 145
hood 61
human interest photography 128–130, 143–144
hyperrealism 147–149

Imagism 101
impressionism 37
industrial photography 86–87, 89–90, 159–160
industrial production 26, 30, 39, 58–59, 65–66
inference method (color) 68
installation 168
intaglio prints 56–57
iodide emusion 28
iodine vapor 24

Jump pictures 140

Kinetic art 97
Klapp-Krauss camera 65
Kodak 65–66, 69, 120

Lacock Abbey 211
land art 148–149, 151
landscape 25, 32, 56–57, 59, 62, 88, 90, 134–135
large format pictures 61, 160
latent image 19
laterna magica, see magic lantern
leaf 61, 65
Leica 109–111, 114, 152
lenses 12, 23, 32–33, 60–62, 66, 103, 109
light effects 144
light sensitivity 16, 21, 58–59

lighting 62, 94
linen 32
Linked Ring 73
lithography 16, 38, 50–51
live photography 122, 128, 152
living tableaus 46
luminogram 146

Magic lantern 12, 15
Magnum 114, 128–129, 152–153
Mammoth 61
manipulation 43, 46, 50, 85, 87, 94, 130, 146
mass media 94, 108, 118–119
melanotype, see ambrotype
mercury (vapor) 18, 24
metal plates 16–17, 19, 22, 32
middle class 12, 36, 40
military 44, 48–49
minimal art 148
MIT 121
mobility 58, 60
montage 148
mounting 32
mouse trap 21
movement 62–63
multiple copies 16
multiple exposure 146
multiple lighting 45
museum photography 59, 160
Museum of Modern Art 75, 87, 132, 138

Narrative tableaus 168
National Child Labor Committee (NCLC) 77
National Endowment for the Arts 164
naturalism 70–71
nature photography 87–88
Nazi period 109, 111, 118, 122, 125, 132
negative-positive process 20, 23, 120
negatives, paper 21–22

Subject Index

New Document (exhibit) 138
New Objectivity 88–91
new photojournalism 155
New York School 138
nitrocellulose 28, 31
noble printing processes 71, 92
nude photography 24–25, 40–42, 71, 73, 134–135, 162, 164–166

Objectivity 100
oil of lavender 17
op art 147
optics 10, 12, 32, 61, 144
orthochromatic 59, 62

Painting and photography 41, 43, 47, 57, 97–98
panchromatic 59, 62, 69
pannotype 32–33
panorama 13–14
panorama camera 33
paper prints 22–23, 25, 30, 32
Paris Commune 36, 50
patents 20–22, 27
peinture pure 97
perspective 34, 44, 105, 137
Petzval lens 23, 32
photo essays 130
Photo-Secession (New York) 73–76, 92, 133
photochemistry 44, 58–62, 144
photogenic drawings 13, 20–21, 97
photogram 60, 97–101, 103, 105, 146, 171
photograph as icon 130, 138–139
photographic photography 85, 89
Photographic Salon, The (London) 73
Photographic Society of London 50, 55
photography and art 37

photography as threat to art 15, 25
photography studios 23–24
photogravure, see heliogravure
photojournalism 47, 50, 108–111, 128, 152
photomechanical process 16
photomontage 43, 97, 103, 105, 107, 146
photorealism, see hyperrealism
photosculpture 168
phototechnology 58–72
phototypography 22
phototypy 37, 51, 53
physionotrace 13, 15
pictorial photography 43, 70, 85, 89, 91–92
pigmented prints 53, 71
pinhole 171
platinum 71, 92
Polaroid 120, 161
pop art 147–149
pornography 40–42
portrait 25, 36, 39–40, 46, 59, 71, 92–94, 138–141, 143
portrait lens, see Petzval lens
positive print 22
positive printing paper 120–121
potassium iodide 30
Pre-Raphaelites 39, 43, 46–48
printing 51–52
printing-out paper 60
prism 146
propaganda 49, 104–105, 123–124, 154
pseudo-solarization 146

Rapid Rectilinear lens 61
raster method, see screen particle method
Rayography 15, 98
realism 45, 47, 76–82, 104
refraction 61
refractive index 12
reportage 26–27

reproduceability 16, 23, 25, 34, 52, 108
retouching 38, 43, see also manipulation
Rhode Island School of Design 138
roll film (celluloid) 59, 65
Rolleiflex 109
rotogravure 128
Royal Institution of London 67
Royal Society (London) 18, 20, 34

Salt paper 22, 31
sandwiching 146
Saronny head support 24
Schadography 15, 98
School of Design (Chicago) 106
screen particle method 68–69
sea photography 44
serial photography 148, 150
shutter 60–61, 64; see also diaphram, focal plane
silver bromide 15, 58, 66
silver chloride 15, 18–19
silver iodide 18, 30
silver nitrate 21–22, 29, 31
silver salts 14
single-lens reflex 109–110
slide projector 12
Société Française de Photographie 51
soft focus 43, 70–72
Solar (enlarger) 31
solarization 103, 146
speed 121
spherical lens 33
spread 52
stereoscopy 28, 34–35
straight photography 70, 74, 84–88, 91
street photography 129, 135
stripping film 66
subjective realism 133–138

Subject Index … Index of Names

subjectivism 143–145
surrealism 82, 89, 99, 101–103, 107, 119

Tableaux vivants 168
tabloid journalism 110
Talbotype, see calotype
technology 58–59
Tessar lens 62
three-color process 68
tintype 32–33
tonal range 32
traces of evidence art 150
travel photography 52–56
traveling photographers 32
tripod 56, 58, 60
typology 93

Urbanization 135–136

Venice Biennale 138
Victorian photography 38
Vienna Actionists 150
Vienna Camera club 72

Wall Street 85
wet-plate process, see
 collodion process
wide-angle lens 33, 158, 162
Woodburytype 53
woodcuts 51

Zurich dadaism 98–99

Index of Names

Abbe, Ernst 61
Abbott, Berenice 83, 92
Abu Ali Alhazen 10
Adams, Ansel 87–88, 134
Adams, Eddie 154–155
Adams, Robert 163
Adamson, Robert 25–26, 71
Agee, James 127
Albers, Josef 107

Albert, Joseph 51
Alma-Tadema, Lawrence, Sir 47
Annan, James Craig 73
Anschütz, Ottomar 64
Apollinaire, Guillaume 97
Arago, François 19
Araki, Nabuyoshi 162
Arbus, Diane 137–138, 163
Archer, Frederick Scott 28, 31
Aristotle 10
Arnold, Eve 153
Atget, Jean-Eugène Auguste 82–83
Avedon, Richard 140–143

Bailey, David 165
Balard, Antoine Jérôme 15
Baldessari, John 168
Barbieri, Olivo 160–161
Barnack, Oskar 108–109
Barnard, George N. 50
Barthes, Roland 155
Baudelaire, Charles 37–38, 43
Bayard, Hippolyte 22, 98
Bayer, Herbert 103, 107
Beard, Richard 24
Beato Felice 48, 56
Beaton, Cecil 95, 119, 125
Beccaria, Giacomo Battista 14
Becher, Bernd and Hilla 146, 159–160
Bedford, Francis 54
Bellmer, Hans 102–103
Belloc, Auguste 42
Bellocq, Ernest J. 78–79
Benjamin, Walter 25, 83, 115
Bennett, Charles Harper 59
Bense, Max 146
Beuys, Joseph 150, 170
Biermann, Aenne 91
Bingham, Robert J. 28
Biow, Hermann 18, 24, 48
Bischof, Werner 131, 153

Bisson, Auguste and Louis 37, 55–57
Blanquart-Evrard, Louis Désiré 26–27, 30
Blossfeldt, Karl 90
Blühová, Irena 107
Blume, Bernhard 168
Blumenfeld, Erwin 94, 101, 119–120
Boltanski, Christian 151, 169–170
Bonnard, Pierre 47, 67
Boonstra, Rommert 168
Boubat, Edouard 129
Bourke-White, Margaret 122, 125, 130, 133
Bouton, Charles Marie 14
Brady, Mathew 25, 39, 49–50
Bragaglia, Antonio Julio 64
Brandt, Bill 115–116, 125
Brandt, Marianne 107
Braquehais, B. 40, 42
Brassaï 113, 129
Brecht, Bertolt 88
Breier, Kilian 146
Breitenbach, Josef 115
Breton, André 96, 99, 102
Brewster, David 35
Broocks, Ellen 168
Broodthaers, Marcel 146
Bull, C. Sinclair 95
Burger, Wilhelm 54–56
Burgess, John 58–59
Burgin, Victor 168
Burkart, Hans-Jürgen 155
Burri, René 131, 153
Burrows, Larry 155

Caldwell, Erskine 122
Callahan, Harry 133–134
Cameron, Julia Margaret 38–39, 45–47
Capa, Robert 113–115, 124–125, 152–153
Caponigro, Paul 134–135
Carjat, Etienne 37–38
Caron, Gilles 155
Carroll, Lewis, see Dodgson, Charles

Index of Names

Cartier-Bresson, Henri 113–114, 125, 127, 152–153

Champfleury, Jules 64–65

Charbonnier, Jean-Philippe 129

Charnay, Désiré 55

Chevalier, Charles Louis 12, 17

Chevreul, M. Eugène 37

Chrétien, Gilles-Louis 13

Christian, Christer 145

Citroen, Paul 100, 106

Clark, Larry 163

Claudet, Antoine Jean François 24, 35

Clergue, Lucien 161

Close, Chuck 149

Coburn, Alvin Langdon 75–76, 94, 143

Coplans, John 170

Cordier, Pierre 144, 146

Corot, Jean-Baptiste Camille 47

Courbet, Gustave 42, 47

Crewdson, Gregory 171

Cros, Charles 68

Cunningham, Imogen 86–87

Curtis, Edward Sheriff 81

Daguerre, Louis Jacques Mandé 14, 16, 18–23, 38

Dallmeyer, John Henry 33

Davidson, Bruce 135

Davy, Humphrey 15, 18

de Maria, Walter 151

de Meyer, Adolphe 76, 94–95

Deakin, John 140–141

Degas, Edgar 47, 67

Delacroix, Eugène 26, 41, 47

Delamotte, Philip H. 48

Delaroche, Paul 50

della Porta, Giovanni Battista 11

Demachy, Robert 72–73

Derain, André 82

Dibbets, Jan 146

Disdéri, André Apolphe-Eugène 36, 39–40

Döblin, Alfred 94

Dodgson, Charles Lutwidge 38, 46, 48, 163

Doisneau, Robert 91, 129

Drahors, Tom 168

Draper, John William 24

Driffield, Vero Charles 60

Drtikol, Frantisek 92

Dubosq, L. Jules 34

DuCamp, Maxime 26–27, 54

Duchamp, Marcel 99, 101–102

Ducos du Hauron, Louis 68

Dunas, Jeff 165

Duncan, David Douglas 131

Durieu, Eugène 26, 41

Eastman, George 65–67

Edgerton, Harold 121

Edwards, John Paul 87

Eggleston, William 162

Einstein, Albert 118

Eisenstaedt, Alfred 130

Elle, Klaus 161

Eluard, Paul 96

Emerson, Peter Henry 70, 72

Erfurth, Hugo 92

Ernst, Max 100

Erwitt, Elliott 153

Estes, Richard 149

Eugene, Frank 76

Evans, Frederick H. 73

Evans, Walker 85–86, 118, 126, 137, 163

Faucon, Bernard 167–168

Faure, Nicolas 160

Feininger, Andreas, Lionel, and Lux 107

Fenton, Roger 49–50

Finsler, Hans 91

Fischer, Rudolf 120

Flaubert, Gustave 26–27, 42–43

Florschütz, Tobias 171

Fontana, Franco 160

Franck, Martine 153, 161

Frank, Robert 136–137, 163

Fraunhofer, Joseph von 12

Freed, Leonard 153

Freund, Gisèle 36, 113–115, 118, 139

Friedlander, Lee 138, 163

Friedmann, André, see Capa, Robert

Frima, Toto 161

Frith, Francis 54–55

Fuller, Marie-Louise 65

Gantz, Joe 168

Garcia Rodero, Christina 157

Gardner, Alexander 39, 50, 54, 57

Gaumy, Jean 153

Gelpke, Andre 145, 159

Genthe, Arnold 79

Genzken, Isa 170

Gerdes, Ludger 168

Gerz, Jochen 168

Giacomelli, Mario 144

Gibson, Ralph 163

Gidal, George and Tim 110–111

Gilden, Bruce 162

Giroux, Alphonse 19–20

Gloeden, Wilhelm von 72–73

Goldin, Nan 164

Goodwin, Hannibal Williston 59, 65–66

Gordimer, Nadine 158

Gouraud, François 24

Gräff, Werner 94, 107

Graham, Paul 156

Gravenhorst, Hein 146

Greene, John B. 27

Gropius, Walter 106

Grosz, George 99–100

Grundberg, Andy 164

Guevara, Che 131

Guibert, Hervé 161

Güler, Ara 143

Gursky, Andreas 160

Haas, Ernst 153

Hajek-Halke, Heinz 99, 144–145

Index of Names

Halsman, Philippe 140
Hamilton, Richard 147
Hanfstaengl, Franz 38
Hardy, Bert 126, 131
Hartlaub, Gustav F. 89
Hausmann, Raoul 99–100, 103, 145
Hawarden, Clementina 46–47
Heartfield, John 99
Heizer, Mike 151
Henle, Fritz 115
Henneberg, Hugo 72–73
Henri, Florence 94
Herschel, John Frederick William 19, 38, 45
Herzfelde, Wieland 100–101
Hill, David Octavius 25–26, 71
Hilliard, John 171
Hine, Lewis Wickes 77–78, 81
Hinton, Alfred Horsley 73
Höch, Hannah 99–100
Hocks, Teun 168
Holmes, Oliver Wendell 35
Höpker, Thomas H. 132
Horst, Horst P. 119
Howlett, Robert 36, 48
Hoyningen-Huene, George 95, 119
Humboldt, Alexander von 18–19
Hurter, Ferdinand 60

Ingres, Jean-August Dominique 47
Itten, Johannes 106
Ives, Frederic Eugen 68
Izis 129

Jackson, William Henry 57
Jacobi, Lotte 118
Jäger, Gottfried 146
Johnston, Alfred Cheney 96
Joyce, James 92, 115
Kahlo, Frida 115
Kaprow, Alan 150
Karsh, Yousuf 139–140

Käsebier, Gertrude 75–76
Katz, Benjamin 160
Keetman, Peter 144–145
Kennett, Richard 58–59
Kepler, Johannes 11
Kerouc, Jack 136
Kertész, André 88, 91, 102–103, 111, 113
Khaldey, Yevgeny 124
Killip, Chris 156
Kircher, Athanasius 11
Kirchner, Ernst Ludwig 47
Klauke, Jürgen 168
Klein, Astrid 170
Klein, William 138, 162
Klein, Yves 151
Klemm, Barbara 157
Klijn, Gerard 145
Klitsch, Karl 52
Koelbl, Herlinde 160
Koons, Jeff 168
Koppitz, Rudolf 91–92
Kossuth, Joseph 151
Koudelka, Josef 153, 156, 167
Krims, Les 168
Krone, Hermann 24, 30
Kruger, Barbara 168, 170
Krull, Germaine 91
Kühn, Heinrich 69, 72–73

Lacan, Ernest 52
Land, Edwin H. 120–121
Lange, Dorothea 126–127
Lartigue, Jacques-Henri 65, 69
Lauterwasser, Siegfried 145
Lavater, Johann Caspar 13
Le Gray, Gustave 26, 28, 37, 43–44
Le Secq, Henri 26–27
Lebeck, Robert 132
Lee, Russell 126
Leidmann, Cheyco 165
Lenbach, Franz von 47
Lessing, Erich 131, 153
Levine, Les 151
Levy, G. M. 61
Lex-Nerlinger, Alice 99
Lichtwark, Alfred 72

Liesegang, A. 33
Liesegang, Eduard 60
Lindbergh, Peter 166
Lissitzky, El 99–101, 104–105
List, Herbert 101
Löcherer, Alois 26–27, 52
Lorant, Stefan 112
Luce, Henry R. 112
Ludwig II of Bavaria 40, 52
Lumière, brothers 64, 69
Lüthi, Urs 168
Lyons, Danny 163

Madame d'Ora 92, 96
Maddox, Richard Leach 58
Magritte, René 103
Magubane, Peter 155
Malevich, Kasimir 99–100, 105, 148
Man Ray 15, 93, 95–99, 101–103, 115, 145
Man, Felix 109, 111
Mangold, Guido 145
Mann, Sally 163
Mann, Thomas 90
Manos, Constantine 153
Mantz, Werner 90
Mapplethorpe, Robert 164–165
Marey, Etienne-Jules 63–64
Mark, Mary Ellen 156
Martens, Olaf 166
Marville, Charles 26
Maximilian, Emperor of Mexico 50
Maxwell, James Clerk 67
McBride, Will 160
McCullin, Donald 155
Meade, Charles Richard 25
Meiselas, Susan 153, 155
Meisenbach, Georg 52
Messager, Anette 170
Meydenbauer, Albrecht 60
Meyer, Hugo 109
Meyerowitz, Joel 162
Michals, Duane 150, 168
Miethe, Adolf 59, 68–69
Mili, Gjen 146
Millais, John Everett 46–47

Index of Names

Miller, Lee 95-96, 125
Miller, M. M. 56
Misonne, Léonard 92
Model, Lisette 123
Modotti, Tina 86
Moholy-Nagy, László 94, 97-98, 100, 106-107, 145
Mondrian, Piet 139, 148
Monroe, Marilyn 141, 148
Morath, Inge 153
Morimura, Yasumasa 171
Morse, Samuel F. B. 24
Mucha, Alphonse 59
Muche, Georg 106
Mudd, James 51
Muggeridge, Edward James, see Muybridge, Eadweard
Munkacsi, Martin 95
Muybridge, Eadweard 57, 62-63, 121
Mydans, Carl 126

Nachtwey, James 153, 155
Nadar 36-37, 66
Napoleon III, Emperor 39-40, 43, 55
Neshat, Shirin 161
Neuke, Angela 159
Neusüss, Floris M. 146
Newman, Arnold 139
Newton, Helmut 165-166
Niedermayr, Walter 160
Niépce de Saint Victor, Abel 30
Niépce, Joseph Nicéphore 16-19, 30
Nothelfer, Gabriele and Helmut 159

O'Keefe, Georgia 75
O'Sullivan, Timothy 50-51, 57
Obernetter, Emil 60
Obernetter, Johann B. 60
Outerbridge, Paul 86, 103
Pabel, Hilmar 132
Pap, Gyula 107
Parks, Gordon 130

Parrish, David 149
Penn, Irving 141-142
Peress, Gilles 153, 155-156
Peterhans, Walter 106-107
Petzval, Josef 12, 23, 32
Picabia, Francis 101
Picasso, Pablo 96-97, 139
Platt-Hynes, George 96
Plüschow, Wilhelm 73
Poitevin, Alphonse L. 51, 67
Polke, Sigmar 169
Pound, Ezra 76
Primoli, Giuseppe 58
Puyo, Constant 72

Rainer, Arnulf 150, 169
Raphael 45, 47
Rauschenberg, Robert 149
Reilander, Oscar Gustave 43-45, 70, 99
Reinartz, Dirk 157
Renger-Patzsch, Albert 89-90
Renoir, Jean 114
Rheims, Bettina 166
Riboud, Marc 129, 153
Richter, Evelyn 8
Richter, Gerhard 149, 169
Riebesehl, Heinrich 145, 159
Riis, Jacob A. 76-77, 80
Ritts, Herb 166
Rivera, Diego 86
Robertson, James 48
Robinson, Henry P. 43-46, 70, 72-73, 99
Rodchenko, Alexander 94, 100-101, 104-105
Rodger, George 125, 152
Roh, Franz 89, 94, 97
Ronis, Willy 129
Roosevelt, Franklin D. 126
Roosevelt, Theodore 81
Rossetti, Dante G. 46-47
Rössler, Jaroslav 91
Rothstein, Arthur 126
Rudnitzky, Emmanuel, see Man Ray
Rudolph, Paul 61

Ruetz, Michael 157
Ruff, Thomas 160

Sabatier-Blot, Jean B. 24
Sala, Angelus 14
Salgado, Sebastião 153, 157-158
Salomon, Erich 94, 109, 111
Salzmann, August 27
Sander, August 80-81, 90, 93-94
Schad, Christian 98
Schavinsky, Xanti 99, 107
Scheele, Carl W. 14-15
Schmidt, Michael 159
Schönbein, Christian F. 28
Schröter, Erasmus 160
Schult, H. A. 150
Schulze, Johann Heinrich 14
Schürmann, Wilhelm 159
Senebier, Jean 14
Senefelder, Alois 16
Serrano, Andres 160
Seymour, David 114, 152-153
Shan, Ben 126-127
Shaw, George Bernard 67
Sheeler, Charles 84, 86
Sherman, Cindy 168
Sherman, William T. 50
Shore, Stephan 162
Sieff, Jeanloup 165
Sieverding, Katharina 170
Simon, Jean-Marie 155
Siskind, Aaron 144
Sixma, Tjarda 168
Smith, Adolphe 79-80
Smith, W. Eugene 125, 129-130
Smithson, Robert 149, 151
Sommer, F. White 144
Sontag, Susan 124, 138
Spender, Humphrey 125
Stankovsky, Anton 107
Starn, Doug and Mike 170
Steichen, Edward 69-70, 73, 75-76, 84, 94-95, 125, 132
Steiner, Ralph 86

Index of Names ... Picture Credits

Steinert, Otto 144–145, 159
Steinheil, Adolph Hugo 33
Stelzner, Carl Ferdinand 15, 24, 48
Stern, Bert 141
Stieglitz, Alfred 73–75, 84–85, 87, 101, 134
Stillfried (Baron) 41, 56
Stock, Dennis 153
Strache, Wolf 123
Strand, Paul 84–88, 114
Strindberg, August 67
Struth, Thomas 160
Stryker, Roy E. 126
Sudek, J. 92
Sutton, Thomas 33, 67
Swan, Joseph William 51
Székessy, Karin 165
Szynim, D., see Seymour, David

Talbot, William Henry Fox 13–15, 20–22, 25, 27, 34, 38, 97
Tas, Henk 168
Tatlin, Vladimir 99–101, 104–105
Teller, Juergen 160
Tennyson, Alfred 46
Thomson, John 55, 79–80
Thornton, John 165
Tillmanns, Wolfgang 160
Tournachon, Gaspard-Felix, see Nadar
Traube, Arthur 59
Tress, Arthur 168
Turbeville, Deborah 165
Tzara, Tristan 98–99

Uelsmann, J. 146
Umbo 99, 107
Unwerth, Ellen von 16
Utrillo, Maurice 82

Vallou de Villeneuve, Julien 42
van der Zee, James 78
van Dyke, Willard 87
van Lamsweerde, Inez 166

Victoria, Queen 35, 45, 48–49
Villinger, Hannah 168
Virilio, Paul 161
Vlaminck, Maurice 82
Vogel, Hermann W. 59
Vogel, Lucien 112
Vogt, Christian 165
Voigtländer, Friedrich 23–24
Vordemberge-Gildewart, Friedrich 107
Vostell, Wolf 150–151
Vroman, Adam Clark 82
Vuillard, Edouard 47

Wall, Jeff 167, 171
Warhol, Andy 148
Watkins, Carleton E. 32, 57
Watson, Albert 166
Watzek, Hans 71
Webb, Alex 155
Webb, Boyd 168
Webster, K. 161
Wedgwood, Thomas 15, 97
Weegee 117
Wegman, William 168
Wehnert-Beckmann, Bertha 25
Weiner, Dan 136
Weiss, Sabine 129
Wessing, Koen 155
Weston, Edward 84–88
Wheatstone, Charles 34
White, Clarence H. 76
White, Minor 134–135
Winogrand, Garry 137, 163
Witkin, Joel Peter 168
Wolcott, Marion Post 126
Wolf, Reinhard 158–159
Wollaston, William Hyde 13
Woodbury, Walter 51–52
Woolf, Virginia 115

Zahn, Johannes 11
Zille, Heinrich 80
Zola, Emile 67
Zwart, Piet 99

Picture Credits

Picture Credits